T0042987

Perfect Wave

DAVE HICKEY

Perfect Wave

More Essays on Art and Democracy

THE UNIVERSITY OF CHICAGO PRESS

Chicago and London

The University of Chicago Press, Chicago 60637
The University of Chicago Press, Ltd., London
© 2017 by Dave Hickey
All rights reserved. No part of this book may be used or reproduced
in any manner whatsoever without written permission, except in
the case of brief quotations in critical articles and reviews. For more
information, contact the University of Chicago Press, 1427 E. 60th
St., Chicago, IL 60637.
Published 2017
Paperback edition 2023
Printed in the United States of America

32 31 30 29 28 27 26 25 24 23 1 2 3 4 5

ISBN-13: 978-0-226-33313-7 (cloth)
ISBN-13: 978-0-226-33314-4 (paper)
ISBN-13: 978-0-226-51515-1 (e-book)
DOI: 10.7208/chicago/9780226515151.001.0001

LCCN: 2017023338

♾ This paper meets the requirements of ANSI/NISO Z39.48-1992 (Permanence of Paper).

Contents

Baby Breakers

I went to first grade in Fort Worth with Lee Harvey Oswald. I went to second grade in Shreveport, where my Dad had a gig in some Dixie Greaser Lounge, but we were moving up. In third grade, we lived in nifty North Dallas. Every Thursday, in social studies class, we drew the name of a country out of a hat and wrote a report about it. We made our own folders for each report. Then we would vote for the best cover. First shot, I drew Italy—and how can you fuck up Italy? I had grapes, columns, and a version of Trajan's Market that foreshadowed the Fontainebleau in Miami Beach. My grapes foreshadowed late Sam Francis. They were especially praised, and I won. I got the Hershey bar that was the prize. Next time I reached in and drew Bolivia. Right, Bolivia. I cut out a brown mountain and stuck it on a blue sky. My friend Cecily drew Egypt and she killed it. Perspectival pyramids with scaled triangles of ocher in different shades. These were major pyramids but I won again.

I thought this was outrageous. Either North Dallas third graders had developed a prescient taste for minimalism, or I won because I had won last time and now I was the guy who won. The insult festered and I gave my Hershey bar to Cecily because I am a critic and not an artist. I don't care about winning. I care about being right. Meanwhile, at home, my mom and dad screamed at one another. They threw clocks and vases. My mother was late for an appointment one morning. She backed out of the garage in a hurry, spinning her wheels, and ran over my Jack Russell terrier, Milton. She reminded me that it was my damn dog—that she was in a hurry—and rushed off, gone before she was gone, leaving me to bury Milton in the backyard. I took the little brass plate off Milton's collar, nailed it to the

side of the garage, and buried Milton under it. No one ever spoke of Milton again. On Saturdays, my parents were in the house together all day, so I would set off on my bike at 10 a.m. and ride down to the Inwood Theater on Lovers Lane and then over to the Village Center on Preston Road to watch movies all day long. Unlike other movie-fugitives I have known, I came to hate movies. Also, eventually, somebody stole my bike.

Then one morning I woke up to silence. There was no yelling or crashing. My dad was gone. He just drove off. We didn't know where he had gone and mom didn't say. Like Milton, he was just gone. So I worked on my social studies covers, played baseball, and read books. One Saturday, my friend Harvey Richman took me to Hebrew school, which was very cool. I wanted to learn English the way Harvey was learning Hebrew, and eventually I did. So we, the Hickey children, cracked and crumbled under mom's thumb, although I was not much concerned with my siblings' distress. Mostly Mom sublimated her distaste for Dad onto me because I bore his name, and anything I loved she hated. Then, in late June, my dad walked in the front door and said, "Start packing. We're moving to California." More screaming, explosions, and slamming doors, but we started packing. I went out to say goodbye to Milton, whom I had named Milton because Jack Russells are notoriously rambunctious animals and I thought a scholarly name would calm him down. It didn't. So bye-bye, Milton, you scamp.

In three weeks we had moved into this great house between the Pacific Coast Highway and Santa Monica Beach. There were wisteria, hydrangeas, a willow, three black plum trees, and a giant bougainvillea. It was Heaven in other words, and I knew the names of the flora because my grandmother ran a flower shop and also because, generally, I know the names of things. I walked through the side door of our new house, out the front door, and ran for the water. I learned the taste of salt-snot up my nose and started bodysurfing right off. I tried a boogie board but it seemed dorky.

As we settled into California, I was enrolled in Santa Monica Ele-

mentary, which was multicultural, to say the least. I liked it because I had never known any black people or Latinos who were my age. It was cool, but I was like a mouse who fell to earth. They didn't know what to do with me, so I gravitated toward the beach. There was an actor named John Agar who lived two houses up from us on the strip between the beach and the highway. (If you drove straight off Wilshire Boulevard, then off the palisades, you would land on our house if you cleared the Pacific Coast Highway.) I got a job shoveling and sweeping sand off John and Gloria's driveway. (I always had to have a job because working felt like freedom.) Anyway, I was often in the Agars' garage, where a beautiful red Billabong longboard hung on a rack and I sort of worshiped it. I just stood there for twenty or thirty minutes at a time, staring and dreaming.

Meanwhile, back at school, my attendance became an issue. They sent me to a counselor, and luckily she had been a surfer in her youth. We talked about whether the ninth wave was the best wave in a set. I argued that the best wave conformed to some irregularity in the bottom of the ocean and the direction of the wave. She looked at me funny, as if I had actually told her something. Then I started taking tests. I took this test and that test and one test with three people. One asked you questions, one watched, and one listened. I took tests where they stuck things on your head, eye tests and ear tests, brain scans, and strangely I never considered the idea that they might be a little bit afraid of me. Finally, my counselor told me I was counterpho bic (whatever that might mean). She promoted me from the third to the sixth grade and told me not to worry much about attendance, so I didn't. Sixth grade in Santa Monica Elementary was sort of a finishing school for gangbangers, anyway—and however awful California schools might be, their testing was top level, which says something about California, I guess. Also, when I learned what "counterphobic" meant, that was me. I walked out of that office absolutely sure I would never attend a school where my kind of smart was worth shit. This would prove to be true.

I wasn't a sissy but logic prevailed. It is less punishing to be

knocked down in the sand than on the asphalt. I never started a fight, because fights are so intimate and sweaty. I did win some of the fights I never started, though. So here I was, six months after Ms. Blackburn's third grade, social studies, and Cecily's pyramids. I was an undersized sudden sixth grader in this beautiful jungle full of large, shiny Californians with Polynesian tattoos. Was it scary or was it a rush? I never figured this out. Mostly a rush, I think, since kids heal easy. They move on in a dazzle of forgetfulness and try to keep their heads up. Also, I had been well schooled by my narcissistic parents. I knew that it was always my fault, and I really don't mean to put down my parents as much as it might seem here. Our relationship was not abusive; it was a fight, not a battle; it was a competition for the oxygen in the room. And even though I didn't like them, I knew somehow that they were just like me: smart, well-educated, working-class people trying to keep their noses above the bubbles.

Then finally, fatally, I got lucky. I was standing in John's garage one day, communing with his surfboard. He pulled up in his Oldsmobile convertible and watched me a minute. Then he said, "You want that board?" I looked at him like a demented forest creature.

"Really," he said. "I broke my ankle when we were doing *Tarantula*. I can't ride it anymore."

"How much do you want for it?" I said.

"Nothing," John said, with his great big Hollywood smile. "I'll even throw in the rack." I think I nearly swooned, whatever that is, but I nodded yes yes yes. It seemed to me that being divorced from Shirley Temple had freed John up a little. I also thought Gloria DeHaven, his current girlfriend, was a little less full of herself than Shirley. So this was one of the four times in my life, discounting spontaneous blowjobs, when people just casually did something nice for me that changed my life.

So now I was a real surfer who couldn't surf. I floated around out beyond the chop. In my head, I called my board Milton, with no sign or anything lest I initiate explosions at home. The board was like an aircraft carrier. I was like a lizard holding on. But I came to like the

wobble of the water and the strong feeling of finding a steady groove. I would practice getting up and down; then, when I felt good standing up, I would climb up and lean to the beach. It took a month for me to get to the beach standing up. Then the local dudes started picking on me. They would zoom across behind me and throw me up in the air. I would be standing on the beach side by side with Red Dog, our boards under our arms. Red would turn away suddenly, and the back of his board would knock me in the face. "Sorry, dude," he would grin. Eventually I learned that surfers don't have friends until they're about thirty. Until then, it's a battle on the beach and in the foam, and thank god for my high pain threshold (that's when you feel it) and higher pain tolerance (that's how long you can stand it).

So I started traveling. It was easier than you think in those days. Every fifth car had a board rack, so I got rides up to Malibu and down to Ocean Beach and Huntington, where the sets were more orderly, the competition more fierce, and the fish tacos were great. I was not a good surfer. I had stupid feet, and in my memory, all my competitors looked like Laird Hamilton: genius feet, big jaws, horse teeth, blond hair, and no mercy. All I had was a genius brain, infinite patience, and a cozy familiarity with failing. So I did my surfing homework. I took the bus to the Coast Guard Office and bought a bunch of cool rayon acetate maps that resist water, fold like paper, and wad like cloth. These maps traced the ocean bottom as it slid off the beaches. You were looking for underwater humps out on the ocean floor and fallaways near the beach, each of which pushed the ocean up quickly, promising good waves.

When I could read the bottom of the ocean from the top, it was like surfing on a clam, so I gained a little cred. Although I could pick the wave, I would nearly always fall off the wave. But I started falling off some very good waves, and when I actually made it, I was beautiful when I did my crucifix thing, arms outspread, like my friend Kenny Price, who lived on the same cliff we did when we moved to Pacific Palisades.

My frenemies were curious, since I was clearly no waterman.

They called me Whoopsy, so one day I took my maps up to Malibu to show them. The minute I stepped on the beach, I knew I had set myself up. My friends might drown me, actually kill me, or they might call me a dork, steal my maps, or stick them down their baggies and dare me to take them back. Since that day I have never approached a group of people without being en garde about the possibility of scorn—although nothing bad happened. My pals were amazed. They ran their fingers down the coastline on the maps and picked out the spots I had found, and some they had found too. They liked the juju science of techno-surfing. We were out on the flat ocean leaning over our boards like a conference table discussing aquatics. After that, when I fell off a big one, they would yell, "Big Wave Dave!" as they shot past me. Just the jokey name made me feel better. I had outsmarted my stupid feet. I liked that, and if I paddled way out, they would sort of drift out with me. You positioned yourself in the ocean by triangulating with objects onshore, just like Captain Cook. This was a learned skill that made you feel good. You made a triangle like Cecily did. You triangulated with two points onshore—the palm in front of the green store, the back of a traffic sign. A triangle like that.

During this time the family moved to Pacific Palisades and into one of those ultramodern houses that hung off the cliff, as if to remind us that Dad, left to his own devices, could make a lot of money. You entered the house on the third floor, into the living room, went downstairs to the bedrooms, and down again to the service rooms. Eventually that house on Posetano Road slid down the cliff onto the highway, leaving a gap that's still on the map, but it was a fine house to live in. I hung Milton Rouge in my bedroom—a name I got from *The Count of Monte Cristo*. Mostly, I stood on the porch and looked off toward Tasmania. (I had lines drawn on the porch rail so I would know where I was looking.) Now I was in middle school and had to go to class on a bus, but I surfed in the morning and in the afternoon. After the last waves of the day, I could barely carry Milton up the stairs to the house. But there was real incentive. Esther Wil-

liams, the swimming movie actress, lived in the house below us, so I would wait for her to come out for a dip.

Meanwhile, I was always looking for anything perfect, and then it happened. It was just before daybreak. I was way out beyond the notches that shiver the waves off Ocean Beach in San Diego. I was standing on my board looking out to sea, and there it came, big and steady and hard out of the north and west, like a set at Waimea. I paddled over to my secret shallow place and climbed aboard. My wave kicked over the bump. It rose above the other waves. We were flying south and east so the approach was a problem. We were heading for the midsection of the Ocean Beach Pier, and I was not good enough to avoid it at that speed. I thought "jump," and then I thought "fuck it," tucked up, and shot the pier with amazed faces looking down at me.

Now I was heading straight toward Sunset Cliffs. Half my brain was shouting, "Jump, jump, jump." Half my brain was shouting, "Hold and spin, hold and spin." The holds won, so I tried to get as close as I could and spin out by shooting my board up in the air. I underestimated my momentum. It didn't work. I flew off the board and hit the cliff sideways. Good for Milton, bad for me. My back crashed into the limestone and ruptured my lower body. This was a big oops but I was lucky to capture Milton as he spun away. I paddled out one-handed as hard as I could, well above my pain threshold, and one-handed my way back to Ocean Beach. Once on the sand I just lay there. Finally, a cute little fat girl came up and asked me if I was hurt. I suggested 911 and took a little nap.

I woke up in the hospital with two hernias and three splintered ribs, annoyed that I had missed the ambulance ride, and honest to god, I was amazingly proud of myself. I had ridden a waterman ride, Jesus. They shot me up with pain drugs and spent six hours trying to reach my family. They finally reached my little brother, who got in touch with my mom at UCLA, where she was teaching. She gave them a bunch of numbers and told them to fix me. They did. Today, my mom would have had to drive down and sign something. If so, I would still be there, but those were easier times, and as I rolled out of

the hospital late the next day, the doctor told me that I had just retired from surfing. I nodded and climbed into the limo I had ordered. The driver and I waited in front of the clinic for the woodie that would take poor Milton home, battered, disheveled, and strapped to the top. I could hardly believe that the EMTs had thrown Milton into the ambulance. I guess it really was a brotherhood. I could hear the EMTs talking . . . "shot the fucking pier . . ."

As we headed back to the Palisades up the Pacific Coast Highway, I found myself dreaming about the high-board at El Segundo. That bounce. Muscle memory. I was also happy I had done the ride alone and in secrecy. The wave was gnarly enough to lie about, and I knew right then that I was going to be okay. I was free in some dreamy way. When we made it home, the limo guy helped me downstairs to bed. The woodie guy brought Milton down and hung it on the wall. Clearly, they had done this sort of thing before. I tipped the guys everything I had. My little brother showed up. He brought me some Cheerios. After Cheerios, I took two of the pain pills that my doctor had recommended one of, and drifted off.

The next morning, a tap on the door awakened me. My dad came in and told me I was breaking my mother's heart, and his too, of course. Then he gave me a secret smile like we were in a gulag and quickly retreated because my mother was coming. She stalked into my room. She told me I was breaking her heart, and would I just look at myself, wrapped up like a sore thumb. I feigned coma until she left. But I felt good. I was breaking their hearts. Damn right! That seemed real, like breaking their legs. There was a frisson of intimacy about it. Even if it was negative, they had noticed me. Since the day they discovered me gestating in my mother's womb, they had been pissed off at me. My dad was a musician and I ruined that. My mom was a painter and I ruined that too. Neither would abandon their dreams unless the other did. It was a Mexican standoff. They just stood there in the shiny glass living room, eye to eye, daring one another.

I lay there in bed for six or seven days gradually shedding bandages, watching *Crusader Rabbit* on my blond, round-screened tele-

vision, and reading ocean books from the Santa Monica City Library. All these books had orange square-riggers stamped on the spine. I started with the little numbers: like *I Sailed with Magellan* and *I Sailed with Captain Cook*. Kids' books but I dreamed them. I could feel the slick quarterdeck and watch the mast tilt toward the rising waves. Finally I got to *The Nigger of the "Narcissus"* and *The Secret Sharer* and I knew I had turned a corner. I could feel the sea in the spray and feel the grammar escalating like a tangle of salty sea rope. Then I read *Lord Jim* and I could feel him seeping into me, the panic, the uncertainty I knew so well. *Lord Jim* was a real fucking book, but it was hard to be fond of it, because, in my eyes, I was Jim. I felt that I should have been braver and started a revolution.

Finally I was mobile enough for school again. I stumbled down the steps and caught the bus to Emerson with one of Esther's kids. We always acted sullen on the bus because we were from the Palisades and fuck you. That evening I came home to an arid new world. I walked into my room and Milton Rouge was gone, the rack upon which Milton Rouge hung was gone, the screw holes that had held the rack were gone. They had been spackled, sanded, and repainted so no trace of Milton remained. And the board would never be mentioned again. I decided that my parents would have made a great success writing Soviet history. I felt as if something had been amputated. That was the board upon which I rode the ride, and there was nothing I could say. So I swore to have my revenge. Like the Count of Monte Cristo, I kept my own counsel. They had killed Milton the terrier, my alter ego. They had killed Milton Rouge, my oceangoing avatar. There would be an accounting soon enough, and today every word I write, I guess, is part of that revenge. Perfect.

Cool on Cool

WILLIAM CLAXTON'S WORLD

I'm having lunch in Beverly Hills with William Claxton, the dean of jazz photographers and one of the heroes of my youth. As a moment, it ranks up there with meeting Link Wray, who pioneered the use of distortion in rock recording, and meeting my homey Ornette Coleman, who invented musical things that still have not been named. While we're waiting for our food, Claxton and I sort out mutual acquaintances. Claxton tells me how he met Dennis Hopper back in 1954. That year, Claxton says, he was making the first respectable money he had ever made as a photographer, and so, being a true Angeleno, he purchased a Ford convertible, and having purchased a Ford convertible, what else was he to do but drive it down the Sunset Strip with the top down? There, on the side of the street, he spotted a kid hitchhiking and picked him up. The hitchhiker was Dennis Hopper in his final days of hitchhiking. Cruising down the strip, these two aficionados and soon-to-be icons bonded in their mutual enthusiasms for cool music, cool films, and cool photography. In this way, two of the great connectors, facilitators, and enthusiasts of the Los Angeles cultural landscape crossed orbits.

In those days, it was all about happy accidents. When Claxton was in college, his first intimate connection with the jazz world arose out of Los Angeles's paucity of late-night dining options. After a Charlie Parker concert, Claxton and his friends ended up taking The Bird home to the Claxton house in Pasadena for an after-hours snack, and having fed The Bird, who was as close to a god as the jazz world has ever produced, doors opened, but the trick was in the generosity. You picked up hitchhikers, took people home for dinner, and the world opened up. These days Claxton still works when he wants

to. He is aging gracefully, if at all—white-haired, tall, thin, and very "old Hollywood." His trademark patrician manner is still intact, and you can understand immediately how his quiet blend of presence, diffidence, and enthusiasm inspired trust and allowed him to take the pictures that he took as unobtrusively as he did. His attentiveness and enthusiasm have not wavered. He recognizes Gerry Mulligan and Antônio Carlos Jobim playing on the Muzak in the dining room, approvingly, as if they were little gifts dropped out of the air.

During lunch I tell Claxton my own little story about how I became cool in the early 1950s, when my family moved from North Dallas to Santa Monica, to a house between the Pacific Coast Highway and the beach—how I found my first real home on that beach, my first real music in the laid-back jazz of that time and place. My first visual icons in Claxton's black-and-white photographs of that musical milieu. They adorned the jackets of albums from Pacific Jazz and Contemporary Records, and to be honest, I started buying the albums for the covers. It was obvious to me that no albums with covers that cool could be bad. The corollary to that premise is that if the cars of that era resembled the cars of this one, I wouldn't be an art critic. In any case, while I listened to the music, I would stare at Claxton's pictures, beguiled by their plainness, their awesome silence— the ordinary guys in T-shirts and chinos set up in vanilla studio settings, wielding the gleaming, outrageous instruments that were the real heroes of the photographs.

A decade later, during the heyday of the Venice Beach art scene, Claxton remained a presence; his photographs were consulted in all matters pertaining to style and apparel. The look of his photographs was the way you wanted things to look. It was palpable in the photographs of Dennis Hopper and Ed Ruscha, in the crisp, banal ambience of Venice Beach studios and galleries. In Venice at that time, Claxton's gleaming instruments were replaced by dazzling objects in glass, resin, and automotive lacquer by artists like Larry Bell, Peter Alexander, Billy Al Bengston, DeWain Valentine, and Robert Irwin, one of whose early paintings, at Claxton's behest, adorns the cover

of a Pacific Jazz album. The gleaming instruments and gleaming art were icons of everyday grandeur. This music and that art were purely a "West Coast" thing, even though their origins were elsewhere. The artists of Venice Beach had roots in the hard-edged Los Angeles painting of John McLaughlin and Fred Hammersley, but the minimalist look that they redeemed with eros and atmosphere was born in New York in the work of Don Judd, Sol LeWitt, and Carl Andre. The "birth of the cool" in American jazz almost certainly took place in the late 1940s in Gil Evans's basement apartment on West Fifty-Fifth Street in New York. Under Evans's mentorship, musicians like Miles Davis, Lee Konitz, John Lewis, and Gerry Mulligan evolved the linear, "cool" aesthetic in its essential form.

Americans, however, as many sociologists have noted, are less interested in home as a point of origin than in home as a destination that "feels like home," and it felt like home in 1952 when Mulligan's pianoless quartet was booked into the Haig on Wilshire Boulevard with Mulligan on baritone sax, Chet Baker on trumpet, Bobby Whitlock on bass, and Chico Hamilton on drums. The musical proclivities were already ambient in the scene. It was a good fit, as designers say, a case of cool on cool, and wonderful music too. Sometimes during these years, there would be kid-friendly jazz shows at Hermosa Beach or at other more fugitive venues, and my dad, who was a player too, would take me along to listen. Late one Saturday afternoon, in a little church on La Brea, I saw the first *really great thing* that I had ever seen. Later I would hear my dad telling people that we saw Miles Davis, but I don't know if we did or even care. It would be better, actually, if it was just a bunch of guys you never heard of.

To me it was five musicians in slacks and Hawaiian shirts standing on a low choir riser playing very good music that disappeared into the softness of the air. Everyone in the audience felt privileged and touched by the occasion. Nobody complained about the lack of press coverage, the secrecy of the venue, the tiny crowd, or the heat in the little church. Nor did the music complain or make demands. It simply declared itself. It was quiet music at a time when jazz was loud

(it was more Chico Hamilton than Miles, now that I think about it). It was played midrange and midtempo even though playing fast and high was an icon of jazz mastery at that time. It did not manifest the honks, squawks, and stinging vibratos that, in that moment, were signifiers of effort, struggle, and "self-expression." To have done any of these things, I realize now, would have been hypocritical. It would have posited resistance where there was none. It would have con-jured up a nonexistent state of repression for pure effect. Stripped of this sort of posturing, the afternoon presented itself as everyday life under optimum conditions, steady and cool.

The group happily relinquished any vestige of power that wasn't required to play the music, and along with it, they divested them-selves of a great deal of pain. This flowering led me to suspect that a great many of the jazz émigrés who landed in Los Angles were bat-tered souls. Once in Los Angeles, the struggle of the mind to keep the body alive and the struggle of the spirit to keep the soul alive were radically diminished, and for the first time, in many cases, musicians who had come running out of the urban ghettos and the backwoods hinterlands, who had run their whole lives and slept in bus stations, could actually stop and think, could actually plan and live in the flow from day to day. Under these conditions, music could actual-ly be designed, not just arranged, and out of these new privileges, a thoughtful, premeditated music evolved. The layered, harmonic thickness of urban jazz, with its catastrophic events and sudden transformations, dissolved into the horn-driven flow of Mulligan's quartet, whose intertwining melodic lines moved along, together and apart, like traffic on a freeway, with no more harmonic support than birdsong, grounded in the drive, tone, and muscularity of the group endeavor. Music became sounds in the air, and one recognized Miles and Mulligan and Baker and Hampton Hawes as much by the eccentric noise they made as by the notes they played.

Unfortunately for all those jazz critics and fans back in New York who were subliminally committed to the politics of struggle and the aesthetics of self-expression, this tempered relaxation of

tone came as a kind of betrayal. These advocates were so eager for the world to change that they didn't notice that it had, or didn't like how it had. The critics were still in a hurry. The musicians were taking a breath, looking around, thinking things out, and happy to be working and eating even as they were excoriated. They considered the new, slower, more premeditated pace of their charts and improvisations to be an evolution, a step toward maturity, an adult relinquishment of adolescent ego. Their detractors in the jazz press took this sea change to signify a profound loss of innocence, and indeed it did. The critics—whose job, as they saw it, was to intellectualize raw expression—resented the new music's cool knowingness and design. They also resented the plain fact that no one was trying very hard to please them. In this breach, William Claxton's photographs took their place, bridging the gulf of cultural misunderstanding between the music and its critics.

Claxton's photographs would prove to be the perfect ambassador for a brand of music by embodying its values without striving to impose them. Today Claxton's work provides us with visual commentaries on a scene and an art form that have persistently eluded written commentary, a scene in which it was more important to be seen being cool than to be written about at all. The secret of Claxton's genius, I have always felt, is in his decorum, his politesse. He is ultimately a formal artist dedicated to a formal subject. He depicts the way musicians relate to their instruments and to the world, and out of that subject some idea of the more mysterious, ineffable relationship between the artist and the art is teased into visibility. Claxton claims to be listening with his eyes, but he is actually making his own quick, visible music, invariably focusing on the human body, the glamorous instrument, and the intricacy of their interaction with the frame of the image. There are no lyrics. The content of the image beyond the player and the instrument is willfully plain, shrouded in darkness or ardently whimsical (Chet Baker on a yacht; Sonny Rollins as a cowboy). From the very beginning of his career, Claxton grasped two things about his subject. First, he understood and exploited the

fact that jazz music usually takes place in settings of stunning visual banality—in poorly lit rooms with linoleum floors, acoustic tiles, random wires, equipment, cheap curtains, and battered furniture. Second, he understood that jazz musicians do not so much dress as disguise themselves, that they are always in costume and never not, in some sense, incognito. As a consequence, the settings and clothing in Claxton's jazz pictures have a genuinely resonant irrelevancy. They speak to the transience and impermanence of everything but the player and the instrument. That is the central romance to which we are privy. Other performers may develop a relationship with the camera, but horn players have a relationship with the horn. It is, to them, the coolest, solidest, best-made, most beautiful thing in the world. In Claxton's famous photograph of Chet Baker sitting in the window with the beautiful girl, Baker is looking at the girl, but he is embracing the horn. Claxton's lens sees that.

As I became a Californian, the politesse in Claxton's photographs and in the music that he advocated was the feature that first beguiled me. Back in Texas, "pacific jazz" would have been an oxymoron. "Pacific" anything would have. Everyone who was not stoned was angry. The climate was hot, *caliente y picante*, with smothering summers that lasted until November, with paranoid Southern pride and overweening Texas vanity, with political partisanship and racial hatred, with religious fervor and poisonous hair spray. California, by comparison, was hazy, lazy, crazy, and bland as a biscuit—and cool, of course—and if weather were everything, it still would be. Cultural linguists since Alfred Korzybski have called our attention to the climacterics of praise and approbation. The inhabitants of cold climates express their approval in terms of warmth and light. The inhabitants of hot climates express their approval in terms of cool and shade. What is hot in Berlin may be cool in Casablanca, it would seem.

In the United States, however, and in the California of my youth particularly, "hot" and "cool" differed in kind. "Hot chicks" and "cool chicks" were different kinds of women. Hot music and cool music were different kinds of music, with differing ethics. Hot music

aspired to grasp the "everything" of all we might desire. Cool music was cagier and less optimistic. It sought, first and foremost, a condition of uninflected candor that did not insist upon itself. The jazz dudes of my youth retained the linguistic dynamics of their African heritage. They aspired to be cool above all else, even if they played hot. In lieu of shade, they wore "shades," even at night, even in gloomy winter, because "cold ain't cool," as Mel Brown once explained to me while we were sitting outside a bar in Chicago.

The brand of cool to which these musicians aspired was, at its heart, a theatrical idea—a bad-weather version of the social contract. To be cool one must be seen to be cool. One must be seen not imposing on one's peers, who are similarly beleaguered by weather and circumstance. One must remain steady, self-possessed, self-aware, and infinitely permissive. One embodied one's beliefs in the ethic of survivalist cool and never tried to sell them. This manner of restraint had an African obbligato, of course, a tinge of Caribbean insouciance, and a whiff of Creole mojo, but it was also touched with the chilly Roman reserve of America's founding fathers and their passionless republican passion, their Senecan plainness.

People always blanch when I suggest the coolness of our founding fathers, but I think it's defendable. James Madison always trumps Patrick Henry, and the event I always cite in aid of Federalist cool occurred toward the end of George Washington's first term as president of the Republic, when his supporters began encouraging him to stand for a second term. The president's objection was straightforward. Since his was not a long-lived family, he argued, a second term would greatly increase the likelihood of his dying in office, and dying in office, he felt, would not be the optimum, republican thing to do. The first president of the United States, he felt, should be seen relinquishing power. When Washington's argument was overridden by circumstance, he managed to survive his second term and achieve his heart's desire. He was seen relinquishing power, stepping down from the dais, the very embodiment of republican virtue, and this act, I have always felt, touches something very close to the heart of

American cool—the idea of being seen relinquishing power as a form of democratic politesse, of refusing to assert one's power while still making that power visible and available.

This brand of American cool is most easily understood when viewed against the "transatlantic cool" that was a product of the 1960s, of the British Invasion, the Italian Cinema, the burgeoning of Euro-trash chic, and the heyday of the Kennedys, the Bouviers, and the Radziwills. Euro-cool was an idiom of distinction, not of restraint, a form of aristocratic reserve, and an instrument of cultural disdain. It was more about hiding things than being something and, ultimately, more about being seen to be hiding something, à la Antonioni, behind a veil of irony. Even at its transcendent best, in the manner of Marcel Duchamp, there was something sour about it, so if Marcel ever showed himself on the beach, he would have been instantly dismissed, not as too hot, but as "way too cool for school"— which is to say, he was no democrat.

Today, of course, the whole of California is "way too cool for school" and worrying about the wine. The distance between William Claxton's photographs of Chet Baker and Bruce Weber's marks the distance between that time and this. In Weber's pictures we get Claxton filtered through Robert Mapplethorpe, whose primary virtue as a photographer was his ardent complicity and intimacy with his subjects; we get Claxton's devices in the manner of Mapplethorpe. In Weber's pictures, the aging, wasted Chet is ready for his close-up. He loves the camera as much as Norma Desmond did, as much as the camera loves him. This is the recipe that made Weber's reputation as a commercial photographer. In Claxton's photographs, the young Chet loves the horn, and the camera loves that relationship. The distance between these two modes of expression is virtually unbridgeable.

In hindsight, then, I have begun to suspect that the California cool of my youth was nothing more than a delaying action. I think we knew that it would never get better than it was, not for people like us. We were, after all, American puritans in the sun, so we knew that our frictionless existence was doomed, that the abrasions that

arrive with crowds, clutter, preening virtue, and the higher forms of social organization were on the way. If nothing else, we would bring them on ourselves, so we felt the impermanence of everything in that permanent sunshine. We understood instinctively that California in these years was less a society than a human infestation, a transient paradise for the misbegotten, so we bought our freedom with caution and anonymity, took a deep breath, and kept it cool.

Why else would citizens of a sunshine habitat adopt the bad-weather ethic of disenfranchised black musicians, if not for fear of losing it, if not because California was something we didn't win but didn't want to lose? It was a gift of circumstance, a happy accident, and a comfortable place, relatively affluent and easily traversed. It was very quiet, as I remember, and absolutely secret, culturally isolated, ill formed, and magnificently disorganized—an imported jungle of tribal enclaves, autonomous subcultures, ghettos, cults, scenes, and secrets that blurred into one another at the edges. There were serious and gifted people, of course, engaged in serious cultural endeavors, but there was no high culture as such, just an unofficial scene or two. For artists, writers, and musicians, however, there was good weather, work on the movie lots and in the recording studios, and all the artistic freedoms that attend upon absolute neglect.

Most critically, the citizens of this Los Angeles were all one in a temperate, hazy atmosphere that eroded the distinction between the mind and the body, between the self and the other, and even so, there seemed to be space around everyone and everything. People seemed not to feel the pressure of the worlds around them, or take much notice of them. I remember my little sister, age ten, referring casually to "the nudists down the street." I remember my father's pleasure at being able to drive on Wilshire Boulevard from Palisades Park to the Miracle Mile without stopping, because the lights were timed at forty. I remember spying on the enclave of screenwriters who occupied the hotels that lined the Santa Monica palisades, who wore ascots and tweed jackets, smoked pipes, and talked about Camus.

In those days one could float like a bubble among these bubble

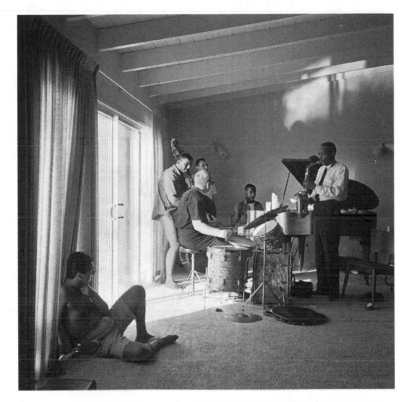

Jam session at Terry Gibbs's home, ca. 1960. Photograph by William Claxton. Courtesy Demont Photo Management.

societies, partaking of them without really participating. My body builder friends at Muscle Beach were good dudes who lived in the bodybuilder world. My beach friends and I lived in the surfer world. My mom and dad lived in the jazz world and the art world. The guys in my B'nai B'rith Scout troop down in Venice Beach, who were all Jews with new goy names like Chapman and Robinson, dwelt almost exclusively in a devout, covert Jewish ghetto. In the realm of fiction, the private eye Phillip Marlowe, whom Raymond Chandler invented for the job, could pass through all these social islands on adventures that were, in effect, designed by the city itself. In the actual Los Angeles, urban adventurers like William Claxton, Dennis Hopper, Chris-

topher Isherwood, Eve Babitz, Kenneth Anger, and Raymond Chandler himself were the actual drifters, connectors, and cool detectives in this sunny, secret world. Theirs was the calling to which I always aspired.

As our lunch is winding up, I have to tell Claxton about my favorite photograph of his, the one that says it all for me. It depicts a Sunday jam session at Terry Gibbs's home, a shag-carpeted, drywall tract house in North Hollywood. The date is around 1960. The musicians are set up in a corner of an otherwise-unfurnished living room that is flooded with sepia-toned sunlight pouring in through a gauzy curtain that covers a sliding glass door. The door is open on to the backyard and the pool, and you know that because you've been in a hundred of these houses. Paul Chambers, barelegged, with a shirt over his swim trunks, is playing bass. Mel Lewis is on drums. Wynton Kelly is behind the piano. To the right, Sonny Stitt, fresh from the East Coast, stands in front of the piano playing an alto saxophone, dressed in bebop de rigueur: black shoes, black slacks, white dress shirt, and thin black tie. Al Porcino is leaning into the corner behind the musicians, while Gibbs, our host, sits on the floor in the foreground, shirtless in shorts, leaning on the curtains against the window. It is a perfect Sunday afternoon in a two-bit tract house in a provisional paradise off in the suburban boondocks, but it is no less paradisiacal for all that. The glow of filtered sunlight stands in for the music, and nothing could seem more lost and ephemeral, more cool or culturally relevant.

When I finish describing this photograph, Claxton laughs and says: "You know, it was all a setup. I wanted to introduce the local musicians to Joachim Berendt, the German jazz critic, so I had Terry get all the guys over to his house. And it wasn't easy. A lot of these guys just didn't go out in the daytime, but a lot of them showed up, we had a few drinks, splashed around in the pool, and when the music started, everything was great."

Far from being upset that the occasion for my favorite jazz pho-

tograph has turned out to be just a "concept," I am actually delighted. It means that, even today, my idea of something very cool is not that far from William Claxton's.

Note

Having decried the lack of serious writing about the West Coast jazz scene, I must cite the exceptions that prove the rule. Art and Laurie Pepper's *Straight Life: The Story of Art Pepper* (New York: Schirmer Books, 1979) and Hampton Hawes and Don Asher's *Raise Up off Me: A Portrait of Hampton Hawes* (New York: Coward, McCann, and Geoghegan, 1974) are worthy books. Ted Gioia's *West Coast Jazz: Modern Jazz in California* (Berkeley: University of California Press, 1998) provides a literate and thoughtful overview, and I am indebted to him for everything in this essay that is factually correct.

"Goodbye to Love"

As I remember it, 1972 was an ominous and sexy year. My wife and I were living on the east side of Manhattan, in a brownstone with high, shadowy ceilings and narrow, shuttered windows through which the gray city light insinuated itself. Outside, the air was full of rainy drizzle, tire swish, sirens, and banging metal. The television was ablaze with napalm, wet with body bags—and every night, somewhere in the neighborhood, in the middle of the night, there were enigmatic, unexplained explosions that shook the pictures on the wall—and every night, as I sat at my desk in the gloom, alternately staring down into the wet street and typing reviews about Nils Lofgren to pay the rent, I could feel the sullen distances of Big America stretching out across the continent under lowering skies. By morning, I would be totally burned out. Mary Jane would come in, sipping her coffee and dressed for work at Time-Life ("the wimp factory," she called it). She would find me with my headphones on, listening to Lou Reed sing "Ride into the Sun," watching *Rocky and Bullwinkle* without the sound.

We would have some coffee, look at the paper, and she would go off to work. I would crash for a couple of hours and then go into the office myself. I was editing an art magazine then, but I was always thinking about the music, because 1972 was the greatest year for loud music in the history of the universe. It was a year that *needed* loud music, and the music that it got was so good you could literally live on it and in it. Lou Reed's first solo album came out that year; the Rolling Stones released *Exile on Main Street*; the Who produced *Who's Next*; and David Bowie arrived with *Hunky Dory*. And those were just the highlights; there were other great albums, hot bands in bars and

secret pleasures, like Mylon LeFevre's "Sunday School Blues," with Allen Toussaint and the Candymen—the absolute quintessence of sorry, sweaty, Stratocaster, gospel funk.

And then—amid all that chaos and cynical energy—there was this perfect, luminous pop single by the Carpenters that just blew me away. And, believe me, the Carpenters were the farthest thing from my kind of thing. But when something that is not your thing blows you away, that's one of the best things that can happen. It means you are something more and something other than you thought you were. The Carpenter's song was called "Goodbye to Love," and that was perfect too, because 1972 was a goodbye-to-love sort of year. The first time I heard it, I was standing in a Danish furniture store on East Fifty-Fourth Street talking with this Scandinavian blonde about a couch for the living room. I was wondering to myself why I could joyfully spend money that I did not have for a painting while a comparably goofy expenditure on furniture broke my heart. Then "Goodbye to Love" came on the radio—just Karen Carpenter's amazing voice, accompanied by an acoustic piano. She sang the title phrase, followed by a melodic elaboration on it that ended up a fifth: "I'll say goodbye to love. / No one ever cared if I should live or die."

I was admiring the nifty, literary "should" in the lyric when I realized that the third melodic phrase of the song, far from balancing the first two, had embarked on a long, cantilevered series of eighth notes that just flowed—that rose and fell through a sequence of minor chords and finally resolved itself, five bars later, in a tiny reprise that fit the phrasing: "Time and time again the chance for love has passed me by and all I know of love is how to live without it. / I just can't seem to find it." For a pop song, this was genuinely amazing, some kind of rocket science. Pop-song writing is, after all, a *forme fixe* practice—a rigorous and convention-bound endeavor, like writing rondeaus and villanelles in seventeenth-century France. Therein lie its delicacy and fun. Pop songs depend on tiny variations so heavily, in fact, that the difference between the very best and the just mediocre is usually a microsecond or two, three notes, an apt phrase, a single syncopation,

or a melismatic voicing by the singer. In a stylistic environment that is this tightly calibrated, Richard Carpenter's melody is like a Jackson Pollock in a roomful of Mondrians.

Usually, the eight-bar statement at the heart of a popular song is divided into four two-bar statements, closely related and conforming to the standard, European AABA musical structure of statement, restatement, release, return (count out the main title of Beethoven's Ninth Symphony). None of us really knows this, of course, but we do. We notice when it doesn't happen, and it doesn't happen in Richard Carpenter's melody. It conforms to the sense and length of this sequence while obliterating its shape. Carpenter's eight bars (counting a half-bar of pickup notes) consist of a one-and-a-half-bar title statement, a two-bar restatement, a flowing three-and-a-half-bar release, and a quick, one-and-a-half-bar return. Thus, the melody, rather than reading as four units, reads as a single statement, and in pop music, an achieved eight-bar statement is bigger than *Blue Poles*.

Standing in that furniture store on East Fifty-Fourth Street, of course, I couldn't have told you all this. I just knew that Karen Carpenter was singing this sad song that made me happy—that it was an amazing recording that got better and more interesting as it moved along and concluded brilliantly. I also knew that if I *really* paid attention to the song, I could figure out why this was so. That's the great thing about cultural artifacts. They are man-made things about which we can, if we wish, acquire some knowledge. The knowledge we acquire, of course, has little, if any, effect on our experience of the work, which can sustain itself for years before we take the time to learn anything about it, or have any occasion to.

So, in 1972, I didn't think about it. I walked over to the record store on Third Avenue and bought the new Carpenters' album. The times being what they were, I actually *apologized* for buying it. I told the kid behind the counter (with whom I had consulted most recently about Lou Reed's *Metal Machine Music*) that I was buying it for my wife (who didn't like the Carpenters either). I took the record home,

and for quite a while, "Goodbye to Love" replaced "Ride into the Sun" as my *Oh my God, here comes the gray light* record, but I never looked at it professionally or learned how to play it, because "Goodbye to Love" is one of those songs—like "All the Things You Are" or Stevie Wonder's "All in Love Is Fair" or Cynthia Weil's lyric to "Just Once"— whose majesty I find too depressing to contemplate in any competitive sense. They make me feel awkward and unpoetic.

A few years later, I was cruising down Las Vegas Boulevard in my old Caddie at five in the morning with the windows down and a big roll of bills in my shirt pocket. I was admiring the magenta atmosphere and feeling pretty lucky when "Goodbye to Love" came on the radio. And, again, it was just perfect. Vegas at five in the morning, when the neon just matches the predawn radiance, is a goodbye-to-love sort of town. Listening to the song then, while cruising through the purple haze, I found myself wondering about value: about the physical certainty we feel about "good" art. I decided to figure out why "Goodbye to Love" is a "good song," because I missed the pleasure of speculating on value, now that the art world had morphed into a perfect, conceptual democracy beyond pleasure, value, and physicality.

In the art world, one never need wonder how something might be physically constructed so that we recognize our experience of it as being valuable, and so I began wondering about the "goodness" of "Goodbye to Love." First and foremost, I decided, the record is good because Karen Carpenter sings on it and because Richard Carpenter wrote a song for her to sing tailored to the range, quality, and eccentricity of her wonderful voice, which is a true alto. Not only can she hit the F below middle C with no effort, but her voice is stronger and more interesting in the lower, darker registers.

This allows Richard Carpenter to write a melody with essential gravity, one that begins low and moves upward but always wants to fall—whose essential motion is always downward. Richard Carpenter's melody, then, allows John Bettis to write a lyric that is adult and

mournful without being maudlin or melodramatic. Despair is always a bit too much for me in the upper registers—too Liza Minnelli. Karen Carpenter never has to strain or weep or gasp. She doesn't have to act. Her voice is physically sad rather than expressively sad. She need only sing the song for it to be sad. (Listen to her singing "On Top of the World," where the real energy and poignancy of the vocal derive from the fact that we don't believe for a moment that Karen is on top

of anything, much less the world.) Add to this the fact that Karen Carpenter was a good musician with great intonation (occasionally sliding off a note but never into one) and that, like Charlie Watts, she was a rock-steady drummer who knew how to maintain vocal propulsion at slow tempos. Add this up and you have a powerful pop instrument. My only complaint is that Karen persists in singing "yew" instead of "yoo." Beyond that, only Dusty Springfield is better at hitting the note, singing the words, and holding the tempo, and Springfield's voice is not nearly as interesting as Karen Carpenter's, which I've always considered to be the aural equivalent of Lauren Bacall's look, that soft, cool tease, full of allure, longing, and promises that you know will not be kept—that cannot be kept.

The strength and timbre of Carpenter's voice in the lower registers also make possible the major stylistic innovation in the production of "Goodbye to Love": Tony Paluso's dirty, blazing, fuzz-tone guitar solo in the third chorus and then again in the coda. At the time, the very idea of laying a gritty rock-guitar solo into the instrumental texture of a pop ballad, with its strings, keyboards, oboes, and harps, was unthinkable. This trick has been much mimicked since. I like Bad Company's "Ready for Love." Nearly all of Nirvana tips its hat to Karen. But Richard Carpenter thought of it, and Karen Carpenter's voice, with its solid, low-end guitar-buzz, made it possible. In truth, even though "Goodbye to Love" is, in its every aspect, a meticulously produced pop ballad, it appropriates any number of its virtues from rock and roll, so the louder you play it, the better it sounds. Most pop songs, for instance, are "you" songs, addressed to some object of the singer's affection. "Goodbye to Love" is an "I" song—a theatrical

declaration by the singer's persona. This, in our era, is a rock-and-roll format. ("Satisfaction" and "Born to Be Wild" come to mind.)

Also, the melody is driven by the push of extended eighth-note patterns like a Chuck Berry song and is manipulated in the same way. The first eighth-note sequence in the chorus is introduced by dotted quarter notes and seems to move in a stately flow. The second sequence in the turnaround is introduced by sixteenth notes and seems to move more quickly. This effect is exploited by Carpenter's arrangement, which creates midtempo crescendos and diminuendos by adding and subtracting instrumentation and increasing or decreasing the note lengths being voiced, which, in effect, accelerate the tempo and push the song through 2/4 bars that crop the flow.

The song begins with Karen Carpenter's voice floating over an acoustic piano that is striking chords in quarter notes. It ends with a full drum kit pumping away while the bass guitar plays sustained whole notes with frills, the choral voices sing half notes, the keyboard and the strings play an obbligato in quarter notes, and Tony Paluso scribbles fuzz-tone eighths and sixteenths over the surface, mini-riffs like graffiti on a freight train.

The coda's design fulfills Kurtis Blow's formula for dance music: "You keep every note length in play." Although "Goodbye to Love" is far from a dance tune, it longs to be one while codifying the "power ballad" recording format that you hear inherited best in Donna Summers's full-tilt "MacArthur Park." These techniques of crescendo and diminuendo, cropping and extending, are prefigured by James Burton and Elvis Presley's live band. This technique leads inevitably toward the dread spectacle of Michael Bolton, but I don't think that Karen and Richard can be held responsible for this any more than Wagner and Nietzsche can be held responsible for World War II, which is to say, maybe a little.

All these virtues would be merely cosmetic, however, if "Goodbye to Love" were not a good song as a piece of music, so we have to begin with the assumption that within a given stylistic atmosphere, some things *are* good. We have to assume that, objectively and quan-

titatively, some things are better than others. How "good" you think that goodness is, is your own business, but the fact remains that some things give us more, give it to us faster, and give it to us longer, and in the cultural economy of this society, that signifies "better." How we recognize that value is the interesting question, and the great music critic Leonard Meyer, in an essay he wrote in 1959, "Some Remarks on Value and Greatness in Music," gave me my first inkling of how we might recognize value. Meyer begins with the assumption that all works of art and music presume a community of beholders or listeners who are in possession of certain internalized generic and stylistic expectations about what they are looking at or listening to. He then suggests that those works of art and music that perfectly fulfill these expectations hardly ever exist. They are virtually invisible or inaudible and useless to our purposes.

Anyone who has spent three hours on the highway listening to AM radio or twenty minutes wandering through a provincial museum can attest to the penultimate inaudibility and invisibility of mediocre cultural artifacts. Meyer puts his argument like this:

> Information theory . . . tells us that if a situation is highly organized so that the probable consequents have a high degree of probability, then, if the probable occurs, the information communicated by the message (what we have been calling a musical event) is minimal. If, on the other hand, the musical situation is less predictable, so that the antecedent-consequent relationship does *not* have a high degree of probability, the information contained within the message will be high. Norbert Weiner has put the matter succinctly: ". . . the more probable the message the less information it gives. Clichés, for example, are less illuminating than great poems." . . . It does not seem rash to conclude that what creates or increases the information in a piece of music increases its value.

Meyer's suggestion that information is related to value leads to

the inevitable conclusion that those aspects of embodied meaning that create information contribute to the creation of value—that within a particular stylistic universe, deviation, uncertainty, surprise, entropy, and the deferral of our expectations are inextricable components of artworks that we choose to call good. Works become visible and audible only because of their complexity and difficulty, and they remain so only by continuing to be complex and difficult. George Bernard Shaw and Morse Peckham mount similar arguments about the quantitative constituents of artistic value, arguing that the *quality* of something is only a measure of the *quantity* of our response to some or all of its attributes. Meyer, however, follows the beast to its lair. He points up the sublimated heroism and unacknowledged masochism involved in an art experience that perpetually deflects and complicates our expectations, then defers their resolution, then defers it again.

There are degrees of deferral, however. When the resolution of our complicated expectations is permanently deferred (as it so often is these days, especially in the art world), the work becomes petulant, puritanical, and bureaucratic. It teaches us to abandon the hope and courage that sustained us. This transforms the experience of art into some dire prophecy—some promised ongoing abjection. When the fulfillment of our created expectations is accelerated, however, we are in the realm of popular art. Which brings us back to "Goodbye to Love"—Its virtue and eccentricity—where we must begin with Tom Dowd's first axiom of pop-song writing: *Don't bore us, get to the chorus!* Or stated in Pavlovian terms: *Give us the cookie!*—defined as the main title, the signature hook, and the fulfillment of our desire to hear it once more among those musical expectations that the song sets up in its opening sections. Simply put, pop songs take a few moments to set up musical expectations, then proceed to reward them at an ever-increasing rate. So, the Ur-structure of a pop song goes something like this: 24 bars of Intro or Verses followed by 8 bars of Chorus; 16 bars of Verses followed by 8 bars of Chorus; 8 bars of Bridge followed by 8 bars of Chorus, followed by 8 bars of Chorus, followed by 8 bars

of Chorus ad infinitum into the fade. Stated more succinctly: 24 bars | *cookie!* | 16 bars | *cookie!* | 8 bars | *cookie!* | *cookie!* | *cookie!* into the fade.

The variations, elisions, and elaborations of this structure are infinite, but this is the basic format. And again, we don't consciously *know* this. We notice when it doesn't happen. This is why I started listening to "Goodbye to Love" only when the expected conclusion of the melodic release was deferred. If we look at the macrostructure of the song, we find this deferral incrementally repeated throughout. The song begins with an unusual eight-bar statement (A); followed by a one-bar turnaround (bb), which initially leads back to A. The second time through, however, a two-and-a-half-bar extension (c) follows Abb. After the third time through the Abbcc structure, the song modulates from the key of C into D major, for another c statement and a variation on the c structure that leads into a repeated statement of the title phrase (àa) and then a long twenty-four-bar coda that abandons the melody but retains the chord tempo slightly modified with voices and Tony Paluso's guitar. So the whole structure goes like this: Abb | Abbcc | Abb | bbcc' | a | a | A'A'A'.

My point here is that this is *all wrong* by the logic of pop music—heresy, in fact. Our return to the A section is incrementally deferred throughout the song; every time, we wait longer for the return, which, as the title implies, is masochism incarnate, and then, when we do reach the coda, the melody is suppressed in favor of a free-form guitar solo. So why does the song work? Why is "Goodbye to Love" a good pop song? Here Meyer and Shaw and Peckham must defer to Aristotle, who understood that we approach works of art with more than just our formal expectations: that we are not just looking for what we logically expect but that we are also looking for what we *want* and what we desire—and these two objects are never the same. So, for Aristotle, the mechanics of tragic catharsis derive from the fact that we want Oedipus to survive and don't expect him to, that we expect Oedipus to fall but don't want him to. Thus, tragedy teaches us that things don't always work out the way we want.

"Goodbye to Love," within the parameters of pop music, revers-

es this trope into comedy. It is true enough that the song defers what we expect. The conclusion of the release in the chorus is delayed, as is the return to the title phrase in the song, as are the pyrotechnics in Tony Paluso's guitar solo, which explodes into slides, bends, and sixteenth notes. But even as the song defers these expectations, it gives us more of what we *want*: which is Karen Carpenter singing and Tony Paluso playing those beautiful, flowing riffs. Rather than giving us the cookie in an innovative way as most superior pop music does, Richard and Karen get our attention by withholding our old cookie, then giving us a *new* cookie. In effect, they seem to say: if you can deal with the anxiety of not getting your old cookie on time, we will turn that anxiety into pleasure by rewarding you with a newer and even sexier cookie. This, of course, is what Beethoven does, what Cézanne does, what *art* does. All of which is to say that "Goodbye to Love" is a *very* sophisticated pop song—a pop song by high-art means. It gives us what we want at the expense of what we expect, thus elevating the song out of the melodrama of pop music (which confounds our desires and expectations) into the realm of pure comedy, in which our desires are improbably fulfilled. The song enacts its title. It says goodbye to love as it segues into a celebratory rock coda.

This, I think, is why a sad song that says goodbye to love can make me feel so good: it gives me what I desire without the implication that I should have expected it. Which brings us to the end of the essay and of the song. After Karen sings the final words of the lyric, "I'll say goodbye to love," there is an instant of silence, like a membrane, then a thunderous drum pickup that drives into the downbeat of the codetta: a wall of choral voices singing the chords over a full rhythm section. After eight bars, Tony Paluso's guitar comes burning in with a chunky balls-out rock solo—twenty-four bars (eight bars per riff) and into the fade—and it's clear that we have now, indeed, said goodbye to love. We have broken into this bright, full-tilt, Dionysian universe beyond the niceties and intimacies of bourgeois romance. All pop-song writers dream of this place on occasion and

long for it. Karen and Richard made it. They got there, just this once, out of soft romance and into the hard energy of rock and roll, as if it were the true province of sad Karen's bleak imagination.

Note

"Goodbye to Love," lyrics by John Bettis, music by Richard Carpenter. © 1972, Almo Music Corp. and Hammer and Nails Music.

Wonderful Shoes

We used to play this cool little bar in Mobile called Thirsty's.
We stayed at a funky motel across the highway called the Moon
Winks that had a winking neon moon out front. Twenty minutes
before our Friday night show, the power went out in the whole motel.
We all had flowing locks back then, and when the entire band simul-
taneously fired up their industrial-strength hair dryers . . . boom. We
looked like sea creatures onstage that night and oddly attired, since
we all got dressed in the dark. Even the cops laughed, but we played
pretty well, and no one got their panties in a bunch. It was a goof, and
people gave us cocaine to make us feel better.

This always reminds me that the best thing about rock and roll is
that you are free because you are presumed damned. Unlike the world
of art and literature, nobody gets their feelings hurt and nobody
talks about their mother. Nobody goes on about where they come
from, and nobody asks. Nobody asks you where you went to school,
because you probably didn't. Everybody knows, as Kris Kristoffer-
son observed, that it takes more brains to get out of Kentucky than it
does to get out of Connecticut, and that's a comfort. Fighting is okay,
especially in gravel parking lots with distracted bass players who are
failing to hit the note, but there are no grudges. When we finish fight-
ing, we go play music together. The gig will end soon enough, but we
will still have the freedom of our chains.

So America doesn't regulate the casually damned very well.
Rock and rollers, artists, poets, strippers, and hookers generally
get a pass. Now we are learning from societies with more proactive
compliance agendas. On a cool afternoon in 2002, Zarah Ghahrama-
ni was snatched off an urban sidewalk in Tehran and hauled away

to the infamous Evin Prison. Ghahramani was twenty years old at the time, a schoolgirl, and she arrived at Evin more dumbfounded than outraged. The prison, since its construction in 1972, has been a hard-core, old-school, pest-infested hellhole with a notorious political wing reserved for intellectuals—known as "Evin University" in the schoolrooms of Tehran. Thrown into a cell in this wing, Ghahramani was stripped, beaten, degraded, brainwashed, starved, shorn, and brutally interrogated. Ominous, insinuating notes, purportedly from another prisoner (but probably not), were slipped into her cell, inviting her to imagine living forever in that cinder-block cell, bruised and humiliated, without a book or a comb.

After a little more than a month of brutal degradation with no end in sight, Ghahramani was marched out one morning, thrown into a car, driven twenty miles outside Tehran, and dropped off in the raw desert on the shoulder of an empty highway, and that was that. Thank you very much. Her crimes? She was doubtless spunky and insufficiently deferential in civilian life. She bitched about the mullahs in campus bull sessions. She handed out pamphlets in Prada, and her couture, it seems, was always a point at issue, so she suspects that her troubles began on her seventh birthday, when her father gave her a pair of bright-pink shoes with flowers on the toes. Her affection for these accessories and others like them would lead her down the yellow brick road from tyro fashionista to enemy of the state.

This is the narrative of *My Life as a Traitor*, written by Ghahramani with Australian novelist Robert Hillman. It is a levelheaded account of a young woman's travails in the early days of the twenty-first century. After I finished reading the book, I was thinking about the absurdity of the outrage over her nifty threads. I remembered a gala at the Driskill Hotel in Austin, Texas, at which I was the bad guy. Amid the drinks and giggles, I shared my views on Laura Bush's footwear with Ann Richards, the ex-governor of Texas. "Prada Librarian," I said. "Not as sexy as the pope's." The governor gave this her horse-laugh, and her lesbian Mossad almost certainly passed it along. Now I am non grata at parties and literary events all over Texas. (Laura is

literary.) I have tried to imagine the logic of gossip and outrage moving upward through the sticky baklava of Texas society and leading to this banishment. But what do I know?

The girl at the Starbucks window the other day was wearing cerise eye shadow. I told her she should dye her hair to match. That had been her plan, she said, but Starbucks demands "natural" hair color from its baristas, or hair that has been dyed a "natural" color. Now I'm peeved that Starbucks of Seattle, of all places, has chosen to take a stand against grunge ebullience. These seem like small things, and they *are* small things—until they're not. The barista can't dye her hair the color she wants. I can't wear my ball-cap at the credit union for fear of obscuring their surveillance cameras. Every day, citizens are expected to abjure the footwear, tattoo, hair color, handbag, or do-rag of their choice lest they threaten the smoothness of the social order. This amounts to a reinstitution of the sumptuary laws whose abrogation liberated the entrepreneurial classes who built the modern world. This is a crime, and if allowed to proliferate, we will all end up locking our bedroom doors like closet queens and parading around in our exotic clothing.

Even so, if worse comes to worse, we still believe that we will gladly die for our closely held and well-disguised convictions for the sake of our souls. We remain less sanguine about perishing for our taste in clothing, but who knows? *It may just be the shoes!* Maybe we would sacrifice our taste in frivolous accessories for the happiness of all mankind, but maybe all mankind would like a few frivolous accessories of its own. They do constitute a language. The protean array of trivial things, real and imaginary, for which we all reach outward defines us more profoundly than all our moral certainties. They wordlessly tell the world whether to fight or flirt or fawn or just stand in awe. When I grew up in the sixties, Americans lacked a spoken language of value, and they still do. There is a shape-shifting vocabulary of terms like "hot," "cool," "fresh," "awesome," "bitching," "sucks," "totally sick," "wicked," and whatever kids say now. Beyond that, we speak in sign. So stop *talking* to me about your faith. Show me some-

thing Christian. I've heard the crummy band whose name is plastered on your T-shirt. Jesus would hate it. Jesus likes Flaming Lips.

Precedent to this, I opened *My Life as a Traitor* expecting moral grandeur, a tale of heroic good intentions escalating to tragedy. If *My Life as a Traitor* had been such a book, if its circumstances had been less preposterous, it might have attracted more attention. What I found was too close for comfort in Dick Cheney's age of radical rendition. Girlish whimsy escalates to mindless brutality in a fundamentalist wonderland where a Pontiac full of whackos can snatch us away, totally unprepared, on a nasty whim—as Ghahramani was snatched away—her entire arsenal of defense against militant Islam residing in her schoolgirl taste for poetry, her penchant for hunky radicals, and her practice of Zoroastrianism, a religion invulnerable to the mullahs on account of its ancient Persian credentials.

Ghahramani and her mother participated in ceremonies that celebrated the Zoroastrians' ancient and unabashed affirmation of sweetness and light. She learned "to honor the light, to join in the ecstatic dancing that creates a unity of the soul and the life force." She learned "to worship the beauty of all that lives and breathes." This spirit proved sufficient to get Ghahramani arrested. It also provided her with sufficient resources to survive the mullahs' inquisition: nothing profound, just a willful commitment to the liveliness of things—a winsome credo adorned with pink shoes, gossip, and ecstatic dancing. This credo provides Ghahramani's critique with a youthful heart—a dream of Eden that illuminates her book without sacrificing its modesty.

The political innocence of Ghahramani's candor also allows us to test W. H. Auden's proposition that we judge a critic's judgments by teasing out the critic's "dream of Eden." We know Ghahramani's dream. Evin Prison breeds nothing else. Auden's dream of Eden, appended to his essay "Reading," includes Paris couture from the 1840s, one extinct volcano, and a law restricting public statuary to renderings of "famous defunct chefs." My own Eden would include paintings by Ellsworth Kelly, a white beach, and serious waves. There

would be a beachside restaurant with space between the tables and a casino with Palladian doors open to the breeze. There would also be palm trees in the fog.

Sharing intimate fantasies is against my nature, of course, but Ghahramani's candor is so disarming and feels so right that I found myself thinking: What if she is *right*—not personally right, not locally right, but generally right? What if the "culture wars" of our time are not armed struggles between low-blink-rate fundamentalisms? What if there is only one, one-way war being waged by fundamentalism in its dying frenzy against a newly refreshed, permissive, cosmopolitan paganism that couldn't care less and never has? What if organized religion in America, except for its media muscle, its dark power over children, and its tax status, is no more than a prim excuse for getting undressed in the closet? Not one of the art collectors, fashionistas, music mavens, designers, and dilettantes whom I know is fighting a war. They are accessorizing the social universe while they're alive. When they die, the accessories they have created or acquired will be passed along, like Aunt Georgia's milk glass. When personal memories fade, these accessories will be dispersed and speak for themselves. Aunt Georgia's milk glass will be all she ever was. This seems to me an elegant mode of fading away.

So I have been contemplating dreams of Eden. Compared with the visions of Utopia that laid waste to the last two centuries, they have much to recommend them. Edens are nonexclusive. They have no moral qualifications or liturgical standing. Most critically, Auden argues, we stand fully revealed in our Edenic dreams. For this reason, common-folk always want to visit rich people's houses—because, knowingly or not, according to Auden, our dreams of Eden render us transparent. The Edens fashioned by jerks, crooks, and sleazoids invariably reveal their moral idiocy with paintings by LeRoy Neiman and his ilk, because Edens are not Utopias. Edens are not big, white places with moving sidewalks and coveralls with numbers stitched above the pocket. They are tangible redoubts that we inhabit in fact or imagination.

Utopias are all idea; Edens are all details. They exist in the fashions, the china, the art, the landscape, and the climate. Eccentric and additive, they require exquisite ensembles. They may require doilies, Keds, Balthus, T. rex, Dave Brubeck, Gilbert and George, or Gilbert and Sullivan, but they can and do exist. Botticelli's Garden of the Hesperides existed in the hills outside Florence. Every Eden ever painted exists or existed somewhere in the sentient world, excepting the heavenly thunderbolt and the cowering naked couple being served their walking papers. When I was twelve, I slipped the surly bonds of parental disinterest, took on two early-morning paper routes, and transformed a drywall garage apartment into a teenage Eden. I bought a coral and cream Ford Victoria. Everything I needed to work, eat, sleep, or entertain was positioned within easy reach of my mattress on the floor. Over the years, my working environment has become more comfortable. It has undergone technological upgrades, but it has not changed significantly. Even Brubeck is still here, now on my iPhone.

By comparison, all our darkling Utopias feel like tarted-up tribal parables or cautionary fantasies like the *Iliad*, which was formulated to exaggerate the threat posed by alien beauty to the unity of the tribe. At their worst, our transient, pop-up Utopias blossom from the malignant dreams of slow-pitch authoritarians to suture their inadequacies. All the cruel, self-serving specifics have been redacted from the Utopias of Jim Jones, David Koresh, and Warren Jeffs. Specifics are all suppressed, like who's in charge, whom must we fuck, what must we wear, will we starve, and what about our shoes? If Lenin could have imagined the nuts and bolts of the future he was proposing, he would have withdrawn his proposal, but Lenin's Utopia required no act of the imagination, nor does any Utopia. Utopias are inflated, theorized community preferences. Edens are about our desires.

That said, Edens and Utopias both arise from our propensity to take names. We habitually catalog the discomforts and inequities of our everyday lives, its blemishes and irregularities, its ugly shoes

and "daring" pantsuits. Confronted with these perceived defects, Utopians first strive to "communicate" as loudly as they can, then they demonstrate in public, then they plot revolutions for the good of *all humankind* while denying themselves even the aroma of payback. We Edenic dreamers shop. We poke around for what we want, or we make it ourselves out of stuff we bought at Home Depot or Pearl Paint. We don't want to recruit you, although we have occasionally teased young people out of the closet because the answers we seek are physical and undeniable. Our Edens reside in a world that we can touch, that sings in our ears and shines before our eyes—the only world that we can inhabit while living in our bodies with all our senses intact. ("Virtual reality" means just that.) So when Edenic dreamers complain, they complain about the shopping—about the shortage of interesting people or of local opportunities to accessorize their private dreams. Inundated as we are by German metaphysics, it's easy to forget that we make ourselves from the outside in, that we strive, as best we can, to be worthy of our wonderful shoes.

A World like Santa Barbara

A few years ago, I was privileged to teach a group of splendid students at the University of California at Santa Barbara. To do so, I had to fly in and out of that coastal paradise on a weekly basis, and as pleasant as my class was and as beautiful as the setting is, I found the community of Santa Barbara troubling in its perfect contentment and uncanny coherence. Contentment is always annoying, of course, but the coherence was extremely confusing, since the community itself, in its ordinary constituents, seemed anything but. But there I was, in a small city populated by petit bourgeois right-wing Protestants, woozy new-age gurus, hard-core libertarian ranchers, overgroomed hacienda patricians, scruffy surfer hippies, retired art dealers, and policemen. There were also well-patronized psychoanalysts, psychologists, group therapists, and self-helpers, academic liberals, assorted movie stars, and tenured Marxists, all living happily together, dining out and shopping, in a smoke-free, herbivorous, puritan utopia.

My confusion was exacerbated by the fact that I did not cohere at all. My clothes were wrong, my hours irregular, my habits unhealthy, and my talk too ebullient and abrasive. For me, it was a hellish paradise. Not a day went by that I didn't violate some tiny statute of Santa Barbara decorum—that I didn't tread on some invisible snake or bump into some invisible vitrine, jostling the invisible objects within. Every time this happened, I asked myself: What does this culturally and ideologically disparate group of Americans have in common that I do not have in common with them? In the final week of my stay, I figured it out. All these people—the Baptists, Marxists, patricians, gurus, surfers, celebrities, and shrinks—believed that

all the problems of modern life derive from the anxiety of commercial urban society and that the goal of any enlightened community should be the alleviation of that anxiety through the ministrations of an enlightened elite.

In a world like this, I realized that art and society as I understood them simply could not exist. I understood art to be a necessary accouterment of urban life, a democratic social field of sublimated anxiety, adventure, violence, fast dancing, sharp talk, and contentious civility. I assumed that free citizens cultivated their responsiveness to works of art in order to mitigate their narcissism and fuel their imaginative grasp of that which is irrevocably beyond themselves, to transform their anxious discomfort at not-knowing into a kind of vertiginous pleasure. In Santa Barbara, such adaptive behavior was unnecessary. Everything was regulated and explained. Urbanity, anxiety, otherness, contention, loud colors, and bright talk were wholly absent. Even shopping (that quintessential urban activity) was conducted as a form of relentless grazing on sites identified by tiny signage. Antique agrarian values had been fully reinstated, and civilization, in this rubric, was defined as a bucolic quietude prefiguring the silence of the grave.

So let me suggest this: that, Santa Barbara notwithstanding, we live in a cosmopolitan age in which civilization must be defined by the ability of a diverse populace to tolerate and appreciate the anxiety of living together in a tumultuous, heterogeneous urban world. For 150 years, Americans left the farm in search of just that heterogeneity and anxiety. Those who were forced to leave the farm found it anyway, because anxiety is the very signifier of urban existence, of living in a world where one's autonomy and identity are compromised by the simple fact that one cannot grow one's own food in a city or slaughter one's own pig or weave one's own cloth or churn one's own butter, and to acquire these necessities, one must interact in a civil way with commercial culture, with people who are different from oneself, people in trade who are totally unaware of your own genteel agrarian authenticity.

The world of art and letters, of graffiti and sexy music, is where we hone these skills, where we acquire the responsiveness, imagination, and flexibility to deal with this world, where we learn to appreciate its anxieties. Because, to speak plainly, one doesn't really need art on the farm, or in Santa Barbara either, if one is comfy there. One of the great ironies of American history, in fact, is that Thomas Jefferson, who invented the idea of America as a nation of contented farmers, bankrupted himself out of boredom with that life—importing fine art, rare books, exotic objects, elegant furniture, and scientific instruments because he wasn't comfy with the bucolic ennui of life at Monticello. Paris it wasn't, and although Jefferson never admitted this, I suspect that the putative father of the American suburbs would agree with me that the idea of a life without sophisticated contingency and with a culture bowdlerized to alleviate the beholder's anxiety presents a prospect that only a farmer could countenance.

I will go even further and suggest that the gradual re-farmerization of America explains the current penchant of suburban youth for killing one another in bunches—that these killings are the direct consequence of a culture that proposes the instantaneous alleviation of anxiety as its primary goal—a culture of ignorance in which weapons are sold, games are designed, and art is explained for no other purpose than a happy ending. Children in the cities kill one another too, of course, but for explicable reasons like poverty, greed, anger, and ambition, for causes whose consequences can be sublimated into civilized endeavors—that are, in fact, being sublimated as we speak: into music, dance, drama, and fashion. These city kids kill because they want more life. The killer children in the suburbs have no such excuses or ambitions. They're just anxious about being teenagers and don't think they should have to feel that way, and they've never read *Tom Sawyer*.

Some people blame the media for this, but that's like blaming the violence of Elizabethan culture on the last act of Hamlet. Some of the same people blame the killers' parents, and this would be plausible, since their first option is to become their parents, to usurp the

authoritarian parental role and obliterate the peers and siblings who make them nervous—because they have been so well nurtured, loved, and protected that they have never been nervous before—because they have never read an exciting book, felt the anxiety of high drama, or experienced the disorientation of difficult art and consequently do not even know how to be nervous, much less how to enjoy being nervous and exploit it. Their only excitement is linear zero-sum games, and these teach you nothing about contingency, games that, if you play them right, work out in the end.

What I am suggesting is that we are well on our way to censoring and explaining away the primary adaptive modality of urban life— that the unruly, uncivilized domain of arts and letters is being robbed of its civilizing function. I offer this because what one perceives most profoundly in these killer children from the suburbs is their absolute lack of imagination and affect. They can't imagine obliterating a million hopes, dreams, and memories by squeezing a tiny metal trigger; they can't imagine tearing open an empty place in future generations; they can't even imagine their own futures or the constituents of an ordinary human life. And those who survive are unlikely to acquire this knowledge either, even from *Oliver Twist*, because their brutal acts—acts designed to do nothing more than instantaneously alleviate anxiety—are deeply motivated by a subliminal desire to obliterate Santa Barbara. The local response will be more parental control, more therapy, and more authoritarian censorship. It will mean fewer works of art, less freedom, and more killings. And all because we wanted to make a safe place. Unfortunately, art is the only safe place, and it is safe only because the world can't be made so.

So I have been thinking a lot about what art does in this civilization, and I have come to the conclusion that, at present, art's not doing very much. It hasn't done much recently. I find this distressing, because one of the things that art can do and that urgently needs doing—one of the things that art has done in the past and does no longer—is to civilize us a little. And the primary

reason for this civility in human civilization is that meanings do not adhere to images. The process of civilization becoming less centralized and less authoritarian has created modes of expression in which the burden of assigning meaning and value resides wholly within the colloquy of beholders. Objects and events that were once instrumentalities of meaning and power have become sites for adjudicating meaning and power: icons have become art; rituals have become dances; history has bred fiction, and clothing fashion. So, today, we all acknowledge that, when we argue about art, we are arguing about the use, value, and meaning of objects that have no power, value, or meaning beyond those we attribute to them. Moreover, as long as we are discussing the consequences of our transactions with works of art among peers, issues of institutional, scientific, and academic authority are moot, and even our personal disagreements are directed nonconfrontationally toward objects in the world.

| 44 |

These factors are calming, I think, and they explain why art critics disagree so happily while bureaucrats, scientists, and academics quarrel so acrimoniously. Art critics quarrel about perceived value and the ethics of one's relationship to objects in the world. Bureaucrats, scientists, and academics argue about the construction of power and authority, and this, of course, would seem to be the more urgent discourse. It would be, too, except for the fact that, in nontotalitarian societies, power and authority are dependent upon the value attributed to them by the populace. In such societies, the discourse of art is the civil site upon which we freely expand and refine our language of perceived value—because, for all the anxiety, disorientation, and putative violence that our transactions with works of art entail, nobody gets killed as a consequence of them anymore. Very few even go to jail, and that is just the point: art is a safe place where we may nonviolently come to terms with disorienting and dangerous situations and adjudicate their private relevance in a public discourse.

We can do this because works of art have only as much power as

we attribute to them by our free response. The habit of responding freely, however, and of tolerating the anxiety these responses generate is a learned activity. If we cannot learn to volunteer our free response—or if we are taught not to respond—the live discourse about art is over, and what Susan Sontag calls the "erotics" of art has been wholly supplanted by the language of bureaucratic explanation.

To put it simply, the "erotics" of art cannot exist separately from our willingness to invest works of art with the power to excite us, confuse us, and arouse in us pleasurable anxiety, nor can our subsequent critique of that experience have any social meaning unless we do grant art this power. Michel Foucault once remarked that critique is a way of not being governed. This is certainly true, but no one understood better than Foucault, the masochist, that such critique is the necessary consequence of allowing oneself to be governed, at least momentarily, by the work's rhetorical power. Otherwise, the critique we generate will tell us nothing about the relationships we seek to understand. Our responsiveness, then, is the primary signifier of a civilized transaction with the world that, at its most refined, sophisticates us and facilitates social change without revolutionary violence or authoritarian edict.

Unfortunately, the right wing of American culture harbors a deep distrust of this sophistication. It doesn't think we can be civilized, except through authoritarian police control; it presumes, further, that any disorienting challenge that issues from a work of art is a direct incitement to civil unrest. The American left wing distrusts this same sophistication because this faction doesn't really want us civilized. It wishes to retain the option of revolutionary violence in the furtherance of a "culture war" and consequently retains its warlike rhetoric, disdaining any inference of art's civilizing mediation.

The left wing suspects that art is opium; the right suspects it's PCP. Neither recognizes it as the conventional, civilized forum that it is. Failing to recognize this, they assume that ordinary citizens are not cognizant of its conventional nature either and thus cannot be trusted to distinguish artifice from actuality, words from deeds,

signs from referents, narratives from actions. This is elitist balder-
dash, yet for the past thirty years, the left and right wings of Ameri-
can culture have urgently conspired to "civilize" art itself. To mitigate
art's ability to civilize us by striving to civilize art itself. They have
conspired to limit our freedom to construct new meanings and val-
ues for works of art: the right wing by seeking to censor any art that
might generate healthy anxiety; the left by explaining away art's abil-
ity to challenge us individually, by presenting art to us in perfectly
controlled, explained, and contextualized packages.

The consequence of this unwitting conspiracy has been the
pollution of art's last free public habitat. Thus, American cultural
institutions routinely embody both factions' prejudice against art's
contingency and embrace their mutual distrust of unadministrat-
ed artistic experience. In public galleries, labeled from PG to X like
cable television movies, unoffending works of art are stranded in
fields of explanatory press type, like ornaments in a medieval brevia-
ry. The wild domain of freedom and imagination—of new meaning
and eccentric value—that a gallery full of unadorned paintings by
Matisse would otherwise generate is now rigorously domesticated.
Its effects are distanced and irrevocably muffled, and all on the mad
presumption that a literate populace, which is perfectly capable of
participating in the knowing carnage of *Scream 2* without henceforth
running amok, is somehow incapable of dealing imaginatively with
the anxiety of Fragonard without "edu-speak" wall texts and signage
denoting ad hoc parental guidance. Thus, we have reached a point at
which members of the literate populace have a right to ask just what
kind of a world they are being asked to inhabit. As a member of that
literate populace, I am more concerned than most, since I have seen
the "ideal" world in Santa Barbara, and I do not like it. I have been
mothered back into my baby shoes and they do not fit. I want crazy,
if only in a book, dissonance if only in a piece of music, exquisite
insanity if only in a painting.

It's Morning in Nevada

ON THE CAMPAIGN TRAIL IN POST-BUSH AMERICA

At 7:30 on a spring morning, I pull up in front of Harre's Bagel-
mania on Twain, three blocks east of the Las Vegas Strip. I'm halfway
to the door when the senator whips into a parking place. Slamming
the car door behind her, she heads in my direction, moving fast. She
is, as she should be, an extremely visible creature, with streaked
blonde hair, large Greek features, and a trim body in a tailored suit.
Add the broad Georgia accent, the quick smile, and the sharp tongue,
and you have a very well-defined persona. Like a lot of other promi-
nent Nevadans—like a lot of people breakfasting at Bagelmania, in
fact—Senator Titus has an aura of stylized readiness about her. You
know, instinctively, that she does not take prisoners and that in the
time it takes Hamlet to declaim his self-conscious soliloquy, Dina
Titus will have gotten something done.

On the wall to our left as we step into the crowded deli is a mural
depicting the façade of a Chicago brownstone tenement. Since
this is Vegas, the mural is rendered in colors unimaginable in the
Windy City. Snapshots of smiling regulars are stapled into the ten-
ement windows—some of whom appear as brooding gorillas in the
oil paintings that decorate the walls of the piano bar over at Piero's.
Many are caricatured on the wall of The Palm over at Caesars. A great
many of these notables, in the flesh, are spreading cream cheese on
sesame-seed bagels when we step into the room and embark on our
separate circuits. The senator stops at a table to chat with Myrna, who
is a county commissioner. I say hi to Jane and Sheryl, who are just
back from Art Basel in Miami Beach. We dish about the art fair.

Over by the window, my pal Steve, in shirtsleeves, is sitting with
a guy in a suit. Depending on when you catch him, Steve is a real

estate mogul, an artist, or a patron of the arts. He is just back from Michael Heizer's gargantuan earthwork in the desert about three hours north of Las Vegas. A French television crew, he says, has been trying to fly over Michael's magnum opus in a helicopter to get an advance view. Michael has been shooting at them with his over-under, peppering the chopper's underbelly with buckshot. The local constabulary, for once, is taking Michael's side, turning a deaf ear to the Frog Paparazzi. This is chuckle-worthy, so we're chuckling when the senator appears at my side to say hello to the guy in the suit. We do introductions and grab a table.

Evan takes our order. The senator pulls out her schedule book and flops it open. "You sure you're up for this?" she asks. I tell her that I am up for it, and I really am, because I am worried about the Republic. In the past, I have worried about Republicans, but never about the Republic. Lately I have been, though, and feeling daunt-ed, so I called Dina, who, in my neighborhood, is the duchess of undaunted. She has been my state senator since 1989 and minority leader of the state senate since 1993. Now she is planning to be Neva-da's first female governor. My idea is to tag along with her during the early stages of her campaign, because I want to look at democracy again, if only to wave bye-bye, but also because Nevada is voguing its way up to a tipping point and the senator's candidacy is part of that strobe-lit dance.

It goes like this. For more than a century, mining and ranching interests in the northern part of the state have controlled Nevada politics. Now, suddenly, Nevada is the most urbanized state in the union. Seventy percent of its 2.4 million residents are concentrated in its extreme southern wedge, like the silver balls in the bottom of a pachinko machine. In 2008 the state will join Iowa and New Hamp-shire as the host of an early Democratic presidential caucus, and precedent to that, Dina Titus—a Bill Clinton Democrat in a state that loves Bill Clinton and voted for him twice—is running for governor from the neon vortex of the hustle and the muscle, from a district that includes the Las Vegas Strip, the Boulder Strip, the bulk of the

state's union employees, and the University of Nevada–Las Vegas, where she is a professor of government.

The local pundits, crediting the senator's power base and debiting her for being a very intelligent woman, give her a chance that is little better than a prayer. Her opponent in the Democratic primary, Jim Gibson, the mayor of Henderson, has twice as much money, which matters because the primary will be won or lost in Clark County, where the population density requires expensive media saturation. Also, both candidates reside in Clark, along with most of the Democrats who will decide between the Mormon lawyer in the six-piece suit and the Greek lady with the tough charisma of a Visconti heroine. The county's large, well-organized community of Latter-Day Saints will vote en masse for the six-piece suit. The district's loose coalition of Mediterranean enclaves, of Jews, Italians, Greeks, Armenians, Lebanese, and Arabs, will likely opt for the street-smart diva.

Since my original idea was to accompany La Titus on her forays out of her power base into rural Nevada, I ask her if this plan will take her too much out of Clark, where the primary action is. The senator shakes her head as she flips through the schedule pages. "I'm running for governor," she says, "not for the nomination. Where do you want to go?" I suggest the Cowboy Poetry Gathering in Elko. The senator blanches, looks up the date, and says she has a conflict. She suggests the bull auction in Fallon, but I have a conflict. Finally, we settle on a trip west to Pahrump, in the terra incognita of Nye County, and a trip northeast into Lincoln County, up along the Utah border. Running a finger down the day's schedule, she asks me again if I want to do this. "It's going to be boring for you," she says. I explain that, as a devotee of Andy Warhol, I am an aficionado of boring.

"Okay," she says, reading off the schedule, "Pahrump. We leave at 6:00 a.m. There's a Nevada Natural Treasures Committee meeting at the Pahrump Community Library, then a lunch, then a newspaper interview, then a visit with some Democrats at the job-training center, then a television interview, then a fund-raiser at the golf club,

for women who are running as Democrats for state office. I do the keynote. We schmooze, have some cookies, and drive back to Vegas."

"Great!" I say. The senator looks up at me, unconvinced.

"For Lincoln County," she says, "we leave at 4:30 a.m. We stop for doughnuts and coffee at the senior center in Alamo. The state water committee meets in Caliente for the rest of the morning, then a lunch, then more water committee, and then a little meeting with Caliente Democrats. Then we drive up to Pioche for a potluck with Democrats at the Episcopal church. Then we drive back to Vegas."

"Way cool," I say, and she looks up at me again, still unconvinced, so I ask her if she does this every day.

"Only when I'm not working," she says.

In between road trips, we decide to dine our way through the gala season in Las Vegas, in support of the symphony, the museum, and disadvantaged children. My original idea had been to add a little Sin City ambience by getting us into Freddy Glusman's fund-raiser over at Piero's, during which strippers would raise money, the way strippers do, to benefit kids. Unfortunately, this event was no sooner inaugurated than wags dubbed it "Tits for Tots," the charity folks got hinky, and the evening was canceled despite the overwhelming generosity it generated. So we are left, gala-wise, with fine cuisine, baroque food presentation, and silent auctions for trips to the Napa Valley.

I am still up for it, however, although I can't help thinking that all this dither can't be *that* much fun, so I ask the senator some questions that might reveal the little engine that drives her train. It may be altruism, of course, but that's always a bad bet in Nevada, and I know it's not money. I've checked the public records. The senator makes fifty grand a semester teaching a three-class load at the university for three semesters out of four. Every other spring, she takes unpaid leave while Nevada's "citizen legislature" is in session. For this public service, she gets about eight grand. She drives a Lincoln. She lives, with her husband, Tom Wright, who also teaches at UNLV, in a seventies ranch-style home in an uncurbed cul-de-sac near the university.

She wears nice clothes, as public servants must, but she doesn't seem to care that much about money or to understand greed, except to deplore it, and it's not because she's so pure (although she is pure-ish). Listening to her talk, I realize the obvious: that the senator is, in fact, one of us. Like any real Las Vegan, she loves the action, the play at risk. She relishes the Robin Hood excitement of going up against the house's edge with a cool head and a cold eye, and she likes to win.

So I ask her, "What are you going to do if you lose?"

"I'm not going to lose," she says.

"But if you do?"

She actually pauses and thinks for a minute.

"I'd probably serve out my senate term and go to France."

"But you wouldn't run for Congress?"

"Honey, I grew up in Tifton, Georgia," the senator says. "Washington is way too South for me . . . and, while we're at it, what are *you* going to do if I lose?"

"I'll tell my editor you purposefully ruined my story," I say.

The Pahrump Community Library is a brand-new, faux pueblo painted in earth tones and decorated with western iconography: cow skulls, horns, cacti, etc. On one side of the library, there is a large rectangle of raw desert, scruffy with weeds. On the other side, there is a green corrugated building with a pink neon sign that says TATTOO. The parlor's unpaved parking lot is already crowded with gleaming lowriders when the senator and I arrive at the library for the committee meeting. Across the street, there is a subdivision of off-white, "permanentized" double-wides that, rather obviously, began its career as a trailer park.

In the library parking lot, the debate that will be carried on inside about the fate of the prehistoric pupfish is nicely encapsulated by two bumper stickers. The sticker on the SUV says *save the pupfish.* The sticker on the pickup says *fuck the pupfish.* The senator nods at the stickers. "You got to love Nevada," she says, and I do, for just that brand of Senecan *claritas.* The state, I have decided, is like *Pure-*

Concentrate-America, geeked-up Americanosity rigorously edited for tabloid publication. All the fat, padding, insulation, obfuscation, and camouflage have been burned away, if they ever existed. There are no segues or artful transitions between nature and culture, city and country, vice and virtue, liberty and tyranny. There is just the new library, the raw desert, the tattoo parlor, and the tarted-up trailer park.

In most states this would be a dog whistle for rancor, for zoning ordinances and restraining orders, but not in Nevada. The state may be a rough jumble; the library may jangle with the tattoo parlor; Bagelmania–Vegas may jangle with Chicken-Ranch–Pahrump. But it is one culture and thrice blessed: first, by volunteer inhabitants who prefer Nevada to the place from whence they fled; second, by being a WASP-deprived environment and the only state in the union that is not run from a white-napkin country club; third, by being virtually farmer free, a site upon which the Middle American equation of agricultural drudgery and Christian virtue has no traction, where mercantile virtues triumph, and your average Nevadan's experience of food production is confined to watching the "lobster plane," with the little red lobster painted on its nose, land at McCarran airport every morning.

Nevada, in a word, is inauthentic. The mise-en-scène, whether it's the eloquent desert or the glamorous Strip, is just that, a theatrical setting, an adaptable backdrop before which the theater of human folly is acted out—a usable dream in the midst of which the tricky business of extracting gold from "them thar hills" or "them thar tourists" transpires—and this raw inauthenticity has its virtues. It repels the cozy communitarians, the identity politicians, and the devotees of Jeffersonian agrarian utopianism who make up a large majority of Those Doomed to Be Perpetually Disappointed. It attracts entrepreneurs, adventurers, engineers, artists, bankers, drifters, accountants, poets, and more lawyers than the nicer parts of hell. It engenders a society of wayward strangers among whom, out of sheer animal instinct, one walks softly and acts right.

As a consequence, the proceedings of the Nevada Natural Treasures Committee, which Senator Titus created and now chairs, are conducted at a level of collegiality that borders on the courtly. The elected officials are a mix of assemblymen and state senators. They sit behind a long table at the head of the room; the bureaucrats sit behind another table facing them; the citizens sit in rows of folding chairs behind the bureaucrats. The elected officials are stylized and highly individuated. The bureaucrats are stylish but not so easily distinguishable. The interested citizens, in work clothes and gimme caps, pedal pushers, flowered dresses, and off-the-rack suits, conduct themselves with thoughtful gravitas, as if in court or church. The bureaucrats testify, the elected officials pose questions, and the public enters in with statements and questions, some of which they have written in advance.

In the process, I learn a lot about nineteenth-century charcoal kilns, wild horses in herds, Lake Tahoe, the endangered pupfish, and the feasibility of building a highway from Pahrump into the Spring Mountains. I learn from Senator Titus just how intimidating a meticulously prepared elected official can be. I learn who is straight and who is crooked, who is bored and who is stupid; but mostly I am led to wonder yet again why the American press corps seems incapable of covering politics at this level of low-temperature nuance. The things I am noticing are the things *I want to know*, the things that matter to me as a citizen, regardless of party. Everything is here, disguised in official prose, revealed in the timbre of the assemblyman's voice or in the fine cut of the bureaucrat's jacket, and *not one* of those big-money media sissies in their rain gear and flak jackets can tell us anything about it. This, I suspect, is because democracy is a subtle discourse, invented by adults for adults. In its design it is an eighteenth-century comedy of manners, and those media dudes can do only adolescent melodrama. They can only stand in the smoke and shout, "Katie, it blowed up!"

That morning, for instance, after we have, once again, swept the fate of the imperiled pupfish under the rug, we are all dawdling along

in cruise control until this officious guy from Highways takes the chair, passes out his photocopies, turns on his slide projector, and starts laying out the parameters of his feasibility study for the proposed highway leading from Pahrump into the Spring Mountains, which separate the Las Vegas Valley from the Pahrump Valley. At present, Las Vegans have direct access to the ski areas while Pahrumpians must drive around. The proposed highway would mitigate that inequity. This is clear enough, but as the explanation of the feasibility study's methodology proceeds, the contours of the study seem to evanesce into the air. By the end of the bureaucrat's exposition, he has achieved a glistening level of ethereal refinement worthy of Gayatri Spivak or Homi Bhabha, and somewhere in the midst of this Senator Titus starts paying attention.

Then everyone starts listening and taking notes. They appraise the civil servant's wardrobe, his splendid haircut. Elected officials flip through papers. Senator Titus pulls out a sheet and assumes a look of impatience. Then the other shoe drops. One small problem with the project, the guy from Highways says, is that a new highway running into the Spring Mountains from the *west* might easily be connected with the existing highway that runs into the Spring Mountains from the *east*. This, of course, would create a major thoroughfare, a shortcut through a delicate wilderness area that would connect North Las Vegas and Pahrump.

He doesn't explain, although everyone knows, that this connection would greatly enhance the marketability of bedroom developments on the west side of the mountains and of resort condominiums on the east, that it would breed instantaneous congestion, require immediate widening, and wreak environmental havoc. Senator Titus intervenes to point this out. She calls the committee's attention, with names and dates, to a shady resort project at the edge of public land that would benefit mightily. Then the senator leans back and raises her eyes theatrically, because she and everybody else in the room knows, just from the elaborate, pseudoprofessional methodology of the report, that some kind of fix is in and that, for better

or for worse, without organized opposition, the highway will go all the way through, and that will be it for the mountains. Later, on our way to the car after the meeting, I ask the senator about the highway project. She reaches up to massage her shoulder. "You just have to concentrate," she says. "If you blink, they'll slip it by you."

Two hours later we are parked in the spring sunshine on the outer edge of an Albertsons supermarket parking lot. Shade is not an option, but the weather is nice and we are halfway through the schedule that Annette, the senator's assistant, has folded in her pocket. We have done the committee meeting, the lunch, and the newspaper interview at the *Pahrump Mirror*, where, for undisclosed reasons, the biker dude with the gray ponytail wanted to talk with Senator Titus about battered women. Now Annette and I are sitting in the front seat keeping a lookout while Senator Titus hastily and surreptitiously changes clothes in the back seat. Articles of apparel fly around the edges of my vision while the senator speculates aloud on her opponent in the Democratic primary, wondering how he can possibly call himself a Democrat, being who he is and what he is, wondering whether he has ever even bothered to come out to Pahrump, which for any Democrat, however bogus, is serious Indian Country.

Actually, Pahrump looks pretty much like Burger King America to me, but I take the senator's meaning. The Pahrump Valley lies sixty miles west of Las Vegas on the road to nowhere but Death Valley, which glimmers in the distance right across the wild California border. In keeping with this "end of the road" ambience, the township has always been bumptious, its residents famous for their libertarian proclivities, their penchant for extraterrestrial speculations, and their disinclination to officially incorporate a human infestation of thirty thousand free souls, not counting felons and folks living off the grid. In its own imagination, Pahrump is the last frontier, and even inhabitants who arrived yesterday will tell you that the place started going to hell in 1954, when they paved the Old Spanish Trail

and dubbed it Nevada 160. The slide was exacerbated in 1963, when electricity came to the valley, bringing with it the authoritarian jackboot of traffic lights and the surveillance-friendly amenity of streetlamps.

During these years, flying saucers hovered and zoomed over the valley. Swarms of black helicopters blotted out the stars. No more. Today, Pahrump is morphing into a yuppie bedroom for Las Vegas. The population is growing fast and its old-time citizens are counting slow, lest Nye County surpass the population total at which any number of state regulations kick in, most notably the population limit set for counties in which prostitution is legal. Just a few too many libertarians, it would seem, and they can kiss the whores goodbye— goodbye to the Brothel Art Museum out in Crystal, goodbye to the Chicken Ranch and Sheri's out on Homestead Road, and to the republic for which they stand.

When the senator's couture has been upgraded to local television standards, she reaches into the front seat, adjusts the rearview mirror, and sets about repairing her hair and makeup. Annette props a map against the steering wheel and plots our way to the job-training center. I glance through a back issue of the *Pahrump Mirror*, described to me by one of its serious young staffers as a "constitutionalist publication." Pink Floyd comes on the radio, and suddenly I feel at home, as anyone would who has ever done the American road. Because if you have ever toured with a band or with a show, if you have ever run for office or peddled women's dresses, practiced evangelism, or promoted a book, you will have had to change clothes in the back seat of a Lincoln in an Albertsons parking lot in the middle of the afternoon.

Repacking her makeup, the senator says, "What's our time like?"

"We've got forty-five minutes," Annette says.

"Then I'm going to go meet people," the senator says.

The car door slams behind her as she heads out across the asphalt. I watch as she positions herself outside the supermarket doors and starts introducing herself, sticking out her hand to passersby: "Hi, I'm Dina Titus and I'm running for governor." While the

senator presses flesh that has recently squeezed melons, I borrow the schedule and discover that the fund-raiser this evening is called "Women on the Run for a Better Nevada," so the biker dude at the *Mirror*, not without justification, thought the senator was in town for an affair on behalf of battered women, for women on the run—a commodity of which Nevada has had no pressing shortage since the days of the divorce mills. At this point, I am as happy as a pig in poop. Everything, so far, has been perfectamundo, *muy poquito*, very local, and pleasantly boring. The public's business never ends. It just dawdles on forever.

That night I see the senator in her element, turning on the technicolor for the ebullient crowd at the Willow Creek Golf Course. Amid the bunting, ribbons, posters, stickers, buttons, and balloons, she does shine, and she is clearly doing what she was born to do. As the ranking Democrat in the room, she is the star of the show, but she would be even if she weren't. Following her movement through the crowd is like watching a kid carry a sparkler through a carnival. The feral ecstasy of American politics is in the air. Eyes light up with the giddy realization that there is blood in the water and, for once, it's not the Democrats who are bleeding. People are up. The candidates on hand tonight are all women, and even this weighs in their favor, since women voters in Nevada are notoriously predisposed to ignore their spouses' wishes when they step into the voting booth.

Later, I follow the senator around and try to eavesdrop, but when she doesn't want to be overheard, she isn't. Her smile is very good, though, and I notice that, even as she projects concern and interest, she casts no shadow. Like a good poker player, she has no tells. Beyond the fact that she is paying attention to you, she is pleasantly opaque. If someone asks her a question, she answers with names and dates. If they press, she elaborates with policy analysis, statutory provisions, and appropriations patterns. If they press further, she gives them a big hug, waves to an imaginary constituent across the room, and moves along.

At the conclusion of the evening, the senator steps quickly on to

the bright stage, shoots the crowd a flashbulb smile, and proclaims herself to be a Georgia girl who owns a gun and drives an American car, who is *not* a lawyer, and is damned happy to be in Pahrump. This, *quelle surprise*, draws applause. She then proceeds to defend the right to bear arms, the right to an abortion, and the option of same-sex marriage as three glaring instances in which the government should stay out of our pants. "The role of government," she says, "is to educate your children, lock up the bad guys, and provide for the common good. Then it should get out of the way." Pahrumpians applaud because (except for the part about "the common good") this is hard-core Nevada, and it leads into an excoriation of the present administration's education policy that segues into a blunt, funny attack on Jim Gibson, her primary opponent, which segues into a mocking riff on Republican Congressman Jim Gibbons, her likely gubernatorial opponent, who, according to the senator, is scuttling home only because his abject loyalty to Bush the Younger has gone embarrassingly unrewarded. The only difference between Gibson and Gibbons, she says, is a little more B in Congressman Gibbons's BS.

All of this, delivered in a rapid-fire drawl that the senator uses in debate, invariably makes her opponents feel as if they are being sprayed with butterscotch. As she speaks, however, I detect sources of the senator's power that transcend her ability to talk Georgia at the speed of a Greek. First, she comports herself like a winner, in a culture that loves winners. Second, she is a serious *wonk* in a culture of hustlers and gamblers who love the edge that secret knowledge gives you. Third, she is a professional civil servant in a political culture that is notorious for its amateurish ruffians. In this, I realize, the senator really does offer a choice and a solution, as much for her intelligence and management skills as her convictions.

Every day, in the conduct of Nevada's public business, a Wharton-Harvard-Cornell management culture, full of hedge-fund wizards and Hayekian derivatives freaks, goes nose to nose with a public sector that exudes the aura of a sepia-toned desert courthouse in 1938. Not long ago, when I mentioned this glaring inequity to a

friend of mine who is CEO of a casino corporation, he smiled and spread his hands. "Hey!" he said. "It's not a fair fight. We're smarter than they are. Lucky us!" The fact that voters seem to recognize this has, over the years, been part of the senator's edge. In every race she has run, Dina Titus has been portrayed as a social liberal running against a fiscal conservative. This, fortunately, means nothing, since most Nevadans are both deeply resentful of taxes and generally unconcerned with drag queens who can't stay off the welfare rolls. Thus, given a choice between a social liberal who can balance her checkbook and a fiscal conservative who clearly can't, Nevadans have, so far, come down on the side of Scholastic Aptitude. As we prepare to leave, I spy the senator demonstrating her intelligence and foresight by slipping cookies into her purse to nibble on the way home. I follow suit.

A week later we set out from Las Vegas at 4:30 a.m., heading northeast toward Salt Lake City. It's still dark when we turn due north onto US 93 and the highway squeezes down to two lanes. This is the old Mormon Trail. It runs five hundred miles up the eastern edge of Nevada through the high lonesome. These days, truckers use 93 as a quick shot from California to Idaho, but we are too early for the trucks, or for anything else. So, as the sun comes up, Senator Titus fills me in on the plight of rural Nevada. At present, she says, Nevada's exurban inhabitants are mostly on the public payroll. Eighty-five percent of the state's land is federally owned, and the entire countryside is dotted with military installations, test sites, research facilities, and prisons of one sort or another. Beyond that, there is a little ranching, a little mining, a little farming, and a little tourism. There are some retirees retiring, some developers developing, some bikers biking, and some tweakers cooking meth. There are roadside people who sell diesel, bad burgers, and Toby Keith CDs to the truckers, and that's about it.

The landscape surrounding us confirms the senator's summary. It feels like high Afghanistan in the angled morning light that swish-

es across the mesas, a formalist's paradise and a hermit's dream, exquisitely beautiful and elegantly dead. Like most of rural America between the Mississippi and the Sierras, the human population of Lincoln County is holding at ultra-sparse. Unlike most rural Americans, however, the citizens of Lincoln couldn't care less. There are five townships in the county, none much larger than a thousand people and all of them "barbell communities," whose residents are mostly under thirty or over fifty—crazy kids on Harley-Davidsons and geezers with Sears walkers—and they are fine with that. The county's 4,391 residents share a space that is double the size of Connecticut, but they would be happier with more space and fewer people. One does not, after all, move to the desert for the traffic, the Jamba Juice, and the Cineplex.

"All of these places are worth saving," the senator says in a tone of voice that does not invite my asking why. I ask anyway, and she says, "Because we can." She goes on to explain that rural Nevadans, unlike most Americans in the rural West, have a hole card: a tax base in Las Vegas and Reno, whose mercantile cultures are not directly tied to oil or agriculture. So Nevada can afford its Anglo-Bedouin residents and its fierce, beautiful countryside, and because of this, Nevada is not the best vantage point from which to observe with relish the waning of red-state America. In Caliente, Tonopah, and Pahrump, you don't experience the resentment you feel in Nebraska or Iowa as people envision the day when their state's entire population will consist of two boozy senators and a golfing congressman, all three of whom have moved their extended families to Washington, DC, leaving the state itself adorned by a scattering of abandoned houses, three satellite dishes, and a defunct Circle K.

Our first stop of the morning is in Alamo, a ranching town and bedroom community for people who work at the test site. The Alamo Senior Center is a white frame house situated on a little rise three blocks off the highway. The room in which we gather is lined on three sides with sash windows and flooded with sunshine. It is furnished with books, tapes, a TV, and a VCR. The county of Lincoln funds the

senior center, and during our five-second drive through "downtown" Alamo, it's not hard to grasp the center's importance. The five women and two men who show up to meet Senator Titus unanimously confirm this. The local options are watching *Matlock* again, going to church again, knocking back shooters in a biker bar, or coming to the senior center.

So they come, and the seniors that morning clearly are up for the senator's visit, less for the politics, I suspect, than for the novelty. I grab some coffee, nibble a doughnut, and watch the senator enhance her power by giving it away. If she had spoken, I realize later, if she had offered any remarks, the locals would have listened politely, sipped their coffee, and then gone home, but the senator doesn't speak beyond "Hello how-are-you-how-nice-to-see-you." She doesn't pitch anything. She smiles attentively, looks at them solicitously, and waits. After a few stuttering starts, just to be polite, people start talking. I learn something about grassroots politics and a little bit about the citizens of Alamo, whom I like and whose repose I envy.

I am shocked, then, to discover as we talk that most of these seniors are younger than I am. They are in their fifties but abraded by the desert, which blasts people out, cripples their hands, and burns their skin with cancers. The seniors of Alamo wear this damage well, of course, since they are desert people by choice. They don't complain much, and when they do, they always preface their complaint with "We love our rural lifestyle, but darn it . . ." As in "We love our rural lifestyle, but darn it, we'd be lost without the senior center" or, from a pretty woman in her midfifties, "We love our rural lifestyle, but darn it, if I have another heart attack, the helicopter to the hospital costs twenty thousand dollars" or, my favorite, from a lady in her seventies with a grandmotherly mien, "We love our rural lifestyle, but darn it, I like to knit, and I'd like to have more than the one color yarn they've got over in Panaca."

Since I have been whining about the lack of Starbucks for the previous three hours, the helicopter price and the monochrome yarn

exacerbate my sense of urban sissydom. I cringe with shame as the people talk and the senator makes notes. Everyone smiles and nods when she writes something down. It seems to make everybody feel better and I'm glad as hell it does.

"I mean, one color of yarn! Oh sweet baby Jesus!"—this, my anguished cry as we drive north on the ascending highway out of town, farther away from the possibility of a latte. A few miles up the road, we pass the "Extraterrestrial Highway," which runs west, out to Rachel, the "UFO Capital of the World." Since the politics in Rachel are more intergalactic than local, we press on. A little farther north, we also bypass Panaca, a Mormon farming community that is, for all intents and purposes, an island off the coast of Utah. "Democrat intolerant," the senator says. We head on into the high country toward Caliente, a railroad town that has hot springs that are not much patronized these days. Now most of the shops are boarded. The railroad's just an old yellow station, and in lieu of the hot-springs tourists, Caliente hosts a young women's detention center with a crisp, military campus. Yellow cinder-block buildings are scattered across a manicured lawn that is dotted with fir trees. I have been hoping for nubile Lolitas lolling on the grass, tipping down their heart-shaped sunglasses to greet us, but no such luck.

The water committee meeting is in the auditorium of the detention center, and the audience there is larger than in Pahrump, about 150 people dispersed on orange bleachers. From this I infer that the acquisition and distribution of water are of more concern to rural Nevadans than the wan pupfish who swim in it. At first we learn what we already know: that geologically Nevada is a gigantic, postoceanic ditch between the Rockies and the Sierras, filled with rough, secondary mountain ranges that stack and twine across the naked landscape like ranks of FEMA house trailers in a storage lot. This reminds us of what the geologists don't say: that once you're in the midst of this arid, self-similar chaos, you are almost certainly lost and doomed to be bones in the scree, you and your big bag of gold nuggets.

So water is life, and it has always been gold in Nevada. (When I asked Steve Wynn what his fountains in front of the Bellagio might mean, he grinned his wolf's grin at me and said, "Liquidity!") People fight and die for water in Nevada and always have. They drill for it, steal it, buy it, litigate for it, legislate its access, and gerrymander its distribution. And there is lots of water down there, according to the testimony. There are aquifers layered with mineral strata going down forever, farther than you can go. The shallow aquifers will dry up in our lifetime, but there are more aquifers down there, if we could only get to them, if we only had the money, if we only had the technological resources, which we will have sooner than later.

"If we only had wings, we could fly to Paris, France," the rancher sitting next to me mutters, sotto voce. Then the state geologist shoots a map of Lincoln County on the screen, and the rancher leans forward to pay close attention. So do I, because it's informative and good theater. The geologists are clear, the lawyers lawyerly, and the citizens have a sense of ceremony. Some even stand with their speeches in their hands, as if they were addressing the second Continental Congress. Even so, the local residents are clearly pissed. The tables have turned on them, and they think (correctly) that Las Vegas is trying to steal the water that they want and to sell it to developers like Harvey Whittemore, whom I overhear referred to as "the Jack Abramoff of Nevada." Mr. Whittemore, looking fortyish, country casual, and slicker than deer guts on a doorknob, testified early in the day on the water requirements and purported benefits of "Coyote Springs," the egregious housing development he is building on the Lincoln-Clark county line about sixty miles south of the young women's detention center. Lately, Whittemore has been spreading joy throughout the county by buying up local ranches to acquire their water rights. The state perceives itself to have a claim on some of this water for its urban needs, so the citizens of Lincoln County, for all their individualism, are at least united in their loathing of Las Vegas.

This animosity is not totally rational, of course, since the citizens of Caliente depend for their very livelihood on the tawdry Easter

Parade of naughty young ladies that Las Vegas provides them, and if Senator Titus is right, the revenue derived from that gaudy Babylon glowing behind the mountains will ultimately be their salvation. But these are side issues. The godfathers of Vegas are trying to steal their water, and after the hearing, listening to the locals talk out on the porch is like listening to my Irish relatives in County Kerry decrying the fleshpots of Dublin. At one point, a lady somewhere behind me declaims: "And what do they want the water for? They want it for Jews to squirt up in the air. They want it so whores can flush down condoms. They . . ." There is more, but the crowd is drifting off. Harvey Whittemore walks away down the sidewalk with his arm around the shoulder of the rancher who sat beside me at the hearing, almost certainly talking water rights.

The senator hangs around after the hearing to talk to some Democrats, so when we leave, we leave an empty parking lot. Two blocks north, we leave an empty town for the empty high desert. There are no cars and no signs of human habitation along the road.

"This is fun," I say. "But it doesn't feel much like a political campaign."

"It does to me," the senator says.

"Well, where are the Learjets?" I ask.

"Well, where are the airports?" the senator says.

"Right," I say.

"Trust me," the senator says. "Learn something. These trips will win it."

"Well, if you don't have a Learjet, I think you should at least have a *spinmeister*," I say.

We arrive in Pioche at twilight. The air is chilly and the mountain's crest is black behind us. The town nestles into the rocks just below that crest, overlooking a purple valley of breathtaking emptiness, shimmering with twilit sage. It's all so bleak and beautiful that I want to do something crazy, and I realize immediately why Pioche, in its heyday, made Deadwood look like Mayberry. Crazy is

in the air, and in the ground too, if you count the seventy-two ne'er-do-wells who were buried in Boot Hill before anyone died of natural causes. Today, Pioche is less crazy but still not totally sane. There are two restaurants on its slanting, angled main street and three bars within staggering distance of one another. Since the senator wants a drink and since she is the senator, we stroll into the big one that dates from the 1870s. The room is tall and dark and deep; the cherrywood bar runs off into shadows along the south wall, as does the looming credenza behind it. Back in the days of profligate silver and cavalry pistols, this whole ensemble came around Cape Horn by clipper ship from London to San Francisco, then overland to Pioche. The extravagance of those days was such that this elephantine amenity seemed a bargain at the time, like the days in Vegas now, where Steve Wynn's perfect little Vermeer is pretty much a blue-light special.

The senator scores a glass of booze and heads around the room meeting people. I take a seat at the bar and hear the blonde barmaid say to someone down the rail, "That's Dina Titus. She's for us little people." I am about to relay this compliment to the senator, but she is waylaid by a local philosopher who proclaims himself to be a "Reagan" Republican, not a "Bush" Republican. This is standard Nevada these days: there are suddenly a lot of "Reagan" Republicans and "Goldwater" Republicans and young, dot-com swifties who admit to being "blue-jean libertarians," all of whom look back in stunned dismay at the fundamentalist putsch that, in their view, has inverted the meritocracy of the conservative movement. They really don't understand it, so they talk with quiet rue about a culture that doesn't pay its bills, doesn't obey its own laws, and doesn't take care of its children. They evoke antique virtues like honor and decorum, such as the guy I was playing cards with who ended a political discussion by throwing down his hand with a thwack and announcing: "Any man who sends other men off to war, he greets the fallen when their bodies come home! He stands there at attention and watches the dead guys put into the ground! If he's a man. I fold!"

Three stools down, as best I can tell, Mr. Reagan Republican is

demonstrating his liberality to the liberal senator by praising, for their perspicacity, Ronnie's clandestinely gay econo-wonks, the "LaissezFairies." I order a drink, confident, suddenly, that out here on the edge of everything, I have heard George Bush's death knell. When the blonde comes back with the bourbon, I ask her where she's from. She says Washington State but she had some trouble in Tacoma. "So you could say," she says with a wicked smile, "that I'm doing life in Pioche." I congratulate her on her choice and tell her that I am doing life in Las Vegas. Then, looking around at the crepuscular space, I say, "Nice bar."

"Damn right," the girl says. "Don't you know those old-timers had some fun."

We chat about Pioche until the senator gives me a "get me out of this" look. I wander over, remind her that we're late for church, and rescue her from Reaganomics. As we step out into the darkness and head up the chilly street, I can't help thinking that Pioche used to be Las Vegas, the confluence of crazy, the locus of poor impulse control, the center of the world in the black desert night. I imagine Mark Twain walking this street. I think about the brute miners and the addled gunslingers, about all the men and women who turned mama's picture to the wall and just set out, hell-bent for Nevada. I step up my pace to keep up with Senator Titus, who is, in her own way, one of them, a mover and shaker who quixotically bets on the moved and the shaken. Unfortunately, since we are prosaic Democrats and not addled gunslingers, we are en route to a covered-dish supper in an Episcopal church that began its career a century ago as a miners' union hall.

The senator raises her arm and points. "Look up," she says. "There it is." I look up and there, indeed, it is, silhouetted against the stars, a gray wooden structure with golden light in the windows hanging precariously off the edge of the mountain almost directly above us. It looks greeting-card cozy.

"This is going to be boring," I say.

"Boring for you," the senator says. "Mother's milk for me."

"So there will be guys there with Hush Puppies on," I say.

"Hush Puppies for sure," the senator says.

"But they are nice people who will help Dina win the primary."

"They are and they will," the senator says with a smile.

At the potluck, the kids all gather on the bed and make a fort out of the coats strewn across it. The food is good and I actually do have fun. Dina dazzles the desert folk. Pioche, I know, will flicker in my dreams.

My Silk Road

It is common wisdom that the nothingness of the desert is a rich source of self-knowledge. In *The Seven Pillars of Wisdom*, T. E. Lawrence reminds us that it is also a source of self-obliteration, and I belong to the self-obliteration school. If you stand there long enough, and look carefully enough at nature in its absence, you disappear and the desert flows through you. I lived in southern Nevada for twenty years, and if you are out there in its cruel mountainous desert, where the heat sucks out your brains, where the absence of vegetation obliterates all sense of scale and perspective, so the line of mountains you see before you could actually be three ranges of orange mountains from two to a hundred miles away, if there is nothing human in sight but a road and that road may run along for four hundred miles and end in a blind canyon, if you are in this desert and you don't have a compass, a landmark, a GPS, or a native's mapping instinct to center you, you are lost—by which I mean, you are *really* lost. You feel like you could tumble into the sky. If you wait till dark and see where west is, even that depends on knowing your latitude and you probably don't have a sextant at hand. The US Cavalry used sextants when traveling across this country because without latitude, you could walk two hundred miles and never notice the difference.

So you are beyond humankind, literally off the grid and effectively obliterated. You are on your way to being bones in the dust. Like T. E. Lawrence, Captain Cook, and the great Polynesian sailors of antiquity, I get off on this anxious frisson of lostness. I like the casinos in Palm Springs, Laughlin, and Las Vegas because you're always lost in them, but I also like the places where nature and culture abut, where nature is rigorously distinct from culture, because

we tend to humanize or spiritualize the natural world and the desert is not our own. There are things and places that can't be humanized. The Roaring Forties south of Cape Town and the permafrost plains of Siberia have never been human or spiritual and never will be. They remain untouched and alien. In the desert West and on the beaches of the Pacific, nature and culture do not blur together as they do in the mythologized Sierras, in historicized New England, or on the tragic battlefields of the brokenhearted South. On these latter sites, like most of Europe, the soil is soaked in human blood, manure, clay bricks, and dreams. On the edge of the ocean or on the edge of a desert highway, you know where you stand: nature is there and culture is here. The distinctions are clear. I love surfing the edge between the wild ocean and the human shore.

Out of all these badlands, I have invented a winding trek through the desert West where one can commune, but never quite bond, with their nothingness and its amenities. I think of it as my "Silk Road"— as the modern equivalent of the antique pathway from China to Istanbul called the Silk Road, although it was actually several roads along which caravans plodded east and west. I imagine myself emulating their strenuous adventure of long-distance desert commerce and the hallucinatory business of pushing on and paying attention in the middle of nowhere. On one occasion, after finishing some business in Fort Worth, I drove down to the Big Bend through country that is not quite desolate and not quite nothing since it is soaked with self-conscious "Texas mythology." In Marfa, Texas, I gave a symposium lecture on the artist Dan Flavin.

Next, I needed to stop in Santa Fe, then head down to see Jim Isermann in Palm Springs, and then back to Las Vegas. So, since I had some time, I decided to do the whole twisting drive through cruel nowhere that begins in Marfa, where Donald Judd's compound and the Chinati Foundation bring high art to the coyotes of the Big Bend country. From there, I headed north and west to Socorro, New Mexico, where you make a loop west to the Very Large Array, a giant complex of radio telescopes, each the size of New

Silk Road. Illustration by Kevin Quach.

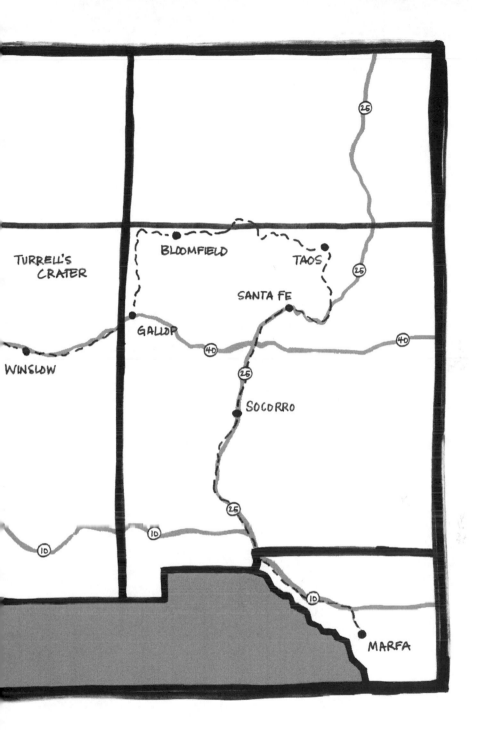

York and its boroughs, this because sound waves are 100,000 times longer than light waves and you need the dimension. Then I push on to Walter De Maria's *Lightning Field*—a valley in which hundreds of lightning rods are deployed. I know of five people who have seen lightning hitting the rods and jumping between them. My friend Ken Baker lived there for two years and never saw a strike. So no surprise that I am disappointed when I turn back to Highway 25 and head north to Santa Fe for a little touch of "Absolutely Fabulous" in the desert, for some fake good food, terrible art, rich people, and adobe huts with rounded corners that look like Flintstone SUVs— sort of Mad Max meets the Hamptons. Then I head up to Taos for Mabel Dodge Luhan's house, Kit Carson's hideaway, and Agnes Martin's paintings in the museum. I like Taos because you can still feel its heritage as a walled trading post where East met West, where crazy Indians and crazy Anglos intermingled to gossip about the fate of their friends still out on the dangerous trails and to trade whatever they had worth trading. From Taos, you can make your way west, somehow, across the top of New Mexico, which isn't easy. When you come off the mesa, you are in Indian country and about to get lost and get your panties in a bunch. So look at the map, the compass, and the odometer, your sextant if you have one, and forget about the signs. This is Navaho country and they know where they are. Eventually, one hopes, you will arrive in Bloomfield, New Mexico, just east of Farmington up by the Four Corners, where New Mexico, Colorado, Utah, and Arizona come together, then you head south to find the turnoff that leads to the astronomical ruins at Chaco Canyon, which is one of my touchstones and I couldn't tell you why—maybe it's the long limestone stonework or the exquisite coordination of the earth and sky that is embodied in the architecture or maybe it's the alluring idea that a brilliant, empirical society without a written language built this gorgeous place. I have been going to Chaco since I was nine, and it always makes me cry. One visit will last me a decade as long as I know for sure it's still there. From Chaco you head south and west to Gallup, then west on High-

way 40 into Arizona. This country, in winter, is very forbidding. Native pedestrians full of firewater freeze on their feet: they are walking along, get a little tired, grab on to a roadside fence post, and freeze in place. The local cops call them popsicles, which is cold but so is the wasteland. Once you're in Arizona, you have lunch at the newly restored La Posada Hotel in Winslow. It was a 1950s movie star hangout, where the train still stops, the dining room is lined with publicity stills of Myrna Loy, Clark Gable, and Ed Ruscha. Then you check out the Petrified Forest for a touch of the Triassic. You stroll through a fallen arcade of three-million-year-old redwoods and buy a really cool PF ball cap at the guest store because my traveling rule is to do everything corny. Cement lizards? Show me the way! (When I was traveling in the South with Jaded Virgin, the whole band let itself be guided through Madison's Montpelier and instructed by a Junior League docent on the quality of Madison's china.) On the American Silk Road, you turn north at Flagstaff on to Route 89. From there you will have to depend on local guidance to find the turnoff east to Roden Crater and depend on James Turrell's hospitality to get in. The crater is a black and red cinder volcano cone about 600 feet tall, at an elevation of about 5,500 feet. It is visually adjacent to the Painted Desert and overlooks its flat grandeur. So if you don't get in, the desert is still beautiful. The artist James Turrell has made a number of nuanced adjustments to the terrain of the crater, about which you will have to decide for yourself, but the crater is always worth seeing for the visual illusion. When you stand inside the cone, the sky seems to top the crater like the roof over a domed stadium. From Roden I like to drive north on Route 89, cross the Colorado River at the east end of the Grand Canyon, then head up to Utah into the Grand Staircase and Bryce Canyon country, where you may dawdle and gasp with awe at the swooping, heartless sublimity of a landscape that John Ford so overromanticized in his movies that people think it is human. When you start to feel like John Wayne, rather than a creature totally daunted by geological time, you head up Interstate 15 to Cedar

City, Utah. You turn west on Route 56 heading for Nevada and intersect the Old Mormon Trail (Route 322) at Panaca. It is now the major truck route from Los Angeles up into Idaho, Wyoming, and Montana, a busy highway through Afghanistan-style desert and tumblerock mountains. Panaca is in the county of Lincoln, which is about the size of Connecticut but with a population of four thousand. A few miles north of Panaca, perched on a mountaintop, is the old silver mining town of Pioche, one of my favorite places. In the old days, rough miners, with cavalry pistols stuck in their pants and pockets full of solid silver, kept the place lively and out of control. For a few years, Pioche was the richest town in the world. It is the site of the original Boot Hill, which had twenty-seven dead residents before anyone died of natural causes. There are still three bars and two cafés within staggering distance of one another, and the town itself, high up on the mountain, overlooks a vast plain that blazes with a breathtaking, endless field of purple sage. Zane Grey wrote *Riders of the Purple Sage* about this country. Nobody much but Mormon ranchers have been there since. From Pioche, you turn back south through American Afghanistan. At night, you are really all alone, a puddle of light in an ocean of absolute darkness. You turn west at Caliente for a hundred-mile detour on the Extraterrestrial Highway over to Rachel at the edge of Area 51. In Rachel, with its jolly, dysfunctional community of delusional Americans, one can dine and chat about people from Alpha Centauri around the clock at the Al-e-inn. At this point, since the "secret government" occupies the desert between you and Las Vegas, you retreat forty miles and take Interstate 93 down into Las Vegas—the Tin Man of American cities. It can sing, it can smile, it can dance, and you can have a good time there. It could be a great city if it only had a heart. You gamble your way through all the money you have saved in two-bit motels and diners, then detour to Michael Heizer's *Double Negative* earthwork northwest of Las Vegas. Soon enough Heizer's *City* will be opened, an enormous city-like earth sculpture rising out of nowhere, three hours north of Las Vegas. Soon the *City* will func-

tion as a stop on my Silk Road. Until the *City* is finished, I head west to Pahrump, which is black-helicopter territory—Area 51's evil twin. Its citizens are so wary and libertarian that they banned streetlights and stop signs for half a century lest the residents feel spied upon or find themselves casually snatched into rendition while stopping at some red octagonal-shaped piece of metal. Driving into Pahrump, it looks like about 200,000 people live there and they probably do. Only 36,000 are on the census roles, however, and this includes the whores at the Bunny Ranch just north of town. Everybody else is off the grid. Death Valley is right next door, and I was fortunate enough to drive through this sub–sea-level wasteland after a wet winter and see its infinite nothingness aflame with wild flowers out to the perfect horizon. Then, you head back south as best you can. The fastest way is to head south and west from Pahrump to Baker, where you can buy Bun Boy T-shirts at the café of that name. These T-shirts are much treasured by the bun boys who hustle their buns on Santa Monica Boulevard in Los Angeles. They mean some whale took you to Vegas. From Baker you can head straight south into the Mohave, although you get less of it. Ideally, you cut back to the California-Nevada border, take the secret Nipton turnoff heading east, then take a quick right south on to a winding, two-lane blacktop road with no road signs after "Next Services 129 Miles," so you have to pay attention, read your map and your odometer, and use your GPS, which is less useful than you might imagine, and remember you're headed for Kelso, an abandoned railroad town in the middle of the nothing. From Kelso (bright, white buildings where nobody lives), you drive south, then west. The road weaves through the beautiful, ominous badlands of the Mohave without a soul or structure in sight; then, for a while, it runs along the railroad and dips at all the railway underpasses so you can just nearly jump across the dips at ninety-five, but not quite. The traffic you pass on this road is mostly limousines with black drivers ferrying high rollers back and forth between Palm Springs and Las Vegas, or making coke runs. You come to Twentynine Palms first

and a lot of drunken military people, then you arrive in Palm Springs, where they have a gay casino and tables where Queens keep coming up. Frank Sinatra's old house is the town's architectural wonder. According to my late friend George Sidney, who produced *Viva Las Vegas* and retired in Las Vegas, Sinatra, Edward G. Robinson, and Vincent Price used to pop Desoxyn pills and paint all night in Sinatra's upstairs studio, which was lined with glass windows overlooking the desert. Sidney could never understand their obsession. He thought it was artsy. Back in the fifties when Sidney was producing all his great musicals like *Annie Get Your Gun*, *Showboat*, and *Pal Joey*, George would just call props, order a Vuillard, and right away, they would send him a painting that looked very much like a Vuillard. Steve Wynn owns a lot of Sinatra's paintings from this period, and my wife, as his curator, had the job of placing them. She put them in the dealers' lounge at first and immediately received an urgent call telling her to remove them lest they be destroyed. Sinatra was the only gambler in Steve's casinos who was allowed to cheat, short-tip, and act like an asshole. The dealers hated him and they were not alone. Libby moved the paintings to the soft count room, where they count paper money and where she discovered a very nice Warhol leaning against the diamond-wire screen. It had been offered as payment for a gambling debt. In Palm Springs, I dropped by to see Michael Childers and buy a print of Michael's wonderful photograph of David Hockney in tweeds and black-rimmed glasses floating on an inflated raft in the middle of a swimming pool. Michael is an old-school, high-end Hollywood shutterbug. He was the late John Schlesinger's longtime companion, and in his day he taught us what Natalie Wood and Rock Hudson looked like, so I looked at some cool Hollywood photographs—a great one of Lily Tomlin looking demure and dykey. Then I headed over to Jim Isermann's restored steel prefab to talk to him about designing the façade for the biennial I was designing in Santa Fe, confident that Jim is the most reliable artist in America. If I were still in my speed freak mode, I would have headed south on Route

86 to the desert below the Salton Sea, down around Westmoreland and Calipatria, and out to Slab City—"The Last Free City." What Detroit is to cars, this country is to methedrine, but I resisted temptation, which I rarely do, and headed home to Vegas through the Mohave.

I have driven parts of this route numerous times, and all of it twice. My friend Katie Arnoldi, the novelist, is a desert driver too, and we're always pouring over maps to design alternate drives through dry country that, barring the tiny human infestations, is pure wilderness, conducive to playing Elliott Carter CDs and swimming in deep cultural memory. Driving back through the Mohave, I should note, is one of the several places on this drive where you start feeling crazy. It's like a film running backward. You drive through a palpable atmosphere, since the desert reflects light back upward to illuminate the particulate atmosphere of dust, and so the atmosphere is lighted from above and below and comes to life as positive, dimensional emptiness. The same thing happens when you're surfing, but driving isn't surfing. I have always done this ride for communion with the original Silk Road, to touch the filigree of pathways taken by those voracious adventurers through vast stretches of wretched nothingness punctuated by oases and dazzling attractions. The Silk Road and Captain Cook's voyages have been my obsession since childhood, and the Silk Road, of course, is where we all come from. It was the primal artery of the society in which we dwell today. No Silk Road, no Venice; no Venice, nothing much of Western civilization. The drive I take is about three thousand miles long all told, with detours and cutbacks. It is way shorter and safer than the four-thousand-mile Silk Road that began in Xi'an and concluded at the docks in Constantinople with layovers in Samarkand, Bukhara, Herat, Bagdad, and other lost caliphates that were once filled with poets and craftsmen.

My trip is bereft of camels, but caravans of trucks and semideserted truck stops populate its wastes. In the truck stops silent truck-

ers sip black coffee. They are adepts of solitude—the camel drivers of
the modern age—moving things from here to there. Unlike most of
my fellow travelers, this drive has nothing to do with America, art,
pioneers, militias, or the Sierra Club. It has everything to do with the
creation of global society by the arduous blending of here and there
and all the alien cultural flotsam adrift between them. The Asian Silk
Road was a wholly pagan endeavor, fraught with danger, driven by

ambition and testosterone.

The comedian Bill Maher imagines one of Columbus's spiritual
friends at court advising him to give up his dream of America, to
forgo the dangers of the wild ocean in favor of an "inner journey."
That would be pure Santa Fe, but, like Columbus, the tough traders,
horseback soldiers, and camel drivers took the trip outward on the
Silk Road, transporting silks, jewels, goldwork, and Persian carpets
through four or five desolate versions of hell. They pushed at the
desert, and I envy the stoic courage of that push. They drove them-
selves on, while dying of sensory deprivation, swooning at the formal
magic of the landscape, sipping tea, and hungry for some exquisite
respite from exquisite nothingness in the magic cities of the des-
ert with their sparkling fountains, curving palms, tiled courtyards,
beautiful women, and elegant poetry. In these oases, the travelers'
hunger was sated.

As I drive, it's easy to imagine, if not to experience, the tenacity
and toughness of this push, since most of the landscape through
which I drive differs from the wastelands of the Gobi only in its
longitude. All the great deserts north of the equator lie along 30°
north latitude. Below the equator, they circle the world at 30° south
latitude. Ride out on the Pampas or into the wilds of Numidia; bet-
ter still, fly from Brisbane to Adelaide in South Australia and look
down into hell. This is why Bob Rauschenberg swore to live as much
of his life as he could "between the thirties" barricaded by deserts
from the ice and snow. These deserts are all the same place, give or
take a few camels, a cactus, and a kangaroo. The ocean is the ocean.
The desert is the desert. Ninety-nine percent of it has never felt the

pressure of a human footprint. In this era, there is nothing but rocks and dirt.

Soon I am back in Las Vegas, where I find myself in Steve Wynn's office on the ground floor of the Mirage Casino and Resort. It is a large rectangular room with long plate-glass walls with clear corners on three of its sides. It is surrounded by a garden of palms, exotic succulents, and decorative cacti. My wife, Libby, is Steve's curator. (Julia Roberts plays her in *Ocean's Eleven*, although not to Libby's satisfaction. I mean, those shoes!) I'm just there for the art. There is a beautiful midsized Jackson Pollock hanging in front of the west window. Across from me, Giacometti's life-sized *Man Pointing* is walking and pointing. On the couch beside the Giacometti, the golfer Nancy Lopez is just there for the fun. On a large round table in the center of the office, an exquisite grayish Cézanne portrait of a seated woman is lying faceup. My friend Richard Schiff is bending over Cézanne's canvas examining every inch of its surface with a magnifying glass. Richard is a Cézanne wonk and a top of the line contemporary critic.

Steve is sitting behind his long desk against the eastern glass wall. He is talking to all of us individually and as a group. He is quizzing Libby about the proper frame, asking me about Steve Martin's Lichtenstein and whether he should buy it or not. (Yes, he should, say I, and keep the frame.) He is quizzing Richard about the Cézanne. Is it a great one? What would be Richard's ballpark price? What about the blur on the woman's face? Is there any visible damage or restoration? Richard answers only the last two questions, but Steve is moving on, trying to get Bill Clinton on the phone about a golfing date with Nancy Lopez. Libby is paying very close attention to the painting's condition. Nancy is enjoying the whole energetic spectacle. I am talking to Richard. I am also trying to imagine a collection of more disparate and talented people among greater works of art in a gaudier room anywhere else in the world. The aura is oddly intoxicating. It's like a scene from a Mughal palace at the

height of the empire, which was founded, aptly enough, by descendants of Genghis Khan—who were the Bugsy Siegel's of their era. I mean, here we are in Steve's office with all this great art, strange people, and exotic skill sets, and there is a Cézanne just lying there on a table—a fucking Cézanne! For this and other reasons the desert West is always more desert than American for me—more brute blandness to make the Edens sweeter. More black blackness to make the sunshine brighter. As I stand there, I feel smooth and clean after my trip, like a desert ruin sandblasted and nearly civilized.

The Last Mouseketeer

It's my third morning in Mr. Disney's world, deep in the heart of cracker Eden, out on the plain of the wet palmetto, and I have seen the Mouse. I have seen the children playing with the Mouse in the speckled shade of an acacia tree. I have wandered through the silver effervescence of their squeals, peals, gurgles, and giggles and found it a pleasant place to be. I have also seen bikers and their bitches, decked out in boots and leathers, borne aloft with giddiness at having their picture taken with Goofy. I have seen antique-store queens from the serious South posing ceremoniously with Chip 'n Dale, and seeing all these things, I could only wonder if, in this hateful moment, Disney World just might be the happiest place on earth.

At this, my inner child threatened to split for Las Vegas, and, properly chastened, I set off in search of Scrooge McDuck and the ride where you swim through the money. I couldn't find it. I decided that this attraction, should it exist, was almost certainly tucked away on the corporate campus out in the San Fernando Valley. I imagined buff Disney execs in Speedos doing dolphin rolls in cash while Minnie waited patiently at poolside, towel spread and at the ready, . . . but not for me. I just rode things, because at Disney World you ride. You ride to get there. You ride to relax between adventures, and you ride to crank it back up so you can ride again. For two days I have been stepping aside so children, stumbling with exhaustion, can flop themselves down on to rides, only to bounce off when the ride is over, wired up like five-dollar mandolins. I have ridden cars, vans, buses, trams, barges, escalators, people movers, and monorails. I rode two miniature choo-choo trains, a whirling teacup, a horse-drawn trolley, a riverboat, a tiny car, and a world-class carousel for which I had to

get up my nerve because it's embarrassing to sit astride a tiny wooden horse slowly rising and falling in a dead heat with six-year-olds. I rode anyway, because I wanted to survey the hundreds of factory-gray baby strollers gathered around the whirling ponies like industrial salvage around a gaudy atoll.

I also rode gondolas—one through outer space, another through a geodesic sphere within which the history of all mankind is twined up like a cow's intestine. I rode one gondola through a haunted house with really cool holographic dancing ghosts and another through a Caribbean-pirate lair that would have benefited from an animatronic Johnny Depp playing Keith Richards. I did not ride the flying Dumbos or the Magic Carpets of Aladdin, because they were down for magic upgrades. The fleeting image of my cardiologist with his wrist to his forehead dissuaded me from the Tower of Terror, within which one falls thirteen floors in a giant elevator, and from Mission: Space, during which one pulls major Gs while spinning in a centrifuge. I did, however, damn the doctors and board a giant log for a G-rated trip through Deliverance Land. I floated along through Southern flora and fauna, zoomed erratically through a twisting sluice, shot out over a waterfall, and plummeted five stories into a pond. I screamed (I think), got wet, got geeked up, and wished I had waited until after Splash Mountain for that cup of corn-dog nuggets.

Then, last night, having ridden well, as one does if one is truly at Disney World, I felt prepared for the high rituals of the Magic Kingdom. With a flock of fellow pilgrims, I made my way through a hot-pink tropical twilight to the nave of Main Street, USA, the primal site. To my left, at the narthex, new members of the congregation poured in through a period train station. To my right, where the county courthouse would have been, if this had really been Missouri, the altar of haute Disney silliness rose in ecstasy: the soaring French Gothic extravagance of Cinderella Castle, bathed in colored light. Taken as a unit, the street, the station, and the castle constitute one of the strangest juxtapositions of cultural iconography on earth. I wondered what possible relationship might pertain between Mark

Twain's quotidian hamlet and the Gothic excess of that fairy-tale castle. The answer was crowding all around me munching hot dogs. Every one of those wistful dads and disheveled moms had once, as rowdy Tom Sawyers and spoiled Princess brats, plighted their troth across the unbridgeable abyss that separates small-town dreams and castle dreams. After that, the fishing was never as good or the parties as elegant and gay.

As a kid, living my Huck Finn childhood amid Princess-crazed young women, I often wondered where one might possibly go to become a Prince—knowing in my heart there was no such place. Now I wanted the courthouse back where it belonged, and right away. Better laws than magic, I thought, and better taxes than sorcery, too. But here I was. The air was balmy, the castle was pretty cool to look at, and my fellow visitors, though damned to their marriages, were uniformly benign. Like all the crowds at Disney World, this one was hyper but nice. If Lourdes were a theme park, the crowd would be like this, because all the pilgrims were doing their part and on their best behavior. Adults wore Disney caps and T-shirts. They carried Disney bags. Little boys wore mouse ears, some, clearly, souvenirs of previous visits. Little girls came dressed as Princesses in sea-green taffeta and net. One little Princess even wore a hennin and wimple, fetchingly askew.

So I stood there in this aura of provisional togetherness and, just for a moment, glimpsed the outlines of Michael Eisner's folly. He must have thought he had been hired to run a money machine, a public corporation straightforwardly dedicated to seducing children and manipulating even-tempered crowds. On his first visit to Disney World, he probably noticed what I noticed, that details and amenities are not nearly as critical when you can depend on the genial complicity of your customers. After three days in Disney World, however, it was clear to me that the crowds did not regard Disney as a public corporation. They regarded it as a *civic* corporation, and they were willing to entertain themselves only because they had come for something more than entertainment—for some cultural affirmation,

some flickering sparklet of residual optimism, some dazzling generosity of spirit. And how do you imagine that? Walt Disney knew how, but lacking his clairvoyant simpatico, Eisner must have lived each day with the terrible certainty that, whatever he was selling, his customers were buying something else. They were buying Walt's something more, his sweet, techno-snazzy future, and that future was vanishing like the dew.

Out on Main Street, USA, however, we were still buying it all. We smiled our stupid smiles and waited for our something more. Then, when the sky had darkened to a luminous bruise, the amplified strains of Bach's Toccata and Fugue in D Minor rose up like a great tsunami. The parade appeared and began its slow procession down Main Street. Hundreds of thousands of tiny lights twinkled. Miles of fiber-optic strands glowed mysteriously. Floats glided past, right in our faces—big, bright, and noisy—each more impossibly ornate than the one before. The Mouse came first, in his purple sorcerer's cape, poised before a dazzling half shell, suspended in a sparkling atmosphere of high-tech confetti lights. Then the genie from *Aladdin* floated by, conducting an orchestra that played brightly colored musical notes. Then the Three Good Fairies from Sleeping Beauty's garden turned night into day. Then Chernabog, the gargoyle from *Fantasia*, flexed his thirty-eight-foot wingspan and frightened the kids into helpless giggles. Then Practical Pig (of the Three Little) made his grand appearance on a hundred-foot-plus island replete with its own castle, its own carousel, and a fancy jeweled coach.

Herr Pig stood contrapposto before a large crowd of Disney characters with a paintbrush in his trotter. He flicked his brush. The characters changed colors. Then, and then, and, ultimately, they all were there: Alice and Ariel, Bacchus and Bashful, the Big Bad Wolf and Ol' Br'er Bear, Pinocchio and Geppetto, Captain Hook and Peter Pan, Goofy, Grumpy, Jiminy, King Triton, and the famous Ostrich Dancers. All these and more, and the whole scene—the brilliant floats wending through the darkened crowd—was very beautiful. It was also exquisitely poignant watching the parade arise out of darkness to light

up people's faces and then dissolve back into infinite night. It was an American moment, like Gatsby sharing his beautiful shirts with Nick and Daisy, like Jack Kerouac going "Aaah!" at the fireworks, and, somehow, the spectacle partook of everything like it. It was a Roman triumph without the chained captives, a masque at Versailles but more jovial and robust, a mini–Mardi Gras with more lights, fewer wardrobe malfunctions, and no puking at all, a saint's-day parade in some futuristic Italian principality with vast technological resources.

When the parade had passed, I dodged in for more corn-dog nuggets and returned to watch the tangled train of lights and music wind its way through the black trees at the foot of Main Street. I thought about everything it was and wasn't, the cornucopia of image, illusion, and icon, and realized, very much to my delight, that Disney is a freaking pagan *cult*, that this goody-two-shoes American institution is promoting a primitive, animist religion dedicated to investing everything with life, to animating everything—from teacups to trees, from carpets to houses, from ducks to mice—with the pulse of human aspiration. In my innocence, I had always thought of Disney as the "bright side"—of Mickey and Donald spreading light, as opposed to Bugs and Daffy sowing darkness and chaos. I thought of them paired and opposed like that, like the Beatles and the Stones, like Berry Gordy and George Clinton, the Colts and the Raiders. Now I had a better, somewhat darker, mildly revolutionary package.

I had roistering Mickey, Donald, Bugs, and Daffy flourishing in gaudy pagan opposition to the ideals of Puritan America. Admittedly, Disney paganism isn't quite your old-school, sacrifice-the-pony-and-pour-the-blood paganism. It's more *about* paganism and the longing for it, less like the cult of Moloch and more like those Melanesian cargo cults that flourished in the Pacific after World War II. The members of those cults believed that the future would wash up on the beach or parachute from the sky in the form of shipping crates stuffed with magically wrought clothing, weapons, and canned goods. The islanders had seen such cargo in the control of Westerners, and when the Westerners departed, the islanders devised idols and rituals of

sympathetic magic to tease the cargo back from the air and sea—to create the new age. They carved headphones of wood and wore them while sitting in control towers. They stitched up uniforms and stood on abandoned runways waving landing signals. They built life-sized mock-ups of airplanes out of straw, wished upon stars, and waited.

Everything I had just seen resonated with these cargo rituals. Every chunk of arcane cargo, ardent magic, and pantheistic bric-a-brac that ever washed up on the shores of the New World from the Old had been evoked that night. Every dazzling, idolatrous image that had ever been smuggled ashore, only to be suppressed by Puritan iconoclasts, had been invited back to adorn a new cosmos, to celebrate the restoration of a lost magical world presently in the sole possession of children. That was the idea. The kids already knew. The adults, with kids as their passports, could be born again into the cult, and Disney was getting away with this outrageous activity, I decided, because if you suppress explicit sexuality, you can get away with anything in America, even if the sexuality is only suppressed, even if every luminous, skintight, cuddly, curvy, shiny surface is redolent of eros. This romantic conceit—that I was witnessing a pagan ritual in a Florida swamp—sexed up my assignment a lot. I felt like Boy in one of those Tarzan movies, creeping into a torch-lit cave full of spear-waving Africans chanting crazily at some Mesoamerican idol overseen by a wild-eyed swami in a turban.

So I was up for the second half of my "evening of enchantment." I had been promised that it would "sparkle with faith, hope, and pixie dust," and no sooner had the parade disappeared than another musical fanfare erupted. An amplified child intoned:

> Star light, star bright,
> First star I see tonight,
> I wish I may, I wish I might,
> Have the wish I wish tonight.
> We'll make a wish and do as dreamers do
> And all our wishes will come true.

On the words "will come true" the orchestra burst into "When You Wish Upon a Star," leaving us no time to contemplate this dubious "wishing" proposition. Instead, a massive starburst exploded over our heads with a shuddering crunch. It hit a musical accent, and the recorded chorus went "Aaah!" just like Jack Kerouac, and we were off into an extravagant *son et lumière*, with fireworks providing a lot of the *son* and most of the *lumière*. Jiminy Cricket (that Sammy Davis Jr. of the insect world) was our master of ceremonies. The Blue Fairy did color. Tinker Bell slid on a wire from the top spire of Cinderella Castle. Music played, things exploded, and the ground shook, all in a passionate, twelve-minute defense of wishing on stars and putting your heart into your dreams—or augury and shamanistic trance, if you want to be technical.

At one point, toward the end, the Cricket assured us that our wishes could come true if we believed in them *with all our hearts.* "And the best part is," he announced, pausing for effect, *"you'll* never *run out of wishes!"* Clearly, Jiminy and I had known some of the same women . . . And when it was over? Well, what can I say, we all just stood there in shock and awe, absolutely convinced that if any of this crap were true, it shouldn't need to be defended so vigorously. Then the kids started shuffling and yawning. Their folks took them off somewhere to pee. I buttoned my jacket against the chill and set off through the darkness, heading over to Shula's for a steak.

This morning, I'm lounging on the boardwalk in back of my ersatz Nantucket hotel, watching the mist burn off the artificial lake. Gulls are skimming lines across its placid surface. In about twenty minutes, a barge will arrive from Epcot and chug me across the water to indulge my new jones for animatronics—this time with Ben Franklin and Mark Twain—but for now I am happy to be alone, smoking a surreptitious cigarette. My reverie, of course, is immediately interrupted by thudding footsteps on the boardwalk. I turn to see a blonde girl running toward me, as slim as a reed, maybe ten or eleven, wearing a blue-striped cotton pullover, white clamdigger pants, and Top-Siders. At first, I think she's running for the barge,

but there is no barge in sight, and having flown by me in a blur, the girl pulls up short at the head of the dock.

She extracts a quarter from her pocket and inserts it into a tastefully camouflaged dispenser. She turns the crank and the machine dispenses a handful of brown pellets. Clutching them in her fist, the girl takes three running strides out on to the dock and throws a pellet into the air. A swooping gull, whipping past her head, snatches it. She throws another pellet and then another, and in a blink the girl is engulfed in a swirling cloud of seagulls, like Saint Teresa among the angels. The gulls dip and wheel, their white wings flashing in the sun. As the girl twirls happily, her hair flies out. The scene is amazing and very American, exciting and a little touching, with the girl bouncing and smiling and the gulls' wings exploding around her like brushstrokes in a summer painting by Alex Katz.

When the pellets are gone, the gulls hover for a moment, then quickly disperse. The girl dashes off again, back past me, down the boardwalk, to cadge another quarter from her dad. I would have gladly given the kid a quarter, if we could still give quarters to other people's children, but we can't, so I take the image of the girl and the gulls as a little gift that is no less authentic (and even a little more resonant) for having been enacted on this bogus New England movie set. I wonder, though, if there is a food chain of ecstasy in Disney theology. I wonder if tonight in Los Angeles, at an outside table at the Ivy, some perfumed executive on a totally heterosexual man date will feel commensurate rapture at having suckered a ten-year-old into paying a quarter for a penny's worth of pet food that the corporation is writing off anyway against an EPA reg about the proper feeding of seagulls.

I hope this is true, that the magic rises up through the culture, but the thought is just diversion. The issue at hand is that, once again, I have been looking at someone else's child, and how do you do that these days? I have never looked at children much, but I am at Disney World, surrounded by children, in the midst of folks who pump them out like gumballs, so I should look, right? Two days before, I had no

sooner stepped into the Magic Kingdom than a kid scampered past my knee and fell flat on his face in front of me. I scooped him up, set him back on his feet, and said something red-state like "There ya go, soldier." His parents were instantaneously there, eyes blazing. The kid's little sister looked terrified. Her eyes widened. She thrust her hand in her mouth. There was a terrible moment of glaring, a pause, then Dad grabbed the kid by the arm, and the family stalked off like angry zombies. I knew that I could easily be marched away in plastic cuffs to the Disney pokey, so I promised myself that, henceforth, I would interact only with svelte soccer moms. Unfortunately, there was only one. We complained to each other about where in the hell are the goddamn Starbucks, and that was it, so to avoid looking at the children I looked at people looking at the children.

I noticed grannies on benches smiling their looking-at-the-grandkids smiles. I practiced that smile as I wandered over to Toontown, where I noticed a guy leaning against a stanchion between Minnie's house and Mickey's. He was dressed like a dad in a ball cap and a Mickey sweatshirt, but this guy was nobody's daddy. Dad's eyes would have been glazed over by the time he reached Toontown. This guy, feigning nonchalance, was hypervigilant, cruising, like a goombah in a South Beach disco, holding his head steady and tracking kids with his eyes. It took him thirty seconds to sense me watching him. He pushed off from his pole, and I tried to follow, but he disappeared like smoke, and now the little creep had ruined my day. I felt guilty. Children were nifty little creatures that I had casually ignored my whole life because I had not enjoyed being one. Now nobody was paying any attention to them but Mom, Dad, Granny, Disney, and the circling chicken hawks.

So I willfully paid attention to the kids because I thought that someone disinterested should and because they were really kind of super, like brave little Disney characters on their way to being people. But it never stopped being scary. That night, riding back to the hotel on a dark bus, I sat across from a family. Dad sat up straight, staring into the gloom with his arms around his two sleeping daughters. The

girls were snuggled up and leaning into him. Their little brother, with his feet pulled up onto the seat, was resting his head in his older sister's lap. They formed a delicate, grisaille tableau in the half-light, a human group in repose of the sort made famous in Victorian paintings by Lord Leighton, Burne-Jones, and Alma-Tadema. It wasn't *Guernica*, of course, but it was the sort of thing one is always happy to see, so I looked while the darkness hid my gaze.

George W. Bush was the best. The audience at the morning show in the Hall of Presidents all agreed. So, it wasn't just me. It was also the two Latino dudes in yellow do-rags and Buccaneer jerseys. We were the audience. I had come for the educational uplift. The Buccaneers had come because they were getting their freaking money's worth—Disney security is so great, they had had to pay to get in. A music video about the Constitution opened the show. Its broad generational appeal was followed by a softly lit tête-à-tête with a coterie of animatronic American presidents arranged before us, standing and seated, like a corporate management team. Each "president" was introduced to us. Each favored us with a few animatronic words. Then the avatar of our current president stepped up to the plate and delivered a short homily that, I swear, the man might have written himself. One of the Buccaneers said, "That's the dude," and we all nodded in agreement. Of all the animatronic presidents, statesmen, heroes, and ordinary Joes we had seen, Dubya was the best. The oft-cited defects of animatronic technology, the fact that it makes characters seem stiff and only intermittently lifelike, were no problem. Dubya was born to the medium, and I was bewitched by the idea that presidents might evolve into animatrons rather than the other way around.

Much earlier that morning, the barge was late, so when I got to Epcot, I had to run to the Georgian building that houses "The American Adventure." I arrived puffing just as they were closing the doors. Between gasps, I told the girl that I was a journalist on deadline. She let me in on the chance that Ben Franklin or Mark Twain might say something newsworthy that morning. I crept into the dim hall and found a seat just as Ben and Mark began their conversation. They

provided us with avuncular deep background but no hard news, so I relaxed and looked around. With the exception of Ben and Mark, I was the only white person in the room. Everyone else was black and nicely dressed, and even I could divine a hook in this. Latino Buccaneers in the Hall of Presidents. Middle-class black people in "The American Adventure." It could be happenstance, but I had two ideas. Either these Latinos and blacks were the only people in the park who felt a vested interest in the principles of the waning Republic, or, less optimistically, they were the only folks at Disney for whom a bunch of robotic white guys in corporate clothing qualified as an exotic attraction. I left the jury out on this. Ben and Mark chatted while seeming to buzz, whine, and whir.

I fell in love with animatronics on my first day in the Magic Kingdom, over in Tomorrowland, at the Carousel of Progress, which was my favorite thing in the park. It reminded me of my grandmother who, having ridden from Georgia to Texas in a covered wagon, regarded herself as a major beneficiary of "progress" in the area of cooking things, carrying things, and getting places. The carousel is housed in a white drum-shaped building adorned with a retro logo of three large overlapping pastel gears. (That's right: *gears!*) Within the drum, a large circular platform is divided like a pie into six theatrical stages facing outward. The platform rotates inside the drum with a lot of whining and grinding, and the stages present themselves in sequence to the audience in a small auditorium, each stage with its own animatronic American family. The idea was Walt's. According to the narrator, "He thought it would be fun to watch the American family go through the twentieth century experiencing all the new wonders as they came." So we do. The carousel turns from a family home in the 1900s to one in the '20s, to one in the '40s, and, finally, to a family room in something like the present, which is really just the '60s, upgraded to digital.

Nobody in my crowd seemed to notice the half-century interval between the '40s and yesterday. The animatronic family of white folks with their brown dog (with the animatronic tail) seemed pret-

ty damned happy with the way things were going. I was happy, too, because long ago, in response to my adolescent sneering at decadent progress, my grandmother had explained to me the downside of stepping furrows behind a mule, the mitigated pleasures of hand-baling hay, and the drudgery of hauling things. "Progress don't make us better," she said, ever the Methodist, "but it gives us time to contemplate what sorry creatures we are." Henceforth, I shut up about progress around my grandmother. Now I envied her easy presumption that the time progress bought us would be spent considering our moral equipoise. I walked out of the carousel feeling that this time had pretty much run out.

Everything was where it should be in Disney World except Walt's imagined future. The animatrons, like human dinosaurs, marked the moment when it died, when Disney stopped imagining a real future with real people and devoted itself exclusively to shilling fantasy. Tomorrowland now is Yesterday's Tomorrowland, since, in this moment, even a fancifully imagined future would involve the ayatollah of Indianapolis and high-rise hospices. Today, Tomorrowland is just another future that never happened, where the Jetsons live, where the Yellow Submarine plows the deep, and where we all have automatic butlers. The wacky aspiration of the animatrons and the residue of optimistic innocence make the place a dog whistle for schadenfreude, and you can't blame Walt for this. Walt thought he was building the City of Tomorrow. His descendants built a prissy, pasty, retro slum called Celebration, which, if Kool & the Gang hadn't written the city song, would have naught to recommend it. Walt thought we were going off to the planets and the stars. It turned out we were only going offshore, off the books, and off the balance sheet. Walt thought it was one small world. It turned out to be an ever-expanding, ever-tightening grid of morally isolating niche markets. So Walt was wrong. So we got perp walks in lieu of moonwalks. So sue him.

The dance clubs at Disney World are all on Pleasure Island, where every night is New Year's Eve for wayward Pinocchios and Pinocchi-

ettes. On Thursday nights, Disney "cast members" get in free to Plea-
sure Island, and this Thursday night, my last at Disney World, they all
seem to have gotten in. In a dance club called Mannequins, I thought
I saw Alice, from Wonderland, who earlier that day, wearing her blue
pinafore, had waved as I passed on the choo-choo. Tonight, she was
a Goth hottie, trailing scarves and swooning on the arm of a black-
haired woman in very tight jeans. In the crowd at the bar, I recognized
one of the bellmen from the hotel. I gave him a look that said, "Wow,
what a relief to be here," and shouting over the music, he assured
me that Pleasure Island was the safety valve that kept "the world"
from exploding, and that Mannequins was the safety valve that kept
Pleasure Island from exploding. I nodded toward the rotating dance
floor and said, "Neato!" The bellman cupped one hand around his
mouth, shouted, "Lazy Susan for lazy cruisin'," and was swept away
into the crowd.

Bob and Doris, carrying Disney bags and wearing floral patterns,
struggled past me with blurry looks on their faces. I wondered if they
knew they were in a techno-chick gay bar? I doubted it. They seemed
so stunned by the lights and noise that the same-sex smooching
didn't make a dent, nor did the fabulosity, which was a little dated, a
little Mudd Club, and a little more desperate than your standard dis-
co desperation. I, at least, for once, knew what was going on. People
were dancing and trying to get laid, so I drifted around with a tonic
water sorting out constituencies. There were the tourists, of course,
with bags on their laps. There were the dancers and actors from New
York and Los Angeles, who, years ago, in a moment of abject insanity
had taken a gig in Orlando, only to discover that once in "the world,"
down in the swamp, a million miles from everything, it was almost
impossible to get out. Then there were the gay kids from the haunted
boondocks, escapees from wide places in the road with a Circle K and
a video store, and they were in heaven, the happiest people in Mr.
Disney's world. When the New Year struck and the sirens went off
and the confetti flew, they all kissed one another. The tourists smiled
as if it were part of the show.

Norman Rockwell, *After the Prom*, 1957. Oil on canvas, 31 × 29 in. Cover illustration for the *Saturday Evening Post*, May 25, 1957. Printed by permission of the Norman Rockwell Family Agency. Copyright ©1957, the Norman Rockwell Family Entities.

After the Prom

The icons of a living culture do not begin as canonical works preserved in books and museums and taught in university classrooms. They begin as treasures of living memory, and when official canonization is not forthcoming, they either fade from that memory or remain and survive there, as Norman Rockwell's *After the Prom* has remained and survived in mine. I remember its appearance on the cover of the *Saturday Evening Post* on May 25, 1957 (when I was as young as its protagonists). Reconsidering it now, I find myself hard-pressed to come up with a better example of Rockwell's penchant for giving us, as John Updike puts it, "a little more than the occasion strictly demands." With *After the Prom*, Rockwell has given us a great deal more than the occasion demands: a full-fledged, intricately constructed, deeply knowledgeable work that recruits the total resources of European narrative picture-making to tell the tiny tale of agape he has chosen to portray—all this for the cover of a weekly periodical whose pages will curl and melt before we have forgotten Rockwell's image.

The Post version of *After the Prom* is a reproduction of a painting done in oil pigments on an easel-size, rectangular canvas that is about 13 percent taller than it is wide. In the narrative of the painting, Rockwell has positioned us so we are at once inside and outside the story. We have just entered a small drugstore in an American town on a spring evening and now stand facing a 1930s-era soda fountain bathed in golden light and populated by local citizens in 1950s-era clothing. A soda jerk is on duty behind the counter. In the right center of the picture, a blonde girl in a white formal dress and a brown-haired boy in a white dinner jacket and dark slacks sit facing each other on counter stools so that we see them in profile.

The boy perches on his stool in an erect posture, holding the girl's purse and gloves before him, with her pale-pink sweater draped across his forearm. He looks on proudly as the soda jerk leans across the counter to inhale the fragrance of the girl's gardenia corsage. She lifts the flowers from her shoulder to present them to him. The third customer at the counter (partially cropped by the left edge of the picture) sits on a stool with his back to us, holding a cup of coffee in his right hand. He glances over and smiles as the soda jerk sniffs the gardenia. A workingman and almost certainly a war veteran, he wears a tattered bomber jacket, an air force cap with a visor, and khaki pants.

The small-town consanguinity of the group is emphasized by the fact that all four figures in the painting bear a vague resemblance to one another. The boy and the soda jerk, who have the same nose, chin, and eyebrows, are almost certainly brothers. Everyone in the picture is smiling the same small smile, and we, as beholders, both inside and outside this cozy scene, are invited to smile as well. We are inside the store but not up at the counter. Even so, the open picture plane still welcomes us. It implies that, even though it is best to be a part of the community, just being a part of the society is not so bad, because even though we cannot smell the gardenia, we can inhale the atmosphere of the benign tableau arranged around it. The clustered burst of white in the center of Rockwell's painting constitutes our gardenia; we stand in the same relationship to that white blossom of tactile paint as the soda jerk does to the girl's corsage.

To compose this scene, Rockwell has divided the vertical rectangle of his picture in the traditional European manner, by laying the short side of the rectangle off against its long side, creating two overlapping squares whose intersecting diagonals create the picture's armature. The bottom line of the upper square runs along the tile line at the base of the stools; the top line of the lower square runs exactly through the boy's sight line (marking one of the horizon lines in the bent space of the painting). The whole action of the picture occurs within the overlapping area of the two squares—at, or just below, our eye level. The counter, the kick rail, and the floor tile create a harmon-

ic sequence of strong horizontals that intersect the regular verticals of the stools, the wood paneling, and the signs on the wall behind the counter. This in turn creates an architectural grid into which the human figures are arranged in an intricate pattern of rhyming angles.

The front edge of the girl's dress, her upper arm, and the soda jerk's extended left forearm all lie on left-slanting 45-degree angles. The veteran's lower leg and the boy's upper leg lie on right-slanting 45-degree angles that reinforce the right-slanting 45-degree sight line of the soda jerk as he gazes at the gardenia. The boy's upper leg intersects the front of the girl's dress at a right angle just above the horizontal center line of the painting; this creates an inverted triangle that cradles the intimate action of the picture. The upper leg of the veteran and the boy's lower leg lie exactly on a falling 30-degree line that traverses the picture, so their bent legs create two symmetrically opposed 70-degree angles, like arrows, pointing to the girl, who is the center of all their attention. The pencil behind the soda jerk's ear—also on a 30-degree angle—points out the girl as well.

In his most elegant formal maneuver, Rockwell takes the right-pointing triangle created by the workingman's bent leg and the left edge of the canvas and rotates it 90 degrees to the right so it reappears as the upward-pointing triangle created by the soda jerk's bent left arm and the top of the counter. In this way, Rockwell invests the static, symmetrical encounter between the boy and the girl with dynamic balance by shifting its center of gravity about 15 percent upward and to the right, as indicated by the direction of the pointing triangles, to a point marked by the inverted triangle that cradles the central action. This device, combined with his cropping of the counter on the left and right, creates a picture that, although harmonious and delicately balanced within itself, does not feel self-enclosed or claustrophobic. It still opens out; it still includes us.

To achieve this peculiar blend of inclusion and exclusion, Rockwell employs a pictorial strategy invented in late eighteenth-century France and subtly alters it to his own purposes. As Michael Fried points out in *Absorption and Theatricality: Painting and Beholder; The*

Age of Diderot (1980), one of the idiosyncratic inventions of the period was the practice of inserting a surrogate beholder into narrative pictures—a character whose response to the action we may take as a cue and through whose eyes we are presumed to see the scene portrayed in its optimum configuration. This device is employed as a naughty joke in Jean-Honoré Fragonard's *The Swing*, where the surrogate beholder has a revealing view of the young lady in the swing that is not available to us. In Jacques-Louis David's *Belisarius Receiving Alms*, we see Justinian's great general, unfairly disgraced and blinded by the emperor, reduced to begging in the street. One of Belisarius's soldiers stands in the background, facing us, witnessing the scene we see from the opposite side. His horror and alarm cue our own responses, and his presence renders the action of the painting self-enclosed, as if we were seeing this drama from outside the moment and behind the proscenium.

In *After the Prom*, the soda jerk is our surrogate beholder (or inhaler, in this case). His response is clearly a cue to our own, but with a difference. Eighteenth-century paintings of this sort, such as Jean-Baptiste Simeon Chardin's *House of Cards* or Fragonard's *Young Woman Reading*, insist on the privacy of the experience—of a young man building his house of cards or a young woman engrossed in her romantic novel. By extension, the private experience of absorbed beholder inside the painting is presumed to be analogous to that of the absorbed beholder outside the painting; both are presumed to be engaged in internal activities outside the realm of the social. In *After the Prom*, however, the soda jerk is not alone. He is himself beheld by the three other figures in the painting. He inhales the fragrance of the gardenia that is symbolic of young love, and he visibly responds; the other figures in the painting respond to his responses, and to one another. We respond to the totality of these responses, but we are not alone either. We are joined by the many citizens glancing at their weekly issue of the *Saturday Evening Post*.

The innocent relationship between the two young people, then, is less the subject of than the occasion for Rockwell's picture. The

generosity of the characters' responses, and of our own, is the painting's true, argumentative moral subject, and this was especially true in 1957, when Rockwell's prescient visual argument that "the kids are all right" was far from de rigueur. Having been a kid in 1957, I can testify to the welcome reassurance of Rockwell's benediction. It was exactly what was needed because, even though we all remember that America's children rebelled against their parents in the 1960s, we tend to forget that American parents rebelled against their own children in the 1950s—that in the midst of the postwar boom they began to regard their offspring as spoiled, hedonistic delinquents who had not fought World War II or suffered through the Great Depression and were now reaping the unearned benefits of their parents' struggle. This attitude is the target of the reproach implied by the veteran's response. His benign smile seems to say: "This is what I was fighting for—this is the true consequence of that great historical cataclysm, this moment with the kids and the gardenia corsage."

Rockwell's picture, then, opposes the comfortable, suspicious pessimism of the 1950s and proposes, in its place, a tolerance for and faith in the young as the ground-level condition of democracy. And, strangely enough, this is probably the single aspect of Rockwell's work that distinguishes him as a peculiarly American artist. In all other aspects, Rockwell was a profoundly European painter of the bourgeois social world in an American tradition that has almost no social painters and very few paintings that portray groups of people at all, except at ceremonial occasions in faux democratic "history paintings" or as figures in a landscape. Rockwell painted mercantile society, in the tradition of Frans Hals, William Hogarth, Jean-Baptiste Greuze, Louis Léopold Boilly, and William Frith, but as an American he painted a society grounded not in the wisdom of its elders but in the promise of its youth.

This, I think, accounts for the perfect inversion of European convention in *After the Prom*. Rockwell was not painting a bucolic genre idyll, like one of François Boucher's romantic encounters of shepherd and shepherdess. He was investing this small-town flirtation with

the seriousness of historical romance. In a comparable European painting by Nicolas Poussin or Giovanni Battista Tiepolo, however, we would see earthbound adult lovers surrounded and celebrated by floating infants. In Rockwell's painting, we have floating youths surrounded and celebrated by earthbound adults. Thus, the two adults in *After the Prom* are invested with considerable weight. The soda jerk leans theatrically on the counter. The veteran sits heavily on his stool, leans against the counter, and rests his foot on the rail. The force of gravity is made further visible by the draped sweater on the boy's arm and the hanging keys on the veteran's belt, while the two young people, in their whiteness and brightness, float above the floor—in one of the most complex, achieved emblems of agape, tolerance, and youthful promise ever painted.

Even as *After the Prom* was being painted, however, the *Saturday Evening Post* was in the midst of phasing out the kinds of paintings that Norman Rockwell had created for its covers since 1916. These covers were justifiably famous and much beloved, but the times were a-changin', and in the rush of things, Rockwell's vignettes of everyday life quickly succumbed to the rising vogue for celebrity icons among American media providers. As a consequence, the last great poet of American childhood, the Jan Vermeer of this nation's domestic history, concluded his career as a glorified paparazzo. For more than forty years, Rockwell beguiled American citizens with generous and felicitous representations of themselves; he ended up painting pseudoheroic portraits of their public surrogates and illustrating moral platitudes.

Of the first 310 covers Rockwell painted for the *Saturday Evening Post* between May 1916 and September 1960, 306 portray ordinary Americans. Only 4 portray celebrities (Dwight Eisenhower, twice; Adlai Stevenson; and Bob Hope). Of the last 12 covers he painted, between October 1960 and December 1963, 7 portray celebrities, 3 of which are paintings of John F. Kennedy. Included among Rockwell's last "noncelebrity" covers is one of those egregious, moralizing Victorian tableaux (April 1, 1961) of the sort once commissioned from

the painter Lord Frederick Leighton: the "world's peoples" attired in ethnic regalia, across whom text implores us to "do unto others as you would have them do unto you."

Yet Norman Rockwell remains a sustaining presence in the public consciousness, a more important artist than his modernist and postmodernist detractors will ever acknowledge, and a more complex artist than his traditionalist defenders are likely to admit. His pictures were loved and respected not only by the American public but also by artistic spirits as dissimilar as Willem de Kooning and Andy Warhol. During the forty years since the zenith of Rockwell's career, the commercial illustrators with whom he competed for jobs have become historical footnotes—as have 99 percent of the modern artists whose work was presumed to be infinitely superior to his, as, in fact, has modernism itself.

During Rockwell's public vogue, popular narratives in all media were routinely compared to his way of looking at the world, and even today the vast preponderance of these narratives begin by evoking some version of his domestic universe, then place that cosmos in jeopardy through the machinations of criminals, bureaucrats, aliens, or asteroids. All of this suggests that the American vision Norman Rockwell invented and refined—which was supplanted by the rise of celebrity culture in the 1960s—was that which was new. In the history of art, Rockwell was the last, best practitioner of a tradition of social painting that began in the seventeenth century. In the history of America's democracy and popular culture, he was the first and maybe the last visual artist who aspired to charm us all, and for nearly half a century he managed to do it.

Viewed from this perspective, the last anecdotal vignette Rockwell painted for the cover of the *Saturday Evening Post* (November 3, 1962) seems ominously prophetic. In this painting, *Lunch Break with a Knight*, the night guard at the Higgins Armory Museum in Worcester, Massachusetts, sits in semidarkness on the edge of a pedestal upon which a knight in full armor, astride his festooned and armored charger, presents a lance that disappears out of the top of the picture, so

both horse and rider seem suspended from it, as if on a merry-go-round. The museum guard is tucked into the lower-right corner of the picture (the least dominant position in the rectangle). We hardly notice him at first, and when we do, it's clear that the little guy is tired and a bit bored. He sits there with an open napkin on his lap and pours himself a cup of coffee from his thermos. He seems prepared to wait out a long and tedious night amid his gleaming, posturing, heroic charges. At that moment, in the early 1960s, so were we all.

The painting of the night guard marks the end of what I consider to be the "real" (or at least the important) Norman Rockwell. The picture seems to be telling us that, and perhaps Rockwell knew it himself. Or perhaps he didn't. In any case, he eagerly participated in his own sanctification (or "maturation," as he would have called it). Having never had a proper "American childhood," Rockwell had always been, in his own perception, a child at heart and an instinctive outsider. During this period, as Rockwell underwent psychotherapy, he stopped thinking of himself as a big kid making pictures to make friends and started thinking of himself as a "mature artist"—as an authority on kids, like his two friends Erik Erikson and Robert Coles.

Psychotherapist Erik Erikson, a former student of Anna Freud's, was one of Boston's first child analysts and the author of *Childhood and Society* (1950), the book that introduced the term "identity crisis" into the lexicon of American childhood. Robert Coles's book *Children of Crisis* (1967) dealt with the effects of the civil rights movement on children in the South, and his story of Ruby Bridges may have provided the inspiration for the young black girl walking to her newly integrated school in New Orleans, escorted by federal marshals, in Rockwell's *The Problem We All Live With* (1964). As strong and accomplished as this picture is, however, its cool, Davidian remoteness marks the end of Rockwell's instinctive identification with the citizens he painted and the beginning of his tenure as a member of the nation's new, therapeutic power elite.

Rockwell would never gain any real access to Erikson's and Coles's peculiarly psychologized and Germanic vision of culture and

childhood, but from this time forward he would routinely mistake his friends' vocation for his own. He would generalize from particulars in the manner of a social scientist, rather than particularizing generalities as he had always done. Henceforth, like a painter king, he would paint his "subjects" rather than other citizens of the republic. He would illustrate "issues" rather than portraying other children of folly like himself. In his notes for a 1966 speech (although not in the lecture itself), Rockwell explains this shift. He begins by announcing, "There was a change in the thought climate in America brought on by scientific advances, the atom bomb, two world wars, Mr. Freud and psychology." In conclusion, he responds optimistically to this daunting roll call by declaring himself to be "wildly excited about painting contemporary subjects," "pictures about civil rights, astronauts," "poverty programs. It's wonderful."

Today it's clear that these remarks mark a turn for the worse in Rockwell's career, but it would be a mistake to blame it all on science, psychotherapy, and Kennedyesque rhetoric. The truth is that, even though Rockwell was one of the great visual narrators of the twentieth century, he always thought of himself as an illustrator, and finally he became one. Throughout his career he was always casting about for the "big picture," for the "great subject" that would establish him as the important artist he correctly believed himself to be. In the end, sadly, he found the one and lost the other. His "big pictures" herald the twilight of his artistic importance. In his fatal misapprehension of his gifts, however, Rockwell was far from alone among American artists and writers. He was, in fact, no more the self-deluded Victorian than Mark Twain, who was similarly incapable of crediting his own (in Twain's case, comedic) gifts—who thought *Huckleberry Finn* paled in its achievement beside his *Joan of Arc*, a novel that, in its platitudinous tedium, may be justly compared to Rockwell's *Four Freedoms* (1943).

None of this diminishes either Twain's or Rockwell's startling achievements, however. And even though Rockwell himself concurred with the then fashionable assumption that his "old hat"

domestic manner had somehow been superseded by the "new" glamour of issue-oriented, celebrity journalism, that does not make it so, since nothing in Western culture is older than that. Homer invented celebrity journalism in *The Iliad*, and its return in the early 1960s (courtesy, one suspects, of wily Joe Kennedy and his tame Harvardeers) signified nothing more than the last, vulgar recrudescence of the "great man" theory of history, the dying swoon of an elitist idea that the virtue of a society resides in the concerns and personae of its leaders and heroes rather than in those of its citizens.

In the history of Western art, this idea expresses itself in the traditional distinction between "history painting" and "genre painting." Genre painting concerns itself with "low" subjects, everyday people whose ordinary, inconsequent activities—eating, gambling, smoking, reading, singing, playing the lute—are portrayed as evidence of human *vanitas*, as testaments to the perpetual evanescence of earthly desires. History painting, on the other hand, concerns itself with kings, heroes, gods, and saints and their consequent (which is to say, historical) activities. Norman Rockwell's great achievement was in traducing this distinction and investing the daily activities of ordinary people with a sense of historical consequence. This, I think, best explains Rockwell's survival as an artist.

Put simply, Norman Rockwell invented democratic history painting—an artistic practice based on an informing vision of history conceived of and portrayed as the cumulative actions of millions of ordinary human beings, living in historical time, growing up and growing old. George Caleb Bingham is Rockwell's only American predecessor in this field, and his paintings are less historical narratives than provincial reportage, their emphasis falling more heavily on the place than on the times. Benjamin West's "democratized" history paintings simply substitute elected officials for crowned heads in the same pictorial universe. Rockwell's best pictures, conversely, treat each quotidian moment as a distinct historical occasion. Moreover, Rockwell presumed that this moment would remain available to us in the continuity of tumultuous microhistories that define

democracy in progress. It is exactly this sense of history as tumult, however, that makes Rockwell a very poor candidate for the position of conservative icon for which he is regularly nominated. He does, indeed, portray a simpler past in loving detail, but this devotional aura derives less from his reactionary tendencies than from the fact that he invariably portrayed the present as a historical moment, as if it were the past—or moving rapidly in that direction.

For Rockwell, the world was ruthlessly tumbling forward, so he passionately captured the moment as it faded. Antique manners and traditional values, however, were never his true subject. His most popular *Post* cover, *Saying Grace* (1951), which depicts a grandmother and her grandson praying before a meal in a crowded downtown restaurant, is routinely cited as evidence of his commitment to "family values": it is presumed to be a celebration of familial obedience, adherence to established religion, and respect for tradition. In fact, as Rockwell himself insisted, *Saying Grace* no more advocates public prayer than *After the Prom* advocates teen dating. Its subject is the crowd of secular onlookers (our surrogate beholders) who respectfully tolerate citizens with values different from their own. *Their* behavior is being celebrated, because in a democracy where everyone is different and anything can happen, tolerance is the overriding social virtue.

| 105 |

Thus, those who look for traditional values in Norman Rockwell pictures will discover a virtual cornucopia of difference and disobedience. Neither a scientific naturalist nor a conservative realist, Rockwell portrayed a world in which the minimum conditions of democracy are made visible. His best paintings insist that the atmosphere of benign tolerance—each tiny occasion of kindness, comedy, anxiety, and *tristesse*—far from being evidence of human vanity, is a critical element in the fate of the Republic. The characters in Rockwell's pictures may be "types," then, but they are alive in time, never trapped in their particular historical instant but living through that moment on a specific historical trajectory.

The kids in Norman Rockwell's America always grow up. They

are growing up before our eyes, in fact, and in Rockwell's pictures they always grow up free. In 1956, on a calendar, Rockwell reprised his famous *No Swimming* cover from 1921; he painted the same kids, thirty-five years later, fully grown but breaking the same rules with a new dog. That is the message: democracy progresses in an untidy dance of disobedience and tolerance. So today I like to imagine the kids in Rockwell's pictures growing up as the kids who grew up look-ing at his pictures grew up. I imagine the kid with his bindle sitting at the soda fountain with the nice cop in *The Runaway* (1958) ten years later. He is standing by a highway with his backpack, thumbing a ride to San Francisco. Or he is bleeding and battered on the streets of Chi-cago, having encountered an altogether different sort of policeman. I imagine the *Girl with Black Eye* (1953), who sits grinning outside the principal's office, a decade later burning her bra. I imagine the kids in *After the Prom* sitting around the campfire in some commune in New Mexico trying to recapture the golden glow of that night at the soda fountain.

I do this because these things actually happened, and more. Because Jack Kerouac took Norman Rockwell on the road to portray a big, flat, magical America full of kindness, comedy, and *tristesse*. Because Hugh Hefner took the grown-up kids from Rockwell's pic-tures into the bedroom and invented a new American iconography of girl-next-door domestic eros. Because all these kids showed up at Woodstock in search of that peculiar Rockwellian blend of toler-ance and disobedience. They stood out there in the mud and waited for Roger Daltrey to sing their anthem: "The Kids Are Alright." They probably still are.

Firecrackers

TERRY CASTLE CELEBRATES HER INDEPENDENCE

I picked up Terry Castle's The Professor and Other Writings, despite the title, despite the shadowy prospect of tenured vipers slithering across the Persian Soumak in the faculty lounge. I bought it because of the author and this was the right thing to do. I read page 1, then read the book three times straight through, like a kid imprinting a new chunk of "Jingle Bells." *The Professor*, it turned out, is a bravura collection of autobiographical essays with the musical attribute of altering and renewing itself every time you punch Repeat. The tone darkens with each reading, but there are always new angels in the clouds.

On my first reading of *The Professor*, I was beaming throughout. It was all so swift and dead on, so profoundly an artifact of the adult world. On my second reading, the book was still funny but sadder too, because we all contribute to the vanity of intellectual culture. On my third reading, the atmospheres turned toxic. The landscape of blanched California, the snow-mantled nights of the high Midwest, and the gray, rainy streets of SoHo began closing in—only to be held at bay by majestic slalom turns in Castle's prose that, while digressing from the content of one essay, elaborate the content of another, so that piece by piece, everything falls sweetly into place. As a consequence, one finishes *The Professor* pretty much convinced that one has experienced a work of art.

So there I was with a real book coming at me. Like a bush-league catcher, I marveled at the spin on the high, hard ones, at the arc on the curves. I marveled at things that could have gone wrong and didn't. How, I wondered, had Castle resisted the marketing pressure to begin her memoir with the sexy acrobatics and the talk-show fodder of her

novella-length title essay? "The Professor" recounts Castle's fraught and feverish lesbian affair with one of those envious, charismatic, brain-gobbling professors who entangle their gifted students in duels to the death in the guise of real "grown-up" love.

I have no idea how Castle won this argument; but in the book we come upon her romantic train wreck on the way out. By this time, we are well acquainted with its high-hearted protagonist. She seems okay. We have accompanied her to France, Sicily, Santa Fe, and Ocean Beach. We have suffered with her through a dour dinner party in SoHo with Lou Reed, Laurie Anderson, Marina Abramović, and Susan Sontag—these four—being special together. We know that Castle prefers Agnes Martin to Georgia O'Keeffe and that her mother does not. We know that, like Mario Praz, Castle finds intelligent people who dwell in "fundamental and systematic ugliness" disturbing and not to be trusted.

Most critically, we know that Castle eschews victimhood, even when she is victimized. We know that she is obsessed with Nicole Eisenman, Ingrid Bergman, cool jazz, rubber stamps, buttons, and twee shelter magazines—all of which stand as a hedge against the gothic and all of which remind us that Castle is the comic hero of her own adventures. She plays D'Artagnan, the bumpkin with the flashing blade. She may feel clumsy, insecure, easily humiliated, and foolish. She often is, in fact, but she is very, very swift to respond when challenged.

We also know that Castle is rather charmingly bonkers, and so discombobulated by the shadow of oncoming tedium that she will fill several shopping bags with a complete pharmacopoeia of CDs for a boring drive from San Francisco to San Diego in her ex-girlfriend's Taurus. In addition to Bird, Dexter, Dizzy, Sonny, Miles, and Jimmy Giuffre, the bags include

Conlon Nancarrow, Fatboy Slim, DJ Cheb I Sabbah, Ludwig Spohr, Amália Rodrigues, Johnny Cash, Dame Myra Hess, Sigur Rós, *Verklärte Nacht*, Brenda Lee, Nusrat Fateh Ali Khan, *Gus*

Viseur à Bruxelles 1949, the Pogues, some early Leontyne Price (yum), White Stripes, Charpentier, Delalande, *Coney Island Baby*, *Historic Flamenco*, *Rusalka*, the Bad Plus, Harry Smith's *Anthology of American Folk Music*, Son House, Reynaldo Hahn (the real guy, quavering away at the piano!), Busoni's Bach arrangements, Ginette Neveu, the Stanley Brothers, Tessie O'Shea, Milton Babbitt, *The Rough Guide to Raï*, Gladys Knight and the Pips, Charles Trenet, Ska Almighty, John Dowland, the organ music of Johann Fux (heh heh), Ian Bostridge, the Ramones, Astor Piazzola, *Ethel Merman's Disco Album*, Magnetic Fields, Flagstad and Svanholm in *Die Walküre*, Lord Kitchener and the Calypso All-Stars, Sonic Youth, Youssou N'Dour, tons of the Arditti Quartet, Kurt Cobain, Suzy Solidor, John McCormack, Greek *rembetiko* music, Jan and Dean, *Los Pinguinos del Norte*, Shostakovich film scores, *Some Girls*, Wunderlich doing *Butterfly* (in luscious, spittle-ridden German), Cuban contredanses, *Planet Squeezebox*, some croaky old Carter Family, Morton Feldman, Beatrice Lilly (and fairies at the bottom of the garden), Elmore James, Giulio Cesare, Miss Kitty Wells, *Vespro della Beata Virgine*, *South Pacific*, *Pet Sounds*, *Les Negresses Vertes*, *Dusty in Memphis*, Ferrier's *Kindertötenlieder*, Toots and the Maytals, *Têtes Raides*, Lulu, *Lulu*—even Gurdjieff's potty piano ramblings. He always makes me think of Katherine Mansfield.

Someday, graduate students will write dissertations on the architecture of taste inferred by this Homeric catalog, but the joke is that Bev's Taurus didn't have a CD player, and Castle's boom box, loaded with new batteries, refused to make a sound, so Castle and her ex listened to "burbly soft rock, stale oldies, [and] Dean Martin singing Christmas carols" down the length of California, steam coming out Castle's ears à la Wile E. Coyote. This cascade of misadventures is funny enough to stand alone, of course, which cleverly disguises its true function in "My Heroin Christmas"—to provide an aural scrim for Castle's discovery of Art Pepper, whose alto saxophone saved her life,

as only music can, whose biography *Straight Life* is the greatest book Castle has ever read, even better than *Clarissa*, she says.

Like Castle, Art Pepper grew up in the raggedy suburbs of Southern California, but well to the dark side, as jail-yard aristocracy, a beautiful jerk, a musical genius, a sleazeball junkie, and a guilt-free sex fiend whose antics were frowned upon even in the jazz world, because, except for the music, everything about Art Pepper was bent. Even the pictures of him are bent. There is a famous photograph of Pepper taken by William Claxton. Pepper is climbing up one of those steep inclines in Echo Park, seen from above. The inference of the photograph is that the tortured Pepper is struggling upward toward some sort of redemption. In fact, Pepper was looking for a fix, and most of the smack dealers in Los Angeles lived atop the hills of Echo Park for tactical reasons they had learned in Korea.

So that was Art Pepper, and Terry Castle's relationship with him is by far the most complex in the book. They never met, and Castle never shot smack, but Pepper's writing and music permeated the world of Castle's youth and awakened her to the heartless grit of genius. Pepper showed Castle the neighborhoods they shared— those sunshine slums—and, more to the point, Pepper's outrageous transgressions with drugs, women, money, friends, crime, and violence made Castle's predisposition to have sex with women seem like a little tic, like biting your fingernails, and that, in itself, is a kind of absolution.

Through a Darwinian logic of association, Pepper's biography also brings Castle face-to-face with the theatrical suicide of her loathsome stepbrother, Jeff, and with her own fierce ecstasy at his death. Jeff was a mute, violent drunk, burglar, recidivist, and closet hottie in the rough trade, and it's clear enough from the essay (although Castle doesn't quite say so) that she recognizes Jeff and Pepper to be comparably bad dudes from the same bad seed, differentiated by nothing more than Pepper's charm, courage, and genius. This is a bitter pill for a "nice girl" like Castle, but when pressed to the wall she

defends her affection for Pepper—as a man and an artist—as a "sex thing," something alive and tangible. She quotes a lifelong lesbian who was in rehab with Pepper at Synanon on Santa Monica beach: the woman "reveals [that] she once considered sleeping with Pepper, anyway, mainly because he was funny and intelligent and 'a kindred soul somehow.'"

Castle understands this. In her view "the tenderness between lesbians and straight men is the *real* Love That Dare Not Speak Its Name"—a brave sentiment from a "mini bigwig" (or "biggish mini wig") in the lesbian-studies game—but Castle has always been interested in men, as fellow mammals, in the benign way one might be interested in beagles or speckled horses. Having grown up in and around the military, she possesses a reservoir of droll and specialized experience with the masculine beast—enough, at least, that in her anthology, *The Literature of Lesbianism*, she had the insight and the onions to include Casanova, Hemingway, and a host of other swinging dicks. So Castle knows a lot about guys.

Her book begins with the mystery of masculinity—with young men dying in droves nearly a century ago. "Courage, Mon Amie" recounts a trip Castle took with her butch cousin Bridget through the cemeteries of World War I to locate the grave of Castle's great-uncle Rifleman Lewis Newton Braddock, who died in that war and was buried near Amiens. Compared with all the laughter that follows, "Courage, Mon Amie" is Castle's most gothic and riven essay. She has willfully begun her book at its spiritual nadir to flatten any incipient affect and to introduce herself as an odd duck, a dusty, plain-style, lower-middle-class girl, afraid of being afraid, who grew up on the Channel coast of the United Kingdom and the Pacific coast of the United States, whose family's favorite movie was Noel Coward's *In Which We Serve*—seen so many times and loved so well that the dry-eyed gallantry and laddish humor of Coward's script still float through Castle's prose like dry perfume.

"Courage, Mon Amie" ends with a long meditation on valor. Castle stands in the wild grass and gazes down the trench line out of

which thousands of young men rose up and walked forward slowly through the mud and rain into death. She can't believe they did it or that she ever could have, but this coda is very close to the theme of the book, a celebration of courage as a nongendered virtue, indispensable if one is a lower-middle-class Navy brat, too bright for her schools, too glib for those who might have mentored her, and a lesbian to boot. Subsequently, Castle's image of Tommies marching slowly through the rain into death puts the edge on her essay about her friend Susan Sontag.

"Desperately Seeking Susan" is an Orwellian parable about the fantasy lives of modern intellectuals. On its first publication, faculty stegosauri were shocked, shocked. Why I know not. Nothing in the essay is news. We all have friends more famous than ourselves whom we see right through, friends for whom our affection stands in for our approval, friends who hate everything we love except for maybe one author and one opera. It takes courage to write about these sacred monsters, but courage is the subject here, and Castle rides the tiger in "Desperately Seeking Susan." The essay begins after Sontag's return from Sarajevo, where she dodged sniper fire, pimped *The Volcano Lover*, and meditated on the suffering of others. Sontag's persona, by this time, had been stylized into vintage Chuck Jones. Like George Bernard Shaw's dashing aviatrix in *Misalliance*, she would land her biplane on your lawn and complain about the berms. On this encounter, Sontag and Castle are strolling down the main drag of Palo Alto. Sontag stops, looks seriously at Castle, and asks if she has ever dodged sniper fire.

Unfortunately not, Castle says (dry wit wasted), and "licketysplit" Sontag is off, dashing from one boutique to the next, all the way to the Baskin-Robbins, bobbing in and out of doorways, pointing at imaginary gunmen on rooftops and "gesticulating wildly" for Castle to follow. Castle doesn't follow. She tells the story as Good Soldier Švejk might comment on the behavior of his colonel, because Castle is a child of her class. She is the doomed Tommy, down in the mud, looking up in amazement at the plumed major astride his black

stallion, shining and jingling—but there is courtesy in the cruelty here. Throughout *The Professor*, there is an exquisite decorum at play. When the subject turns dire, Castle plays pianissimo, wry and glib, like a Michael Franks tune. When the ground gets rough, she keeps the prose sleek and wiggly, moving with the uncensored fluency of Art Pepper's alto. When there's a bad story to tell, the narrative floats on sly bubbles of happiness, as Dickens's prose floats through its most brutal narratives, as if to say, "This is a nasty story, but what a joy to be writing it."

/ *113* /

Castle's true decorum can be measured by the fact that her account of Susan Sontag in full Shavian goofiness follows on the heels of "Sicily Diary"—in which Castle herself is quite literally the butt of the joke. This essay locates Castle in her own element, traipsing through Sicily with her wife, Blakey, in American tourist togs, like medieval mummers on a spree. They visit Palermo first and then set out into the blue Tyrrhenian Sea to visit Stromboli, an important station of the cross for those who worship Ingrid Bergman. Unfortunately, like many hardworking writers (myself included), Castle takes the free time afforded by being on vacation to get really sick, this time with some Mafioso brand of diarrhea.

They land at Stromboli at dusk. The volcano is belching smoke. Castle's innards are writhing like Laocoön. Castle sets off down the pumice beach thinking perhaps a swim, "then nothing to do but break for it: bowels suddenly on fire. B. watching in horror. Mad, self-flinging plunge into the waves, followed by Byronic exaltation (*this is something I've never done before; I am breaking every law of God and man*); then sordid, liquefying release. Catharsis accomplished, I hurried back onto the beach groaning like Mr. Pooter after the umpteenth insult from Lupin, his annoying ne'er-do-well son." Castle's stomach is never as bad again, but the ordeal continues. She is off her food, and the Polish lady who runs the hotel, who "wore sunglasses indoors, like a sort of elderly cokehead," takes Castle's failure to clean her plate as a commentary on the hotel fare. She showers Castle with

frosty disdain. Castle hides behind a gorgeous book of paintings by Antonello da Messina that she has borrowed from the front lounge. Then, in an Art Pepper moment, Castle is sullenly tempted to steal the damned book.

Thus, Castle is driven toward a life of crime by illness and the sheer foreignness of everything, like Kurtz in *Heart of Darkness*, if Graham Greene had written *Heart of Darkness*. My point being that there are a lot of seamless divertissements in *The Professor*, glimmering subtexts and literary allusions, inserted, one suspects, as much for the author's amusement as our own. Some are dead serious. Some are sheer play, like the conclusion of "Travels with My Mother." In this essay, Castle, her mother, and Blakey tour the sights of Santa Fe. Their group dynamic and the eccentricities of Santa Fe are run through their paces, and it seems, for a moment, that Castle is at a loss for a physical way to get the three of them out of Santa Fe and a literary way for Castle to get herself out of the essay. But no! Castle reaches up in the air and grabs Larry McMurtry's gallant nineteenth-century diction and we view the trio's exeunt as it might have happened a century ago.

> Today we set off on the arduous eight-week stagecoach journey back to California. Though rough and indelicate in manner—as I learned to my dismay when one of them was so careless as to miss the spittoon adjacent to where I stood awaiting our departure—the young gentlemen in Stetsons at our hotel in Santa Fe were most eager to help us secure our heavy boxes. I wore my pretty yellow calico dress for the journey; Miss Beaverbrook had chosen her usual frayed blue gingham suit with the buttons missing. So as not to delay our embarkation I thought it wisest not to mention that her muslin petticoat was besmirched with some small unknown foulness. The day was fine and bright and despite an oft-expressed fear of those savages who might molest us en route, my Venerable Mama proved a delightful traveling companion.

This bathetic snap, from the New West to the Old, is what I call a "fire-cracker." Castle sets them off whenever she feels like declaring her liberation from solemnity and scholarly decorum. You can actually feel the lift of freedom as sentence after sentence (no longer tethered by footnotes to the tundra of "the text") takes flight in the pure air. To have studied literary prose for twenty years, taught it and thought about it, and then done the deed is an amazing achievement—like learning to bloom by looking at a rose bush.

In truth, Castle's prose has always been lurching toward the pure air. In an essay from 1997, "Resisting Casanova," she notes that,

> like the gentlemanly seducers of today, Casanova was . . . careful to take hygienic precautions whenever any "voluptuous com-bat" was about to ensue. To minimize the risk of a "fatal plump-ness" in his lovers, he tells us, he never hesitated to wear a "little garment of very fine, transparent skin, eight inches long, closed at one end, but resembling a purse and having at its open end a narrow pink ribbon." Way excellent!

In my copy of the text, I speared a large check mark in the margin beside "Way excellent" when I first came upon it. I thought for a moment that Castle had experienced a little Tourette's event and written what she was thinking. Then I thought. What could be bet-ter than *Way excellent*? I imagined the light-years of culture, geog-raphy, diction, rhetoric, and genre that separate Castle's account of Casanova's memoirs from *Bill and Ted's Excellent Adventure*. Put them together and they go bang, like a firecracker, because to embrace the whole language as Castle does is to liberate words from their pro-prietary vocabularies, to give us Bill and Ted and Castle and Casano-va too, as writers from Catullus to Curtis Mayfield to David Foster Wallace have so happily done, not because it's cool but because it's liberating to write with the unabridged language in play. It creates a quantum magnification of our literary expectations, and the idea

that one might, when the occasion arises, write anything is exciting in itself!

All of this leaves the impression that Terry Castle is a very flashy babe, and on the page she is. As a working artist, however, Castle is one of those thoughtful, studious latecomers, like George Washington or Andy Warhol, who makes plans, studies hard, plots things out, then makes them so. These heroes aspire to be the epitome of what they are—as Andy would be the epitome of an artist, as Washington would be the epitome of an American republican. As Castle would be the woman she imagines in *The Apparitional Lesbian* (1993), her book about victorious lesbians like Greta Garbo, Sylvia Townsend Warner, Djuna Barnes, Janet Flanner, Brigitte Fassbaender, and many others. In her introductory homage to Garbo, Castle insists,

> We need to recognize how fully, if invisibly, the lesbian has always been integrated into the very fabric of cultural life . . . how thoroughly, despite all the hostility ranged against her, she has managed to insert herself into the larger world of human affairs. None of the women invoked in this book . . . ever let a sense of sexual alienation or "marginality" stand in the way of her curiosity, self-education, or ambition: each sought to participate to the utmost in the rich communal life of her time (and usually did).

As does Castle herself, who conceptualized the sort of lesbian she planned to be very early on. Who imagined the insouciant hero she planned to play in prose before *The Professor* was a blip on the radar. In Castle's cultural model, lesbians, for the past two centuries, have been lively apparitions, whispering in our ears, shaping our expectations so subtly that I myself walked Janet Flanner's Paris for decades and never noticed. Castle's candor and dazzle go a long way toward investing that ghostly presence with elegant physical life.

¡Una Lesbiana Enamorada!

SUSAN SONTAG

I picked up Susan Sontag's Reborn: Journals and Notebooks, *1947–1963* hoping for a peek into the origins of her first book of essays, *Against Interpretation.* In 1966 this collection was the first serious, nonacademic book that encompassed the constellation of my own generation's passionate enthusiasms. Sontag was "against interpretation." She was for "an erotics of art." She wrote about Alain Robbe-Grillet, Albert Camus, and Claude Lévi-Strauss, all of whom we were devouring on a daily basis. She wrote (less kindly than she should have) about Nathalie Sarraute, my favorite professor, whose novels were fine French acid trips, whose low-heeled, lace-up, black nun-shoes were the coolest. Sontag also wrote about camp, and we were such ardent devotees of *The Velvet Underground & Nico* that louche coeds kept bullwhips on hand for dancing to "Venus in Furs."

In her most famous essay, "Notes on 'Camp,'" Sontag identified this sort of behavior as having its origins in the homosexual community. She characterized "camp" as an infectious project to empty out the received meaning of fine art and popular culture with the aid of feathers, mascara, whips, and pink dildos. She was right about that. She was wrong to presume this maneuver was new. "Sacred art" became "fine art" in late fifteenth-century Italy because Italian bankers wanted the pictures. "History painting" became "political painting" in late eighteenth-century France because revolutionaries wanted the narratives. "Sissy" became "camp" in 1969, when the New York City police tried to frog-march bridge-and-tunnel campsters, feathers askew, out of the Stonewall Inn in Greenwich Village. Under this assault, the frothy white bubble containing Busby Berkeley, Betty Boop, and Tinker Bell exploded into a rough piece of street theater

that ignited the riots that changed the world. So Sontag was wrong to describe camp as an "unserious, 'aesthete's' vision." Aesthetics is always serious when agreed-upon interpretations are changed or stolen or emptied out.

None of these quibbles mattered in the moment. Sontag caught a rising wave, and *Against Interpretation* came to us like a message in a bottle from an antique land. We were hiding from the Vietnam War by miming education. Sontag was a thirty-something Jewish Intellectual who had trekked from Tucson to Berkeley to Chicago to Cambridge to Oxford to Paris and, finally, to New York, devouring schools like a cat on a trail of kibble. For us, this was mysterious and quaint; it meant no Yucatán, no Casablanca, no Lhasa, no Waimea, no smuggling, no jail, and no rock and roll—and we were no less vain about our prerequisites than Sontag herself. So Sontag was not one of us, but she was a hottie—one of those supersmart lipstick lesbians you met at Saint Adrian's Company down on Broadway for all-night marathons of intellectual speed-rap.

By the late sixties, however, Sontag had begun to hedge her bets. She saw herself as having enabled an orgy of sordid piracy. Like Jack Kerouac, cornered by hippies a generation before, she looked into the maelstrom she had helped create and flinched. By 1975 she was insisting that some subversive tastes that "pose only innocuous ethical issues as the property of a minority become corrupting when they become more established." This edict appears in "Fascinating Fascism," an essay in which Sontag reads Leni Riefenstahl's final but inevitable fifteen minutes of fame as a threat to all mankind. Everyone giggled at this, of course. My own interpretation of Sontag's self-repudiation has always been that, back in the sixties, the writer's disobedient body told her a story about freedom and transgression that, ultimately, her mind and temperament could not countenance.

Sontag's career continued apace, of course. She wrote and wrote well, but her call for an "erotics of art" dwindled into darkness, surviving only in repudiated texts and jottings in the journals she

kept all her life, in a row on a shelf in a closet. These contain diary entries, notes-to-self, shopping lists, cris de coeur, and other stuff writers need to charge their batteries. After her death, the administrators of Sontag's estate decided that she intended these intimate jottings to be published posthumously. I *seriously* doubt this. Sontag's son, David Rieff, has written at length about her conviction that she would survive her affliction. Yet *Reborn* is in print, the first of three volumes. Rieff himself is the editor, and he has exercised his Victorian perquisite to abandon all scholarly apparatus and cut enormous sections of Sontag's text to fashion what amounts to a gay chick-lit memoir with a few big words.

Everything of historical or intellectual interest has been suppressed, compressed, or jumbled. Reading through the residue of tatters and scraps, as if through the Dead Sea Scrolls, I remembered an afternoon in La Sarraute's class when she discovered a misprint in our edition of *Tropismes*. Sarraute went pale, marked the misprint violently, and announced (in English, to be sure we understood): "If one cares about one's texts, one mustn't die, ever!" Now Sontag is dead, and her son should have known better than to fool with his mother's text—although I could not help but imagine how I might do if given as clean a shot as this at my mom. Not well, I fear.

Consider Rieff's strategic elisions. Throughout her career, Sontag, who was a woman of words, made lists of words that interested her. Rieff cites *one* example. In 1957 Sontag made two lists of childhood events: one from memory; the other in chronological order. Laid side by side they constitute a Nabokovian meditation on reverie and chronology. Casually spliced into one list, as they are here, without annotation, they mean nothing. In 1961 Sontag kept a list of all the movies she saw that year in the order she saw them, sometimes three movies a day and never with a break of more than four days. We get a paltry sample. Denied access to these words, vignettes, and movies in their proper times and places, we are denied an armature of understanding. (A ballpark sum of the accumulated hours Sontag spent watching movies in 1961 would tell us more than half this book does.)

Consider this even more egregious lie of omission from 1957. During the last days of her marriage to Philip Rieff (whom she married in Chicago at seventeen and followed east to Cambridge), Sontag began keeping an account of her mundane activities à la Robbe-Grillet. She noted where she found stamps, what she ate for dinner, what time she went to bed, et cetera. I was enjoying this *nouvelle vague* excursion when it was stopped, suddenly, with a cut. Why? Does Rieff have a problem with Robbe-Grillet? In her actual journals, we learn from a note, Sontag's minimalist narrative continues, recounting her train ride to New York, her first night in New York, her voyage to London, and her trip with a friend through Italy. We also learn that, once at Oxford, Sontag kept notes in her journal on her philosophy class with J. L. Austin, the great philosopher of ordinary language.

The notes on Austin's class have been cut, too, and we are favored with a filial redesign of Sontag's emotional life. Her stark narrative of soup and stamps in Cambridge reads like a suicide note for her marriage. Having climbed on some trains myself, my best guess is that once Sontag found herself a seat on the train, Philip Rieff disappeared from her consciousness, and she noted this in her journal. (And if the editor doesn't want us guessing, he should print the text.) The censored entries almost certainly trace a bridge of tiny, jotted milestones that mark Sontag's journey from one life to another, so we want to know what she noticed, however trivial. We want to know what she wrote because she wrote it. We want the notes from her class with Austin because Sontag rarely faced off with intellects of Austin's caliber. If Sontag's observations were less than profound, we would think no less of her.

And why would we? Sontag won. We are reading her work because she won. She grew up to be the woman of her adolescent dreams, a Wagnerian luminary streaking across the intellectual firmament scattering cuts and slights like confetti in her wake—a warrior princess with the social instincts of a wolverine and a vestigial fondness for mothering young men. In her maturity,

Sontag took young strivers like the curator Klaus Biesenbach and the singer and actor Casey Spooner under her wing. She liked their world and her status in it. She liked traveling with them because they stayed up late, and Sontag never slept. One night in Berlin, Sontag and Biesenbach set out for a disco at four in the morning. The girl guarding the door recognized Sontag and fell without hesitation into a *Wayne's World* salaam, protesting her unworthiness. Sontag graciously accepted her obeisance. When I heard this story, I imagined all the wounded culturati who now wear Purple Hearts for Sontag's public cruelty, wishing they had simply fallen to their knees and cried, "Not worthy!"

Back in the eighties, I stood with one of these wounded warriors at a party at the St. Regis, watching the ever-watchable Sontag, who had taken command of the opposite corner of the salon. She was showing us her profile, standing with her arms folded, swathed in scarves, her black mane accented by that theatrical streak of white, scanning the room for traitors. "About as close to a James Bond villain as you're likely to encounter in real life," my friend said. "She ought to be stroking a cat." And she should have been, but I always forgave Sontag. I always saw a fellow faker from the West, and a more accomplished one. Only the most attentive faker can get it that infinitesimally perfect. So I owe her.

The scraps I knew of Sontag's premature adulthood kept me young well past youth's "use by" date. I would imagine this luscious twenty-year-old Sappho in a raw-silk frock masquerading as "faculty wife" at a formal dinner with Philip Rieff, the E. H. Carrs, Herbert Marcuse, and Owen Lattimore. That would send me off to CBGB's. So I have no social quarrel with Sontag. Once, I think, she failed to laugh at a riposte I tried out on some fancy Texas lesbians at an art opening. Sontag hovered on the edge of the group, pulling down at her vest, like a baritone about to make an entrance. We were talking about how stupendously decadent we were. I suggested that people should be considered innocent as long as they think "syringe" is an Irish playwright. Giggles ensued. My pal Skeeter pressed her wrist to

her forehead and declared, "Oh my God, I haven't been innocent since I was eight!" I corrected her grammar: "Don't you mean, 'Since I was eaten'?" More giggles, except from Sontag, whose eyes widened as if I had slapped her. The next time I looked, she was gone.

No surprise there. Everyone knew Sontag did not like glib. She did not like jokes. She was a very bad listener and offended even by the imposition of incoming telephone calls. She liked serious. She liked to think that any fool purporting to understand her writing deserved her public scorn—that any gauche slug caught admiring works of hers that she had since orphaned deserved worse, and got it. A woman who grants herself these kinds of privileges, of course, mustn't die, ever.

The combination of all this—the reverse bowdlerization, the willful cruelty, and its collateral damage—conspires to transform Sontag's journals into a cheapskate Telemundo production of ¡Una lesbiana enamorada!—a project as woozy and revealing as a messy telenovela should be. Lesbians of Sontag's generation assure me that Sontag's sexual narrative bears the marks of emotional authenticity, that she doesn't seem to be posing for posterity. They also agree that Djuna Barnes did it better, and that Barnes's great novel Nightwood—in all of its toxic grandeur—is omnipresent in this journal. It probably should be. Most twentieth-century American lesbian writers aspire to Barnes's status as an artist of such majesty that her sexuality is embraced as an aspect of her art and not the other way around.

Sontag's ability to internalize texts, as she does with Nightwood, was her great virtue as a critic. It is for any critic. We are all predisposed to bouts of pathological connoisseurship. We are always falling in love. That's why we're critics. The idiomatic admission that one is "blown away" by something captures it perfectly. Sontag could be blown away. She was wired for art, and her journal is filled with moments when she declares herself ravished by great books, music, film, and theater—so often ravished that Reborn sometimes reads as if Sontag is feverishly trying on a closetful of Continental couture.

Silly-putty mimicry like this is to be expected from any young writer's journal, but Sontag never lost it.

She never found a voice that bore its own melody, and she seemed to know from the start that she could never make music of the world, whose particulars held no interest for her. There are only two pieces of physical description in *Reborn*. Together they constitute less than a page. There is no news, no conversation, no weather, no fashion, no gossip, and no society. There are no faculty dinners, bar scenes, cocktail parties, lunches, or bull sessions. There is no popular culture and nothing much American. There are no waitresses, cabdrivers, landlords, grocers, or delivery boys.

Absent these mundane domestic accouterments, *Reborn* locates us in a shadowy space where we eavesdrop on a colloquy between Sad Susan and Serious Susan. Sad Susan is the "sensitive" one. She loves movies, literature, babies, and interesting women. She speaks of these in the early pages of *Reborn*, but as the book progresses she becomes increasingly silent. We are left to judge Sad Susan's inadequacies by the urgency of Serious Susan's hectoring admonitions, and Serious Susan is a moral juggernaut. Like a Tucson pachuco, she is determined to "customize" the jalopy she has inherited into something fierce and fabulous. On page 1, at age sixteen, Serious Susan announces that "the only difference between human beings is intelligence." This is a bad start, and her subsequent, vainglorious Intelligenciad isolates Sad Susan from a world of dumb fun, maybe a little lovey-dovey, and a lot of great sex with surf bunnies and dancers (classical and exotic), whose wisdom is of a different order. Soon Sad Susan is pleading, "How can I help me, make me cruel," then confessing, "I discover in myself an eradicable and very dangerous streak of tenderness."

Ten years later, in a sequence of plangent entries, Sontag conveys the grotesque progress of the writer in academe. She begins by reminding herself: "Never complain publicly about Brandeis or money." Then, a month later: Never "criticize publicly anyone at Harvard." Eight months later, having obviously internalized a long litany

of things about which she cannot speak, she writes, "Try whiskey. To find a voice. To speak." Two months later she has internalized the academic ego. "Why is writing important? . . . Because I want to be that persona, a writer, and not because there is something I must say." Then Serious Susan swallows the Ivy League hook with a preposterously Freudian metaphor: "This book is an instrument," she writes, "a tool—and it must be hard + shaped like a tool, long, thick, and blunt." This is followed by "My innocence makes me weep," then by the "price of freedom is unhappiness. I must distort my soul to write, to be free."

After this bit of jejune posturing, the final third of *Reborn* moves into a moral universe with which I am totally unfamiliar. My best speculation is that Sontag was abroad when these entries began: she was socially out of her depth, entangled in a bad relationship, and somehow some careless book clerk stuck *The Portable Nietzsche* in among the self-help classics. Thus beguiled by chaste Friedrich, Sontag decides that love should "be a transaction of hostilities." So even though she hates "being treated like a plebeian" by Eurotrash intellectuals, even though she hates being accused of having an "unrefined sensibility" by her condescending lover, she buys into Nietzsche's bogus proposition that what doesn't kill you makes you stronger. Actually, what doesn't kill you breaks your fucking heart.

Even so, Serious Susan still berates Sad Susan for her pleasant days with Philip Rieff. "I grew accustomed to his flabby adulation," she writes. "I ceased to be tough with myself and accepted my defects as loveable since they were loved." To mitigate this lovability, Serious Susan embarks on a badass regimen. She reminds herself that her "ignorance is not charming," that "people may seem to sympathize" but "really they despise you a little." "Weakness is a contagion," she writes. "Strong people rightly shun the weak," so "it's better to hurt people than not to be whole," so "don't be kind. Kindness is not a virtue." "Think of Blake. He didn't smile for others." So "don't smile so much, sit up straight, bathe every day, and above all Don't Say It . . ."

She composes a mantra for days when the regimen gets arduous:

"I'm not a good person / Say this twenty times a day / I'm not a good person. Sorry, that's just the way it is." A few pages later this twenty-nine-year-old woman, at the peak of her sexuality, is reassuring herself that her "notorious flirtatiousness" and "seductiveness" are naught but a ruse to make sure that her "underlying stubbornness is never touched." Believing this, she seeks out tough alternatives to flirting. "The look is a weapon," she observes, and scolds herself for being "afraid (ashamed?) to use my weapons." Sontag quickly mastered "the look," of course, along with her fear of using it and, perhaps, even that parenthetical "shame," which seems to be the last peep we hear from Sad Susan.

Now I feel terrible. I have read *Reborn* and I know that Susan Sontag, when she was a girl, had a crummy, clumsy sex life, that it was excruciatingly painful. I am privy to the creepy saga of Sontag's purported "struggle with her lesbianism"—which was really a struggle between Sontag's lesbianism and her ambition—which, if she had had better taste in women, would not have been so fraught and, even as fraught as it was, is still not that interesting. Like most of my beautiful friends who beguile both sexes, Sontag shied from losing half those lustful glances. Duh! Also, the early sixties were rough on public lesbians, and Sontag wanted to be loved. She wanted to be a major intellectual without "lesbian" scare quotes. She didn't want to belong to any club that was not about being beautiful and brilliant. Like Djuna Barnes and Robert Mapplethorpe, Sontag resisted the idea of being paraded around as a "legitimate queer"—a perfectly honorable caveat in an underground culture that scorned legitimacy.

My opinion of Sontag's writing has not changed. I still love the essays that she came to hate. My understanding of her character has changed a little. She was braver and more willful than I ever imagined, and more hateful of herself. She was always more the moralist than the theorist. When her arguments led into the abyss beyond her moral universe, we could not follow. Realizing this, I understand why Sontag, when we accosted her down at Saint Adrian's, could barely countenance our youthful enthusiasm. We were the *worst* niche mar-

ket she could ever have imagined. We were kids, and straight, and we "got it." This meant Sontag would never be our Great Mentor. She would never be Gertrude Stein or Joseph Beuys or Marcel Duchamp. She was our uptight big sister, maybe fifteen minutes ahead of her time, disgusted by our feckless penchant for moral free fall, contemptuous of our new tattoos. *And this really must have hurt. And it was really bad luck!*

So I don't care how Sontag behaved. She was tricked by history; she studied at the wrong schools; and, yes, she may have deserved comeuppance for her cruelty, but she doesn't deserve this book. It targets readers she would have detested and invites the wistful and the wet to smile through their tears at her plight. Nor do *we* deserve such a book. Now I am full of dread. I imagine a future in which the maiden sisters of a dead princess gather around a bonfire on the lawn. I imagine them tossing the *Refined Theory of Everything Cool* into the flames while carefully laying aside their sister's ribald accounts of mutual masturbation with her chums.

His Mickey Mouse Ways

So how would you feel? It's 1958. You're twenty-one years old, spinning wax at a two-bit radio station in the middle of West Texas, just happy to be out of the cotton patch and not knowing nothing about nothing but Ernest Tubb, Pepsi-Colas, drive-in movies, and MoonPies. That's you, and one day your good friend, who is also your mentor and role model, who also sees a lot more in you than you see in yourself, waltzes into the booth at the radio station, tosses you an electric bass guitar, and tells you to learn how to play it. He's taking you on a rock-and-roll tour, starting next month, January 1959. A week later, your friend flies you to New York City and puts you up in his Greenwich Village apartment. You sleep on the couch, learn the bass, rehearse with the band, and explore Manhattan. The two of you have your picture made in a Grand Central photo booth. Then you climb on the bus, and in a wink, you're crisscrossing the frozen Midwest in the dead of winter with a bunch of one-hit wonders, playing rock-and-roll shows in high school auditoriums and basketball gyms.

By the end of January you've played twenty shows. Your friend has decided to take you to London as his opening act, which is nice, but that's a few weeks away, and right now it's forty below in Duluth and the heat on the bus is out. The tour moves from Duluth to Clear Lake, Iowa, and nobody has any more clean clothes. West Texas boys (on account of their dirty minds) require clean clothing, so your friend charters a plane from Clear Lake to Fargo so you can all find a laundromat before the next night's show. After the gig in Clear Lake, however, you and the guitar player get wangled out of your seats on the plane.

"You're not going with me tonight?" your friend asks. "Chicken out?"

You say no, that the Bopper wanted to fly.

"Well, I hope your damned bus freezes up again," your friend says.

"Well, I hope your ol' plane crashes," you say, and, of course, it does.

| 128 | Your friend is dead, slammed into a frozen wheat field, and you are sitting in a Minnesota truck stop, staring out at the frozen morning, realizing that, just for a minute there, you were sort of about to feel free. Then you feel bad about even thinking that. You're nothing now in the middle of snowy nowhere, and the promoters don't want the band to go home. They offer to fly you to your friend's funeral, first-class. They offer you more money if you'll stay on the tour. What decides it, though, is that you are a West Texas boy, a bad-weather cowboy, and a man of your word. So, like a fool, you stay, but you get no tickets, first-class or coach. You get no money, and at the end of the tour, in a daze, you go home. You've got no friend and you've got no future. How do you feel?

Well, first, you're extremely angry, and second, you don't care anymore. About some things (like businessmen, lawyers, and bourgeois respectability), you will never care again. You've just been awarded a thirty-day doctorate in the music industry, so, from Jump Street, you trust no one except out of laziness and make few friends because, somehow, it seems, you kill your friends, and anyway, you are too far gone for any but the farthest out. From now on you will sit a long way back from the screen and see yourself acting out the roles that life requires of you—son, friend, lover, husband, music star, culture hero—but you will never take any of them very seriously.

You're plenty screwed up, in other words, and if you had a shrink, if anybody in West Texas had ever heard of a shrink, he would probably diagnose a permanent case of low-grade depression, dissociation, and survivor's guilt, along with a heavy dose of the old "And Suddenly" syndrome. He would probably prescribe the pills you're

taking anyway, because at this point, you are morally certain that the better things get, the more likely they are to blow up in your face; that the brighter the sun, the softer the woman, the sweeter the song, the darker the oncoming storm. The future closes like a shutter in these moments, so you live in the music, which has its own time. You can strip it down, tighten it up, clean it off, and ride it like a rising wave. The music, in the moment of its making, sets you free, but it doesn't cure anything—and, really, it never will.

On February 13, 2002, in Chandler, Arizona, Waylon Jennings died in his sleep, at the age of sixty-four, of having lived. Six months later, we gathered in Lubbock at the second annual Buddy Holly Music Festival and Symposium, to remember him together. Waylon's son, Buddy, was there, as were Richie Albright and Billy Ray Reynolds, his primal rhythm section. Billy Joe Shaver, who wrote the archetypal Waylon songs, showed up, and Lenny Kaye, who cowrote *Waylon*, the autobiography, flew in from New York, on leave from his gig with Patti Smith. I flew in from Las Vegas to reminisce about my years as an embedded journalist in the outlaw music movement. We all sat at a long table in a white conference room, like a posse without the sheriff.

In ragtag fashion, we projected the man we knew back onto the things we had heard and, in doing so, imagined the narrative that opens this essay. It seems a plausible one to me, and all the more plausible since we had all known Waylon Jennings at various times and in varying circumstances, and clearly, we all knew the same man. We recognized his preternatural, ironic self-awareness, although we didn't all call it that. Billy Joe, in fact, looked at me funny when I used the phrase, but we all located the trick of his charm in his benign sense of his public persona as a crazy cartoon of himself. Somehow, he could throw bullshit at you with one hand and wipe it off with the other. In a world full of evil dudes pretending to be good guys, Waylon was a good guy pretending to be an evil dude and never quite succeeding.

You would see him driving around Music Row in some butter-scotch, gold-trimmed, East LA pimpmobile, dressed up like the "third outlaw" in a spaghetti western, and you would smile, know-ing that no one bore less malice in his heart. Onstage, he would step up to the mike, swinging that Telecaster from his hip, and glare out into the lights, projecting an aura of dark, unrepentant machismo with so much good-hearted irony that the aggression bore only the faintest hint of real menace. Out in the audience, you got the buzz of his sexual charisma, but you knew you were one of the gang, that Waylon was sincere in his insincerity. But it was not all a joke. Some things were taken very seriously indeed, and if you crossed the line, you quickly saw the glint, and things got a little, uh, gritty.

You had to violate the code for this to happen, and those who did invariably thought that it was all a joke, that Waylon was totally inside the ongoing party. Eventually, you figured out that, onstage or off, Waylon Jennings loved the party, the performance, and the costumes. He loved the distance they put around him, but part of him was always standing outside, leaning against the proscenium, watching from the wings and keeping things in line. Proper distinc-tions had to be drawn, because Waylon had rules. He knew the differ-ence between being a man and being an animal, between being crazy and being insane, between being bad and being mean, between being an outlaw musician, a thieving crook, or just a plain old scuzzball, predatory criminal. He never confused these modes of transgression, and although he lived by the Code of the West—as all West Texans must—Waylon never confused cowboys on the stage and cowboys on the range. He insisted, in his music and in his presence, that these distinctions be observed as a hedge against self-delusion.

Having said this, of course, I must concede that guarding one-self against self-delusion has never been a high priority among drug addicts of my acquaintance, myself included. Among this delusion-al legion, however, Waylon Jennings was by far the least deluded. I remember once, not long after I arrived in Nashville, asking Waylon why the locals took speed rather than smack and barbiturates, like

us Manhattan sophisticates did. He said, "Hillbillies and hairdress-
ers take speed because they're not comfortable, but they still have
to work." That, I thought, just about said it, although it's clear to me
now that Waylon's discomfort derived in large degree from the self-
awareness that made him so appealing.

One night on the highway, in his new shiny bus, on the teetering
brink of his pop success, I asked him how he liked his new audiences.
"Well, it ain't exactly living in the love of the common people," he
said dryly. He went on to explain that when you start performing,
you play for people who are just like you, and that's not really per-
forming. Then you perform for people who just like you, and that's
really fun. Then, "if you're lucky," you end up performing for people
who want to be you, and that's really not as much fun because these
people who want to be you always hate you a little because they're not
you. They secretly want you to fail so you can know how it feels to be
them. "Actually," he said, "it's not that complicated. There's a lot of
people in a room. One guy's got the microphone. Everybody else's got
the beer. They're all having about the same amount of fun."

I sat there and thought that knowing this much about yourself
and your audience was probably not much of a benison for a per-
former. It does, however, account for some of Waylon's special vir-
tues. In "Good Hearted Woman," for instance, there is a line that goes
"She loves him in spite of his wicked ways she don't understand."
Waylon never sang it that way onstage. He always sang "She loves
him in spite of his Mickey Mouse ways that she don't understand."
Because, I think, Waylon knew what wickedness was. He knew he
wasn't it, and his comic vision of Mickey Mouse machismo let every-
one in on the joke. He could characterize himself—in a phrase at once
self-deprecating and deftly cosmopolitan—as "too dumb for New
York City, too ugly for LA." No other singer in Nashville would ever
dare to be this candid.

He could stand in the wings, watching himself onstage, and
write, "I've seen the world with a five-piece band looking at the back-
side of me." I can't imagine another country performer confident

enough in his own masculinity to acknowledge that he knows the band is looking at his butt. And what other leather-clad, asphalt cowboy could walk up to a fellow who's bitching about somebody being "a goddam queer," drape his arm around the fellow's shoulder, snuggle up close to him, and say, sotto voce, "Aw, come on, Hoss. We all just grab onto something warm and worry 'bout the details later." If you were familiar with the pathological caginess of most Nashville singers, this cowboy hipster candor was scary at first. Then you realized how profoundly Waylon did not care, and ultimately, I think, the magic cloak of this not caring kept him alive for more than six decades. Because the truth was that if Waylon wasn't on the stage, in the studio, on the bus, or having dinner with his wife, Jessi, he was in trouble or about to be.

His gift to us, of course, had nothing to do with being in trouble, although it got him into some. He made strong music. He sang great songs that said things beautifully and spoke with some precision to the times for which they provided the soundtrack. More than that, of all the artists with whom he is associated, Waylon Jennings had the most passionate sense of how you put things together and what things you leave on the bus. He was an artist, in other words, and an artist of his time. At the exact moment that American painters and sculptors were cutting away the obfuscation and expressive nonsense that had accrued around American art during the postwar period, at the very instant that the kids at CBGB's were beginning to jettison the pretentious theater that was drowning rock and roll, Waylon was taking country music back where it never had been.

He stripped away the decorative bric-a-brac that had plagued Nashville product for decades and created contemporary roots music in the minimalist tradition—a music that was not really simpler, just stronger, better organized, and more totally focused than anything that came before it. Dispensing with virtually everything but the rhythm track and the vocal, he changed the focus of the sound from the orchestral grandeur of the setting to the sinuous muscularity of the music's forward drive. Abandoning the pop-hillbilly flummery

of contemporary country songs, he embraced the poetic license and compression of lyrics like Billy Joe Shaver's. In the end, he made a new music that, like the singer of Billy Joe's song, "left a long string of friends, some sheets in the wind, and some satisfied women behind."

The trick was in the bass and drums, and Waylon's producer, Jack Clement, helped with this. As Richie's drums got sharper and cleaner and the bass got louder, the tempo could get slower and the vocals softer, so everything fell into balance. The songs rode on the bong-bong of this "Cajun march" that Richie and Waylon invented—it sounded like an old four-four but bounced like a bluesy twelve-eight, with hidden triplets flowing through the drum track, accentuated by Waylon's Telecaster. To Nashville ears, it sounded like nothing or, even worse, like rock and roll, but it moved like a new wheel on an empty highway and still does, although there are no more empty highways and no more hipster cowboys at the Dairy Queen. Even so, history keeps a special place for artists like Waylon who scrape off the paint and carry out the trash, who bet their whole heart on the unadorned shape of the music. You have to be crazy to do it, of course. You know that soon enough the vehicle will be repainted, that stripes, chrome, and all manner of gewgaws will ultimately accrue, but what you have done doesn't go away. It survives at the heart of the music.

And Waylon survives as well, on his records, of course, but most profoundly in the memory of fading gypsies like those who gathered in Lubbock, who never saw bad done so well. This is the picture of Waylon that I carry with me today: We are milling around the crowded greenroom after a show in Atlanta. Waylon is flopped down in the middle of a leather couch, flanked by two exquisitely coiffed, extremely plump white ladies. The ladies are attired in pastel pantsuits, and the three of them make a nice tableau—the gaunt King of Darkness bracketed by two painted and powdered Easter eggs. Waylon sits forward with his elbows on his knees, grinning and soaked with sweat. His hair hangs in wet, greasy ropes, some of

it plastered across his forehead. His shirt is stuck to his body, and his wristband is stained with dark blotches. He sinks heavily into the pillows of the couch while the fat ladies seem to float weightlessly. I am imagining the strain the ladies are putting on their knees, trying not to look heavy, when I realize that, at that moment, they are not heavy at all. They are in heaven.

I sit down on the arm of the couch and find the three of them in a deep discussion about the almost insurmountable difficulty of running a beauty salon in Atlanta, Georgia, what with taxes, zoning, sorry help, and the burgeoning complexities of interracial hairstyling. Waylon is contributing what he can, which is more than I would have expected. His limited experience of beauty salons, I surmise, has been considerably enhanced by his wide experience with beauticians. Also, Waylon is a small businessman himself. As he points out, he started off as a very small businessman, picking Texas cotton and getting paid by the pound. The ladies chatter away, giddy but perfectly at ease. They are telling this dangerous outlaw things they have never told anyone, but they are not complaining, as they are wont to do, because Waylon is not a complainer and he is contagious.

Whatever they expected as they tiptoed backstage, it was never this! They are having a conversation with Waylon Jennings! It's better than the sex they fantasized about and thought they wanted but didn't really. Waylon knows this. He knows that, as a culture, beauty-salon ladies are incurably romantic and less worldly than they like to pretend. They are not prudes, exactly. They will have sex with you if they must, but what they want is Scarlett and Ashley. They want the rituals of courtly flirtation, and Waylon, with his devil smile and attentive gaze, is giving them that. It occurs to me, as I blatantly eavesdrop, that Waylon is selling a hell of a lot of records with this little gesture. Then I feel bad for having thought it, because Waylon Jennings, in that moment, is clearly happy as hell to be chatting with the fat ladies, behaving like the perfect young cowboy, being thoughtful and curious and whimsically generous, living in the love of the common people.

Mitchum Gets Out of Jail

Robert Mitchum died this summer at the age of seventy-nine. According to friends, he rolled a joint, took a couple of hits, laid back, and went to sleep. Twenty-four hours later, Jimmy Stewart, unassisted by the evil weed, died as well, and I choose to see the Hand of Providence at work in this, since the prospect of Jimmy Stewart in a world without Robert Mitchum is not one I like to contemplate. Just imagining the world without Mitchum is hard enough, since my earliest memories of the popular landscape are of a world with *only* Mitchum in it. This was in the late nineteen forties and early fifties, when I was a kid, and Mitchum *was* the counterculture—a one-man zeitgeist. In the bland, herbivorous pasture of popular entertainment, he was the single, successful, visible icon of America's dark inheritance. Others tried to bring that darkness out of the closet, only to be cast back into it. Mitchum brought it out, stuck it in the face of nice America, and got away with it.

Among the likes of Jimmy Stewart, Henry Fonda, and Ronald Reagan, he was like a switchblade on a plate of cupcakes. For kids like my friends and me, however, out roaming the streets, Mitchum was a familiar spirit—our adopted "rambling uncle." He was someone we knew for whom we had some sympathy because we had seen guys like Mitchum hanging out at the filling station. We had seen them prowling the shadowy depths of downtown pool halls and loitering on the edges of family reunions, wearing jeans and a white T-shirt and battered roping boots, sipping a cup of Hawaiian Punch. So we recognized him for what he was. Like Art Pepper he was jailhouse aristocracy—the best of the worst—a loser with a winner's heart—an American archetype whom Mitchum introduced to the American

screen. So we knew things about him. We knew that, however often he fell, he would remain a "stand-up" guy. He would never snitch on a friend or pardon his failings with some lame excuse or ever, ever change. That was the glory of jailhouse aristocrats: they could be killed, but even in their abjection, they could not be defeated. The pity was, they rarely ever won.

Even in the movies, in the magic mirror of desire, jailhouse honor could triumph only if the hero died. So, for a while there, Mitchum was always dying in the last reel. "That's me," he said of these roles, "dead but undefeated." In life, however, nose to nose with propriety, armed only with his wit and aplomb, Mitchum proved a lot harder to dispatch. Disasters that would have extinguished other, more virtue-dependent careers just fed the flames of Mitchum's aura. In 1948, just as his career was becoming viable, he was nabbed in the first "Major Celebrity Drug Bust," for marijuana, at a house up in Laurel Canyon. Standing before the booking sergeant that night, in handcuffs, he was asked to state his occupation. "Former actor," Mitchum said without a blink. The reporters wrote that down, and the next morning, people all over the country, all of them well prepared to be incensed by Mitchum's drugged-out wickedness, chuckled with amusement.

He did sixty days, stand-up, at the county farm and emerged larger than life. "What's it like 'inside'?" one reporter asked. "Just like Palm Springs," Mitchum said, "without the riffraff, of course." When the requisite mea culpa was demanded of him, he said, "Well, I'm not stupid, and I don't plan to get into any more trouble. But who can say what I might do tomorrow? If I put out some phony reform story and then fall from grace, I'll just look like a liar." That was Mitchum: know yourself, privilege veracity over virtue, and behave with absolute plausibility. Henceforth, nobody expected anything of him, except that he be Mitchum, and Mitchum, of course, remained a mystery behind his sleepy gaze.

So there were always surprises. A few years later, he precipitated the first great *paparazzo momento* when the Euro-starlet with whom he was posing on the beach at Cannes, suddenly dropped her biki-

ni top. With whimsical gallantry, Mitchum restored her modesty by covering her breasts with his hands. The cameras popped, and there it was: *Major American movie star holding two formidable, naked, foreign, female breasts!* For an amiable herbivore like Jimmy Stewart, this would have been suicide. For Mitchum, it was *no problemo*, because of his jailhouse cool, his psychological unavailability. In this, although it's an unlikely comparison, Mitchum's public vogue was a lot like Oscar Wilde's, in that they both did "moments," confrontational situations in which we are afforded a glimpse, not of secret self, but of the embodied attitude. So what we get is the *performance*: the perfect gesture and the shrewd aperçu, not so much expressed as delivered— and Mitchum could deliver a line. My favorite, from a movie, is in *His Kind of Woman* (1951):

> *Jane Russell:* I hear you killed Ferraro. How does it feel?
> *Mitchum:* He didn't tell me.

Then, in 1958, Mitchum transcended the status of "rambling uncle" for jejune car freaks all over the country when he produced and starred in *Thunder Road*, the first authentic "cult-teen-noir." He also wrote and sang the title song. In case you don't remember, *Thunder Road* is a broody little black-and-white rhinestone based loosely on the legend of Junior Johnson. It narrates the last days of a doomed hot-rodder driving illegal whiskey through the mountains of the mid-South, and as we all sat together in the old Majestic Theater and watched it, everything we always knew was out there—the whole dark, sleazy romance—oozed around the edges of the screen. Later that night, around a table at the Toddle House, we just gave up and admitted that nobody was cooler than Mitchum. Not even *Elvis* was cooler than Mitchum, and thus it was, in recognition of this fact, that I would ultimately make the best decision I have ever made in my life: after a little trial and error, I decided that if I dated only women who thought Robert Mitchum was cool, I would be okay—and, amazingly enough, as long I did, I was, and still am.

This may sound like a joke, but I'm being perfectly serious. This is what culture does for us: it positions us in relation to one another. So, again and again, applying the Mitchum test, I found myself in sexy, dangerous, kaleidoscopic relationships that, somehow, at their heart, were grounded in calm equanimity. When, on the other hand, hormones and ambition drove me to ignore the Mitchum test, to chase some woman who loved Cary Grant, I immediately found myself adrift, lost and confused in alien latitudes of the gene pool. So the Mitchum test worked, like a charm, and I still don't know why. I don't know what it says about Mitchum or myself or the women who found us both presentable. I only know that I owe Mitchum big time, and for some reason, I eluded every chance I had to meet him and maybe compliment him in person on the vivacity of his female fans.

I have been thinking about this a lot since his death, because I could have met him, you know, and nearly did a number of times. I have friends who wrote for him and about him, friends who worked on films with him and sold paintings to him, but for some reason, whenever the opportunity arose, I shied away. Once my friend Scott and I delivered a painting by Edward Ruscha to Mitchum's house. He walked in and we said, "Hi." Mitchum said, "Hi. Hang it over there," and that was that. Upon reflection, I think it was because the privacy of Mitchum's private life was a part of the public magic for me—the terra incognita whose present absence lent his persona its subversive weight. Because whenever Mitchum is on camera or on tape, in character or in person, in word or in deed, he always seems to be declaring the primacy of things we do not know about him.

So, I didn't want to see the private Mitchum plain because I loved the shadowy, refracted glimpses one caught in his public manner. That is the "Mitchum effect"—that jailhouse thing: the commanding physical presence, the cool demeanor, the suppressed inference of a spirit and a sensibility whose unavailability has a haunting appeal. You *know* there is something back there driving the engine and paying careful attention from a remote vantage point, but you don't know what it is. So, whatever Mitchum does on the screen—in per-

son or as a character—seems at once surprising and plausible, full of potential power and menace, whimsy and élan.

Peter O'Toole can do this too, and he describes it in similar terms: there are actors, O'Toole says, who construct a character out of details, who make you believe their characters by constructing a plausible narrative for them, and then there are actors *who are plausible*, in their bodies, who can invest anything they choose to do with plausibility, who *make* you believe it. O'Toole and Mitchum are actors of the latter sort, and in truth, what they do is not really *acting* at all; it is more like performing with a vengeance, physically convincing us that the actions we see arise from a coherent source to which we have no access and cannot understand.

To see the difference, watch Robert De Niro and Mitchum playing the same character, the rapacious Max Cady in the two versions of *Cape Fear*. De Niro's performance is very good and perfectly explicable. You understand the character because it is artfully constructed and powerfully enacted, but you *believe* Mitchum. He's *really* scary because we don't understand, we only sense that the character's behavior arises from some plausible, fucked-up rats' nest of damaged intention lurking somewhere back in the shadows. So we are always surprised and we believe it when we are, and we are afraid of being surprised again. For De Niro, the text is a vehicle, an instrument; for Mitchum, the text is a jail, and by treating it as a jail, Mitchum effortlessly subverts the niceties of popular narrative.

Mitchum is always playing a presence, a moral creature, incarcerated by the text, and when a Mitchum performance works, he burns a hole in the screen, invests the vacant platitudes of professional screenwriting with something dark and strange, simply because he is not playing by the rules: He is *obeying* the rules, of course, as any convict must. He is hitting his marks, making the moves, and saying the words, but he is not *acting* by the rules, not deriving the subtext from the text. Like Coltrane playing a standard, he is investing the text with his own subversive vision, his own pace and sense of dark contingency. So what we see in a Mitchum performance is

less a character portrayed than a propositional alternative: What if someone with Mitchum's sensibility grew up to be a sea captain? Or a private eye? Or a schoolteacher? Mitchum puts himself, literally and physically, into the part and this would be boring if we knew who Mitchum was, but we don't. He remains a stranger in a world where everyone's a stranger.

A few years ago, I was sitting in a friend's loft in SoHo watching Robert Mitchum on a local talk show, and as always, Mitchum was being wonderfully watchable. He was promoting a movie, but the interviewer was one of those well-dressed Broadway queens who like to schmooze on subjects like "the actor's craft," and Mitchum (who could talk about anything) was obliging. At one point, the interviewer asked him about the difference between movie acting and stage acting. Mitchum thought for a minute and said the difference was that the audience watching a movie believes what they're seeing is real. "Not the story," he said, waving his hand, "but the setting and the props, the mise-en-scène. Movies ask us to believe that stuff is real, and we do, because usually it is.

"If I'm on location, shooting a scene where I'm leaning against a tree, the tree is real; the sky behind it is the real sky; the ground I'm standing on is real dirt. The clothes I'm wearing are what the character would wear in that situation, and they're real, too. If I'm carrying a gun, which I often do, it's a real gun. Everything is real, in other words, except *me*, my character. That's fake. It's a made-up person. So you have to use the audience's belief in the setting and the props to make the character real. I'll give you an example: Most actors handle guns on-screen as if they were cap pistols or they blow bubbles. They are real guns, of course, but the actors make them fake. Because they're in a movie, they forget that it's a real gun.

"Now, a real gun is a very serious instrument. It has serious implications and terrible consequences, so you have to handle a gun like that, as if it were serious—as you would handle a very serious thing. If you do this, your character gets real in a hurry—your

character steals the reality of the gun, which the audience already believes. Onstage, it's just the reverse. The setting and props are fake. Or, even if they're real, they look fake. So it's a completely different thing. Also, the stage is *still*. When you're acting in a film, you know that when people finally see what you're doing, everything will be moving. There will be this hurricane of pictures swirling around you.

"The projector will be rolling, the camera will be panning, the angle of the shots will be changing, and the distance of the shots will be changing, and all these things have their own tempo, so *you* have to have a tempo, too. If you sit or stand or talk the way you do at home, you look silly on the screen, incoherent. On screen, you have to be purposive. You have to be moving or not moving. One or the other. Look at Lou Costello on-screen. He's not an impressive creature, but he has *tempo* in spades. He's like a fat little dancer. Also, a lot of times, in a complicated scene, the best thing to do is stand *absolutely* still, not moving a muscle. This would look *very* strange if you did it at the grocery store, but it looks okay on-screen because the camera and the shots are moving around you.

"Then, when you do move, even to pick up a teacup, you have to move *at a speed*. Everything you do has to have pace, and if you're the lead in a picture, you want to have *the* pace, to set the pace, so all the other tempos accommodate themselves to yours. In a furious action scene, for instance, if you move a little more slowly and a little more deliberately than everyone else, you control the tempo. Everyone else looks out of control. Or let's say your character is standing on a bluff looking at a sunset. The sunset is big and still, so if you move—just glance around or resettle yourself on your feet—the sunset wins. You look weak. If you *don't* move, you control the sunset, like John Wayne in *The Searchers*. If that's what you want to do.

"So that's movie acting. You steal the reality of the props and control the pace of the pictures. Oh, also, you have to say these lines, but that's purely secondary. You try not to stutter or drool or blink too much. Otherwise, it's pace and props. If you have the

tempo and people believe you in the setting, they'll believe what-
ever you say, however you say it, if they hear it. So I always try to
speak slowly and very clearly, because I'm a baritone and I have a
lot of melisma in my voice. And that's it. One take. It's not easy, but
it's not hard either. What's hard is believing what you're doing will
work when it's finally on the screen. It's more like riding a horse
than what they teach at the Dramatic Academy. Or shearing a sheep,
as I have, indeed, done."

And that's it: Mitchum's theory of acting. I have elaborated on
his exposition here, to compensate for the absence of Mitchum's
delivery, but this is the full sense of what he said. I wrote it down
in my notebook that night and considered it a very nice gift. It was
like finally understanding, with a little help from the artist, why a
painting has been breaking your heart all these years—and under-
standing, as well, that there is something to understand, that it isn't
just charisma—although it may be an American brand of postim-
pressionism, since Mitchum is less concerned with the validity of
the thing portrayed than with the authority of the portrayal. Then, a
couple of nights later, in that same loft, I saw the theory in practice.
I was watching *The Yakuza*, a 1975 film in which Mitchum plays an
American involved with the Japanese underworld.

Late in the movie, there is a scene in which Mitchum and his
Japanese costar, Takakura Ken, are approaching the gangster's head-
quarters at night, moving through a dark garden. Ken is holding a
sword at his waist. Mitchum is carrying a shotgun. They are both
slightly crouched and moving at a pace through the darkness. Then,
as they descend a shallow embankment, Mitchum's pace breaks; he
seems to overbalance for an instant, and with a little jerk of his hand,
he shifts his grip on the shotgun, tests the balance of its weight,
and moves on with authority. And in that split second, as Mitchum
would put it, the scene gets real in a hurry. We sense the weight of the
gun, its reality and seriousness, the anxiety of moving in the dark
toward danger, the purposefulness of the characters. Everything in
the action sequence that follows draws its frisson from the author-

ity of Mitchum adjusting the weight of the gun, that little hitch in the flow of movement. So I have been thinking about it, testing it in my mind, and on the whole, Mitchum seems to have come up with a pretty good theory: Touch the world. Set the pace. Fuck the text. À *bientôt*, Robert.

The Real Michelangelo

*Late in her life, when Djuna Barnes was living in unapproach-*able isolation in an apartment in Greenwich Village, she became something of a cult figure for the fledgling hipsters in Lower Manhattan, an icon of undergrounds *perdu*, the Garbo of American Bohemia. So Djuna-sightings were faithfully reported. She would be spotted on the street with a little bag of groceries, or gliding past us, eyes forward, on the Fifth Avenue bus. Friends of mine would follow her home, but none of us dared approach her, or even thought to. Just seeing the woman who wrote *Nightwood* was enough for us—and more than enough for her. Once, passing her on Thompson Street, I had the temerity to say, "Hi, Miss Barnes." She glared at me balefully over the top of her sack, hugged it tightly to her chest, and scurried on. I felt like a shit.

A few years later, at a more political moment, a group of women actually gained admission to her parlor. Once there, they importuned La Barnes to speak out on lesbian issues, and she replied firmly, "I am not a lesbian. I just loved Thelma Wood." The women came away from this encounter feeling Djuna Barnes's consciousness to be in an imperfect state of elevation. Those of us who had read *Ryder* and *Ladies Almanack* felt differently, of course. Speaking for myself, I have always been beguiled by the implications of Barnes's remark, because it has always seemed to me that if our worlds change at all, they do so on those singular occasions when passion overrides preference, when desire shatters the hegemony of taste. If we ever know ourselves at all, I suspect, it is only in those moments when we discover exactly what we want—when we encounter that one thing that we never could have imagined, that does everything, and nothing like it will do.

These days, I always quote Barnes's remark when people want to talk about "the art of the motion pictures," because I am not, in truth, a film buff. I just love Michelangelo Antonioni. I saw *L'avventura* in 1961, and that was that. It was everything I wanted a motion picture to be, and nothing like it would do. Since then, I have tried to see everything Antonioni has made, and then tried to see them again, and, today, fifty years after that first bright encounter, I have no reservations: they still do everything, and nothing like them will do. Everybody else is making movies and cinema (which have their own virtues). Only Michelangelo Antonioni is making narrative motion pictures that live in experience and memory the way art does.

Here are the first things I liked. I liked the way the camera stood still and the people moved, because usually the camera is fluttering around like a gnat, shooting reverses and multiangled two-shots. As a result, when I am watching Antonioni's films, I always find myself watching aggressively, hungrily, because everything on the screen is being offered up to be seen. So, as slow as they are, these films always seem to go too fast. I am always reaching for the remote when I watch them on video, then hesitating, because the thing I wanted to see again has been replaced by something just as interesting and affecting. Now I settle for specialized viewing. I watched *Blow-Up* the other night in letterbox, just looking at the corners; then watched it again and just looked at the cropped verticals, the harmonic intervals, and the rebatments of the rectangle. The film was great both times, and different, because you don't just remember Antonioni films, you remember seeing them, the times you saw them, the conditions of watching them, the atmosphere in the theater or the room.

As a consequence, when you see them again, you are really revisiting them, as one revisits a painting in a museum. When you do, however, you realize that the people and places and things in these films have somehow escaped the boundaries of representation, have insinuated themselves into the mainframe, so they now seem to reside in live memory, to possess the tactile contingency of real recollection. It is a very strange effect, but very real, I can assure you.

I never watch the closing sequence of *L'avventura*, in which the heroine, on the morning after the party, wanders through the disheveled palazzo, without smelling the sharp mix of spilled whiskey and cool morning air—without thinking, *Jesus, I've been there!*, and knowing that I never have.

This, in my experience, is exactly the kind of preternatural consciousness that great art evokes, that sense of having been told everything and knowing nothing. Because you are never not aware of the fact that you are watching a sequence of flat pictures on a rectangular screen when you watch Antonioni—and never not aware that these pictures are radical edits of a larger three-dimensional world—and never not aware that you are watching actors in a made-up cinematic narrative. And yet, somehow, amid all this self-disclosing artifice, a genuine and original sense of the way people live in the world always resides, almost as a residue—and this sense lives on in real memory.

So let me tell you about *L'avventura*, the first one I saw. The film begins with a group of friends on their way to a tiny Mediterranean island for a day's outing. Once there, they set out to explore the island, and after a few minutes, one of their party, a woman, seems to have disappeared. Her friends begin an anxious search for her, and at this point, everyone in the theater settles down, recognizing a classic film-narrative setup. The characters have been introduced. Their relationships have been sketched in. Now one of them is apparently in jeopardy. Nothing that follows this setup, however, follows the logic of film narrative. As the friends disperse to search the tiny island, the narrative dissolves into the flatness of real time. The characters pass and encounter one another in a series of tiny, desultory glimpses, gestures, and conversations. The dramatic hooks in conversation, those moments that, in movies, usually signal a changed angle or a cut, are overridden when the narrative continues into the conversation's aftermath. Thus, the urgency of the quest dissolves into the minutiae of everyone's ongoing life, and their attention is diverted, as ours is, by the bleak beauty of the island setting, the lovely effects

of wind and weather, and we think, *Yes! This is what would happen! But ... but ...*

At this point, we realize that we are seeing something a little special. The setup of the quest and its dissolution are too skillfully handled to be inadvertent, but the effect is not a film-effect or a reality-effect, it is an art-effect—a manipulation of artifice that aims to evoke some sort of emotional immediacy—the sort of thing that Beethoven does, and that John Huston would never consider. So we watch the group of friends becoming more and more involved with their own private responses to the situation, less and less concerned with their friend's actual disappearance. They begin to feel put out, exasperated with their lost friend, and now, because we are watching a film, we begin to suspect that the lost woman will eventually reappear to shame her friends for their self-involvement—but Antonioni's characters fail to behave as people in films are supposed to behave.

This expectation hangs there, like a dominant seventh, but it is never resolved. The woman is never found, and eventually, even her disappearance disappears. The narrative splinters, spins out, and concerns itself with new settings and new relationships. New narrative promises are made and never kept, questions are asked and never answered, and the pace of the film is carried forward by the physical logic of Antonioni's exquisite pictures. They succeed one another, cutting and panning from one cadence to the next in a stately adagio that feels like real time, and the characters seem to move in real time, as well, although we can't quite sense their direction, or quite what they are doing. As a consequence, they begin to feel less and less like characters in a movie to us and more and more like real people.

They are *not* real people, of course, only characters moving against the grain of our expectations. Yet we continue to watch because the pictures are beautiful, and because we are not quite sure what's wrong—because we suspect that it may be right. Eventually, we realize that our discomfort is arising *from* the pictures, from the fact that the camera, which we expect to love the characters—which

we expect to zoom in on and highlight the gestures that betray their inner selves—doesn't care. The camera seems to be in love with the physical world instead. It selects one handsome arrangement of that world after another, isolating each fragment in a composition that insists upon the framed rectangle of the whole screen. The characters drift through these pictures, wandering in and out of frame, not knowing exactly what they are doing, and we begin to sympathize with their lostness.

Occasionally, when the characters do something purposive, the camera will pay attention to them, follow them, but then it finds some handsome, geometric arrangement of landscape and architecture and lingers there as the characters wander out of the frame. The effect of this passionate bond between the camera and the whole image of the physical world is to set the characters adrift in a world that extends beyond the image, to emphasize their "aloneness" while granting them a rare kind of psychological privacy. We never know their thoughts. Their neuroses are in their hands and arms, in their faces and in their voices. Monica Vitti is neurotic in her fingernails! Their emotional temperature is totally externalized in the palpable landscape.

Finally, we realize that Antonioni has transformed the visual language of Italian painting—of Guido Reni and Veronese—into a kind of music, and this is troubling to us because "serious movies" in our culture traditionally speak the language of Rembrandt; they aspire to deliver the invisible subtext, the inference of troubled interiority, the psychological truth made visible on the character's anguished face. Antonioni's characters, however, more closely resemble the figures in those antique paintings. Like the heroes and heroines in Tiepolo, they have no interior. Antonioni's characters are handsome and self-contained; they live completely in their bodies and inhabit compositions of similar elegance. In the criticism, this psychological opacity is routinely taken as a signifier of the characters' "shallowness." In my view, this simply means that Antonioni's characters more closely resemble the opaque people who inhabit our lives than the transpar-

ent people who usually inhabit movies, or they *would* resemble the characters in our lives were it not for the fact that everything they think and feel is irrevocably externalized and somehow embodied in the whole picture on the whole screen.

This, I think, is the real key. We can always look at the whole screen when we watch these movies, at everything Antonioni chooses to show us, well assured that the psychological reality of the film is right before our eyes; it is not in the head of the actor, to be inferred from our reading of the actor's face. In American movies, it is precisely this actor-based, face-crazy obsession with Northern European interiority that routinely denies us the spectacle of the whole screen; the camera in these films loves the actor's face, as Rembrandt did, seeks out the "hidden" truth behind it. Antonioni's camera, on the other hand, respects the actor's body and, behaving like a character itself, treats the other characters in the film with elegant decorum.

So the camera pans slowly, horizontally and vertically; it retreats, but it rarely moves in. Time and again, to achieve a close-up, a character will move toward the camera as the camera politely retreats, just a little more slowly. Or the character's face is discovered, suddenly, at the end of a long horizontal pan. If the camera must advance, it never zooms in. It jumps forward with a cut—usually to a classically composed two-shot. Very rarely does the camera advance to anything as crude as a cropped head-shot, and this, I suspect, is because Antonioni is an Italian, who presumes that people live in the world. Head-shots, after all, occlude the whole picture of the body in the world, where meaning resides. The only sequence of extended close-ups I can remember in Antonioni is in the "orgy" scene in *Zabriskie Point*, where the analogy between the dusty bodies of the lovers and the desert landscape that surrounds them is being explicitly drawn.

The consequence of Antonioni's insistence on our watching the whole world in the frame is that we tend to acquire the narratives of these films as we acquire narratives from the actual world, subliminally, while we are watching something else, looking at the corners, or at the handsome diagonals. So, throughout these films, one senses

that the real limitation of the characters is that they cannot see the world they live in—not the way Antonioni does and not the way we do through his eyes—and, consequently, they cannot feel. It is hardly surprising, then, that so many of these narratives tend to resolve themselves in tangible visions of the world—with the characters lost in man-made Arcadias, as they are in *L'avventura*, *La notte*, and *Blow-Up*—or with physical poems like the breathtaking, crepuscular urban montage that concludes *L'eclisse* or with physical visions like the heroine's apocalyptic hallucination that concludes *Zabriskie Point.*

| 150 |

In the aftermath of these final visions, for which the preceding images function as a kind of resonant underpainting, the question of what these films might mean seems trivial, because, in a real sense, they don't mean anything. They *are* something, something we have experienced that will live in memory. So, to cap off a lifetime of experiences with his films, I would like to see Michelangelo Antonioni himself, just once, maybe pass him on the street. I wouldn't make the mistake I made with Djuna Barnes and say something corny like, "Hi, Michelangelo," but I would remember the tangible occasion. I would frame it in memory, in the manner of the master, so, as he approached, he would not seem to be approaching, only growing larger and larger within the frame.

Reading Ruskin Writing

During the spiritualism craze that swept Victorian London in the 1860s, John Ruskin would occasionally allow himself to be brought along by fashionable ladies to complete the circle at séances. On one such evening, Ruskin and a group of earnest seekers had seated themselves around an elegant table in a darkened Mayfair drawing room. They were trying to access "the other side" when the medium in charge suddenly announced in a quavering voice: "John Ruskin! John Ruskin! Do you wish to speak to your grandmother!?"

"I do not," Ruskin replied with alacrity. "I wish to speak to Paolo Veronese."

This is my favorite anecdote in Tim Hilton's magisterial, two volume biography of Ruskin and by far the most intriguing, since Ruskin's remark sounds like a cool, Wildean bon mot, and we know that it is no such thing. Ruskin had no wit, and, as always, Ruskin is making an argument, but, as ever, he is doing so with mixed feelings. With his impertinent request to speak to Veronese, he is reducing the whole "spiritualist" occasion to absurdity by conjuring up the after-life as a vast waiting room within which the legions of the dead mill about throughout eternity, awaiting calls from home. (One imagines Ruskin's grandmother, in the midst of this crowd, turning around and shouting, "Paolo! Paolo Veronese! Call for you!") No one who knows anything about John Ruskin, however, would suspect him of simply speaking for effect or doubt that, had the medium been in actual contact with Ruskin's grandmother, he would have said anything other than what he did.

The more one knows about John Ruskin, in fact, the more one feels the undertone of petulance in his demand to speak with

the Italian painter, because Ruskin was a great critic and a master of English prose, but he was also, always, a sad, excitable boy, a genius mad as a hatter, who made extravagant demands on the world around him. As Hilton puts it, "erudition never calmed him," and so, even as Ruskin mocked the fantasies of that beau monde séance, we can be sure that a part of him was hoping against hope that a torrent of demotic Italian might suddenly issue forth from the medium's lips, presenting him with the opportunity to chat with the noble Veronese. It would have been a good chat, too. No one was better prepared for or more desirous of such a conversation than Ruskin, and this ardent preparation and unquenchable desire, I think, are his great gifts to us. Ruskin *really* cared, and he *really* looked. In the extremity of his caring and looking, he would ultimately evolve into something of a sacred monster—as much addicted to the realm of the visible as he was an adept of its virtues—but the fact remains that no one, before or since, has taken visual art more seriously or written about it with more passion and eloquence. In the words of Rodgers and Hammerstein's song, Ruskin was an adept at "falling in love with love."

Today, no critic in the history of art is less read and more sublimely present. It is really to Ruskin that we owe the idea of visual art as the quintessential manifestation of human endeavor, to him that we owe the idea of visual culture as an enduring embodiment of public and private virtue, and to him, for better or worse, that we owe the idea that "the teaching of art . . . is the teaching of all things." Prior to Ruskin, critics had revered works of art and architecture as the products of human genius and divine inspiration, as objects of spiritual devotion and national pride, as instruments of emulation and instruction. Ruskin regarded works of art and architecture as the moral and spiritual substance of human history, as the palpable texture of human culture, and upon this rock our whole idea of the art museum (as distinct from the museum of artifacts) has been constructed. So it was perfectly appropriate that the old Tate Gallery in London reopened last spring as Tate Britain with an exhibition titled

Ruskin, Turner and the Pre-Raphaelites, concurrent with the opening of the new Tate Modern across the Thames.

Both of these institutions (and all such institutions, in fact) are the progeny of Ruskin's conviction that seeing clearly, "rejecting nothing, selecting nothing and scorning nothing," is a redeeming activity in itself, one that binds us both to the natural world and to our fellow humans. Even the division of mandates between the "old" Tate Britain and the "new" Tate Modern acknowledges the great cultural schism that, in Ruskin's view, made the refuge of the museum necessary: the rise of industrial modernity, whose agencies befouled the air, beclouded the waters, and regimented thought, thus making clear sight impossible. Along with Marx and Carlyle, Ruskin is one of the three great contemporary critics of burgeoning industrialism, and he shares with them a clear-eyed view of its brutal depredations and a repudiation of the common delusion that the future of humanity is ineluctably bound up with industrialism's simplifications. Since these critics have been proved correct, we may, perhaps, divine an intimation of Ruskin's renewed currency from the fact that the "old" Tate Gallery (now Tate Britain) feels so much more available to us, in its Georgian intimacy, than the "new" Tate Modern, which, sadly enough, feels like a grandiose period piece—an oppressive, outsized exercise in plangent industrial nostalgia.

Ruskin, Turner and the Pre-Raphaelites, as organized by Robert Hewison with Ian Warrell and Stephen Wildman, was as thoughtful and scholarly in its conception and selection as anyone could wish. It showed us a great deal about Ruskin at his best and most powerful, at the apogee of his generosity and modesty. We could see in the assembled works why Ruskin's intellectual contemporaries in Britain found him "wild" in his loathing of perfection and order, why Americans like Henry James and Charles Eliot Norton found him "weak" in his revulsion for the "great world" and his retreat into the local and the domestic. In a century obsessed with the grandeur of "great ideas," Ruskin celebrated the fugitive and the factual. In a

century devoted to the rigor of intellectual abstractions, to the logical mechanics of global imperialism, industrial expansion, and utopian social theory, Ruskin revered the intricate, irregular precision of tiny things, distant prospects, and transient atmospheres, clearly seen.

By the inclusion of a large selection of Ruskin's drawings to mediate between the works of J. M. W. Turner and those of the Pre-Raphaelites, Hewison's exhibition managed to demonstrate the paradigm shift that divides Turner and the Pre-Raphaelites while clarifying Ruskin's enthusiasm for each. Turner's paintings portray a world that is virtually all atmosphere. Their subject is always the tragic fate of empire (and of all human endeavor) when pitted against the sublimity and grandeur of nature. The Pre-Raphaelites, on the other hand, painted sharply focused pictures with virtually no atmosphere at all. The narratives of their pictures concerned themselves with the consolations of nature and the "naturalness" of romantic relationships proscribed by traditional society. Turner laments the fate of the old world; the Pre-Raphaelites dramatize the difficulties of the new. What they share is the passion for veracity that we see in Ruskin's fragmentary drawings, which are bereft of any ideology beyond that passion. Thus, for all their acuity, Ruskin's drawings are more critic's art than artist's art, embodying as they do Ruskin's own critical edict that we should see what is before our eyes as clearly and as innocently as possible before passing judgment on it.

At the Tate Britain exhibition, unfortunately, we could share Ruskin's passion for veracity only while enduring the outrageous, Liberace-Victorian mendacity of the installation design, which rigorously embodied everything that Ruskin, Turner, and the Pre-Raphaelites were not about. According to the logic of "New" Historicism, it would seem, works by these artists are damned to hang forever amid the accouterments of vacuous imperial grandiosity that these artists had set out so urgently to contravene. Or, perhaps, there was another agenda in place. Perhaps the idea was to make the freshness of Ruskin and his contemporaries look dated, so the dated modernity of the new Tate might seem a little fresher. In either case,

the ploy probably worked better on the locals than it did on visiting Americans, who could hardly fail to note the eerie resonance between the London art world of the 1850s and '60s and the art world of Manhattan a century later.

Both London and Manhattan, in these decades, were undergoing periods of vertiginous urban growth and consequent social fluidity while experiencing a radical transformation of artistic practice. In London, the tragic expressionism of Turner was being supplanted by the graphic domestic comedy of the Pre-Raphaelite Brotherhood, and under Ruskin's aegis, the British bourgeois art market was coming into existence. In New York, the tragic expressionism of Jackson Pollack was being supplanted by the graphic domestic comedy of Pop Art, and the American bourgeois art market was coming into existence. To understand Ruskin's power and importance in his milieu, then, one need only imagine what it would have been like if the most passionate critical advocate of Pollock had been simultaneously the most passionate critical advocate of Andy Warhol—and had been, as well, a best-selling author, a lecturer in much demand, and a practitioner himself of a vernacular realism that was distinct from both Warhol and Pollock.

All of which is to say that in London, in the 1850s and '60s, John Ruskin was the man of the moment, beloved, respected, and listened to but never quite respectable, you know, and never really accepted by the official administrators of Victorian culture, who found his views too extreme, too ardent, and his private life quite notoriously suspect. As a consequence, perhaps, of the persistent institutional reservations about Ruskin's public preeminence, and certainly as a consequence of his loathing for industrial society, Ruskin's writings have become less and less available to us during the hundred years since his death. Also, there is the problem of religion. During his life, Ruskin fought the nineteenth-century war between the Art of Religion and the Religion of Art within the confines of his own spirit. Now that the Religion of Art has long since triumphed, the anguish and equivocation of Ruskin's struggle can seem a bit quaint. The fact

that Ruskin was deeply concerned with the nature of the sacred and the substance of devotion, however, should no more diminish the contemporary relevance of his writing than it does that of Walter Benjamin, who was similarly obsessed.

It has diminished it, however. In the current moment, Ruskin's presence remains as the ghost of his detractors—so much so that a great many of the inconsistencies in high-modernist theory may be traced directly to inconsistencies in Ruskin that modernist critics (setting out to rebut Ruskin point by point) perpetuated. Adolf Loos's remark that "ornament is crime," for instance, seems strident and peculiar today without the inferred presence of Ruskin's contention that all great art is praise and that, in architecture, ornament is the modality of praise. For a utopian like Loos, of course, the very idea of praise was counterproductive, noncritical, and an invitation to complacency. It made the utopian rigor of the modernist future seem less necessary, and anything that impeded this future was a crime. All this is lost, however, with the loss of Ruskin's prior discourse, leaving contemporary architects with the task of reconstituting Ruskin in one form or another to repudiate Loos.

Ruskin is always there, in other words, and always returning, yet never quite codifiable, and the charm of his legacy might be said to reside in the proliferation of his protean inconsistency. As Ruskin himself remarked in 1858, in an inaugural address to the Cambridge School of Art, "I am never satisfied that I have handled a subject properly until I have contradicted myself at least three times." This may sound whimsical, but Ruskin was deadly serious in both his argument and its application. His entire critique of industrial society began with high detestation of specialization and the division of labor, which, he argued, resulted in the division and diminution of human beings, enacted through the fracturing of thought and sensation, of time and space, of body and mind, of act and intention, of planning and execution. Thus, he became mildly hysterical at the proposition of either "pure thought" or "pure sensation," and in this, he quarreled with utilitarians and romantics alike. Here, from the

third volume of *Modern Painters*, is his response to Walter Scott's and William Wordsworth's contentions that their delight in nature was the benison of thoughtless, pure sensation:

> [Wordsworth's and Scott's] delight, so far from being without thought, is more than half made up of thought, but of thought in so curiously languid and neutralized a condition that they cannot trace it. And observe, farther, that this comparative Dimness and Untraceableness of the thoughts, which are the sources of our imagination, is not a fault in the thoughts at such a time. It is, on the contrary, a necessary condition of their subordination to the pleasures of Sight. If the thoughts were more distinct we should not see so well, and beginning definitely to think, we must comparatively cease to see.

Ruskin's response precedes Oscar Wilde's subsequent observation that Wordsworth went into the wild and found "sermons in the stones." Both observations rather succinctly define the discomfort modern readers feel when reading Ruskin (and sometimes Wilde). Ruskin's writing never ascends to the geometry of pure thought, nor does it descend to the atmospheres of pure sensation. Ruskin argues (as does Gilles Deleuze) that neither event can actually take place—that, in our vanity, we only mimic the pretense of such pure disassociations. Embodying this conviction, Ruskin's writing cleaves to the world; it rides the fulcrum of cognition and sensation, so when we are reading him, we are never reading books or encountering thought; rather, we are dwelling in the realm of sense, reading Ruskin writing and experiencing the flow of Ruskin thinking on the edge of sensation. Our experience in this realm is further complicated by the fact that Ruskin is probably the most learned writer in English literature without the faintest scholarly inclination. His colleagues at Oxford would remark that he seemed to possess virtually no "knowledge" yet somehow maintained the full

resources of Latin and Greek, the whole of the Bible, and the bulk of English literature not in his head but on the tip of his tongue, in a condition of intricate verbal readiness, as a vehicle for his passion.

So the writing is dense and the later writing even more so. English literature would have to wait until James Joyce for more elaborate explosions of cultural reference and allusion than those found in *Fors Clavigera*—indicating roughly Force, Fortitude, and Fortune comingled—a series of personal meditations addressed to the English workingman published as pamphlets between 1871 and 1884. For spirits like Ruskin's fellow dons at Oxford and their contemporary descendants, in search of ready knowledge, such explosions of allusion and reference are invariably exasperating, in Joyce or Ruskin. This, however, is no reason not to read Ruskin, because we don't read Ruskin for his thoughts; we read him for his vision and conviction—for his writing and because he makes *us* think. We read him because even though Ruskin is occasionally a fool, he is never stupid, never cold, and never boring. Here he is responding in a letter to a believer's assertion that the Bible is the "word of God": "Nothing could ever persuade me that God writes vulgar Greek. If an angel [with] all over peacock's feathers were to appear in the blue sky now over Castle crag—and write on it in star letters—'God writes vulgar Greek'—I would say—'You are the devil, peacock's feathers and all.'"

A contemporary reader, having been exposed to excerpted aperçus of this sort, and confronting the intimidating mass of Ruskin's writings, has a right to ask about the possibility of personally gaining access to them. The tendency is to stand in a state of extreme frustration at the edge of what seems to be an impenetrable jungle, fully aware that it is populated by angels in peacock's feathers and at a loss for a way in. By way of entrance, I would suggest *The Stones of Venice* (1851), Ruskin's history of Venetian culture as told by its architecture. Specifically, I would suggest an unabridged version of the section entitled "The Nature of the Gothic," which expounds at some length on Ruskin's primary, informing idea that human beings, being predisposed to resist boredom, invariably resist authority and

seek freedom, whose physical signifier is irregularity, variety, and intricacy. From this premise, Ruskin derives his critique of contemporary architecture and contemporary government as "planning practices" that isolate themselves from the actual creative work of building. Ruskin's question is this: how can an ethical architect, or an ethical bureaucrat, possibly design a structure that degrades the spirits and steals the souls of the beings who actually build it—that destroys them with repetitive labor which requires of them nothing of their humanity?

From this question, one may achieve access not only to the writings of Ruskin but to the entire discourse of postindustrial culture as well; and one may locate Ruskin within this discourse by regarding *The Stones of Venice* as the only achieved precursor of Walter Benjamin's unrealized *Arcades Project*, which was planned to be what Ruskin's volumes are: a cultural history told through the proliferating relationships of material artifacts, in Benjamin's case the shopping arcades of nineteenth-century Paris. Benjamin's writings, in general, offer us the most congenial contemporary entry point into Ruskin's sensibility. Ruskin is by far the better writer of the two, but both Ruskin and Benjamin are confirmed mystical materialists, lovers rather than fighters, who understand the technological and economic changes afflicting the world they live in and who, fully aware that one cannot go back, remain irrevocably nostalgic for a lost way of seeing and being. When Ruskin laments the loss of "awe" and Benjamin laments the loss of "aura," they are lamenting the same loss, equally unaware that the industrial culture they saw flourishing around them was not going to last forever, that another time would eventually present itself in which freedom, eccentricity, foolishness, clear streams, blue skies, variety, and intricate diversity would once again attain the status of virtues toward which human beings would aspire.

The Villa Poiana, designed by Andrea Palladio. Photo: Sistema Siti Unesco Veneto.

Palladio's Song

In the year 1535, in the small city of Vincenza on the Venetian terra firma, a twenty-six-year-old stonecutter from Padua married a carpenter's daughter. The groom, one Andrea di Pietro, was a member of the masons' guild and locally employed at the Pedemuro workshop under the tutelage of its *capomaestro*, Giovanni Porlezza. His bride, Allegradonna, worked in the service of Lady Angela Poiana, a Vincentine noblewoman who provided her maidservant with a dowry valued at twenty-eight ducats and consisting of a bed, a pair of sheets, three new shirts, three used shirts, handkerchiefs, and assorted clothing and lengths of cloth. For the first two years of their marriage, Allegradonna and Andrea share his room at the construction shop. They use the lengths of cloth for curtains.

Ten years later, Lady Angela's husband, the *cavaliere* Bonifacio, commissioned this same young man to design and build for him a substantial agricultural villa at Poiana Maggiore, and Andrea di Pietro (now better known as Andrea Palladio, architect to the *nobili*) would reward his old friend's patronage by creating one of the touchstones of domestic architecture in the West, the Villa Poiana, which still stands on the flat, lowland plain south of Venice just beyond the hamlet of Poiana Maggiore. It is visible from the road, a chalk-white, symmetrical shoebox of plastered brick surrounded by cultivated fields.

The villa's unadorned, gabled façade pushes slightly forward from the rest of the house. It hints at being a temple front, but the horizontal entablature of its triangular pediment is interrupted by a tall, central plaster fascia. The fascia is penetrated by one slender arched doorway that is flanked by two slender portals. All the open-

ings provide access to a loggia, an elaborately decorated recessed porch. These openings are flanked in turn by two rectangular windows. The plaster fascia over the main entrance is haloed by five circular recesses—an arch of blind oculi. The entire ensemble, atop a shallow flight of stairs, forms a radically stylized Palladian door. The effect is eccentrically handsome and sweetly austere. For a modern visitor, approaching the villa on foot, the building stands there like the ghost of a modest and elegant past amid an agricultural landscape dotted with curvaceous, candy-colored contemporary farm equipment.

I remember wondering, as I climbed the stairway for the first time many years ago, how I could be so aware of the villa's cultural remoteness while sensing with the same certainty that there was nothing ill-designed about it. Any temptation to read some prescient modernity into the façade's simplified design is forestalled by life-sized statues of three Muses (of drama, music, and painting) that adorn the top of the pediment. Two more statues, these representing Hercules and Neptune, stand on the stair abutments guarding the entryway. Yet Palladio's forms were so physically impeccable and deftly arranged that the building could just as easily have been an icon of the future as of the past.

Intrigued by this impression, I walked back out into the courtyard and stood there staring at the building. I began to see that the elements that had, to my modern eyes, at first appeared extrinsic and decorative—three ethereal Muses at the peak and the edges of the roof and two other mythical figures on the stair abutments—form a circle that rests on the top of the stairway, embraces the heart of the house, and implies another circle whose diameter rests on the stairline. Above this, the blind oculi crowning the entryway create a smaller circle that centers the whole composition. These elements—harmonized in real space—constitute the essence of what I now think of as Palladio's song: one design, three circles, five life-sized gods of grace and power, five generous portals for their mortal counterparts, and five blind eyes to gaze with calm disinterest on the world beyond their brave redoubt.

To hear the song more clearly, one need only step from the villa's shadowy loggia into its grand *sala*. If the villa's exterior is all rigor gladdened by *sprezzatura*, the interior is all *sprezzatura* harmonized by formal discipline. The *sala* is exactly the size you want it to be, about the size of a generous SoHo loft, with a frescoed ceiling. Its white walls are washed with complex patterns of light from a large rear window whose design mirrors the front façade, although the oculi are clear this time and have been glassed and look out across ancestral lands. The rooms off the *sala* are more personal and ebullient. Their walls are solidly frescoed with trompe l'oeil architecture designed by Palladio to frame a profusion of painted narratives and landscapes. In the grandest room, the Sala degli imperetori, Anselmo Canera has painted a series of intricate but antiseptic Roman equestrian battle scenes. Off this *sala*, a more intimate *camarino* has been frescoed by Bernardino India into a fantasyland of monkeys, parrots, nymphs, satyrs, and lascivious cherubs.

The overall effect comes close to that which Inigo Jones would describe, nearly a century later, when characterizing his own Banqueting Hall in Whitehall Palace: "Outwardly every wyse man carrieth a graviti in Publicke, yet inwardly hath his imaginacy set on fire, and sumtimes licentiously flying out, as nature hirself doeth often times stravagantly." Jones expounds Palladio's idea that a building might emblematize our inner and outer selves, but he misses the delicate tonality that marks Palladian architecture as regional. The charm of Palladio in stucco becomes overbearing and breathless in granite. As a child of the Baroque, Jones instinctively pressed Palladio's theatrical balance of the inner and outer self into the realm of Manichean drama. By contrast, Palladio's "stravagance" was never that extravagant nor his licentiousness ever that lusty. He built civilized structures to sit in cultivated land, and the secret of their elegant theater has always been their blessed absence of drama.

Today, Palladio is acknowledged to be the most influential and imitated architect in the history of Western civilization, and *I quattro libri dell'architettura* (1570), his masterpiece of practical lucidity,

ranks along with the Bible, Shakespeare's plays, and Caesar's commentaries as one of the indispensable texts that accompanied the culture's expansion. Amazingly, all Palladio's written works survive, along with nearly three hundred of his working drawings. Of his buildings, the vast majority of his palazzi, basilicas, theaters, and churches, built of stone in Vincenza and Venice, remain. They were designed to last and most of them have. In addition to these, Palladio designed thirty agricultural villas to be made of altogether more ephemeral materials—timber, brick, and stucco with stone accessories. Construction was initiated on twenty-eight of these villas, twenty-four were completed, and today, four hundred and fifty years later, seventeen survive, tucked away in the Italian countryside. These buildings constitute the jewels in Palladio's crown, and Witold Rybczynski's book *The Perfect House: A Journey with the Renaissance Master Andrea Palladio* (2002) is an amiable and knowledgeable companion for anyone making the pilgrimage in search of them. Rybczynski recounts his own tour and provides us with an evenhanded historical introduction to Palladio, accompanied by a thoughtful meditation on the extent and sheer complexity of the architect's achievement and influence.

The human resources out of which Palladio's achievement was constructed remain elusive. The bare historical narrative illustrates the most beguiling attribute of Andrea Palladio's career: his apparently effortless ascent from the artisan classes to heights he could not have imagined growing up as a mason's apprentice in the Venetian lowlands. It is a career that bears comparison to that of Palladio's near contemporary William Shakespeare, who codified modern English as Palladio codified architectural practice. Through what seems an improbable confluence of talent, circumstance, and happy chance, they were able to follow their interests, find their friends, do their work, and achieve the fame they deserved in their own lifetimes. In Palladio's case, you can search the documents for those revealing moments of conflict, rejection, and misunderstanding that define our perception of artists like Michelangelo or da Vinci and find no

evidence that Palladio ever even complained, much less fought or ever struggled.

His friend and biographer Paolo Gualdo, who was canon of the cathedral at Padua, assures us that Palladio "gave the most intense pleasure to the gentlemen and lords with whom he dealt" and that he also kept his workmen "constantly cheerful, treating them to so many pleasant attentions that they all worked with the most exceptional good cheer. He eagerly and lovingly taught the best principles of the art, in such a way that there was not a mason, stonecutter, or carpenter who did not understand the measurements, elements, and rules of true architecture." Looking at the buildings, I tend to believe this. Even Vasari, who was instinctively competitive and far from an easy sell, found Palladio to possess "a nature so amiable and gentle, that it renders him well beloved of everyone." And the people of Venice, who were, if anything, an even harder sell, rewarded him with a satirical encomium of the sort one bestows upon a beloved but eccentric uncle.

> Palladio does not visit prostitutes for any bad reason
> And even if now and again he does visit them
> He does it in order to urge them to build
> An ancient atrium in the brothel district.

So what do you do, biographically speaking, with a great artist whose talent and intelligence no one ever thought to doubt, whose secret intentions no one ever thought to question—who seems to have been, in fact, the incarnation of charm as an epic virtue? Well, first, you don't doubt it. Charm is the one, unfailing resource of artists who function in the social sphere and who, like Palladio, have risen in the world. Charm defends these spirits by investing them with a giddy sense of well-being that makes even the most casual curiosity about the source seem de trop. Who, after all, would presume to cavil at Cary Grant's *pedigree*? Or Elsa Schiaparelli's *motives*? Or John Singer Sargent's *morality*? Charm is the last, single, solid, impervious shield

against the vices of modernity, and in Palladio's case, since charm is a virtue universally ascribed to his buildings, there is every reason to believe that his was genuine.

Nonetheless, architects in the sixteenth century were paid by the drawing and only occasionally honored with a casual gratuity by their all-too-forgetful clientele. Sometimes, if they were exceptionally politic and lucky, professional architects were placed on municipal retainer. Late in his career, Palladio himself was so retained by the city of Vincenza, but Vincenza is a small city and the retainer was proportionately modest. As a consequence, Palladio's fame and exalted professional status, even at its apogee, never translated into financial security or genuine social advancement. So, from the age of thirteen, when he was apprenticed to a stonecutter in Padua, until the age of seventy-two, when he died on a construction site at Masur, Andrea Palladio worked, and as his friend Giambattista Maganza remarked, "what he made he spent." And that is the whole story. Palladio carved, carried, studied, wrote, drew, designed, built, and died. He sailed like a steady ship of industry through the tempest of vanity, vendetta, and violence that ravaged his times. He produced tangible things that people valued, preserved, and passed along to people who valued them, preserved them, and passed them along in turn.

It would be hard to imagine a better setting for Palladio's coming of age as an architect than the Veneto of the 1530s. In truth, only there and at that time was Andrea Palladio even possible. During the late fifteenth century, the Republic of Venice's maritime power had weakened and loosened its grip on eastern trade. These irrevocable economic realities occasioned a new interest on the part of Venetian aristocracy in the commercial possibilities of agriculture on unexploited terra firma surrounding the city, which in turn led to a building boom in the Veneto. As luck would have it, this burgeoning commercial renascence was intellectually enhanced when Lutheran mercenaries sacked Rome, in 1527. The Sack of Rome caused social chaos and the collapse of papal patronage, and a top-

tier diaspora of aristocrats, artists, and intellectuals fled to Venice and the Veneto.

Thus, there were buildings to be built, money to build them, and a competitive intellectual atmosphere to refine their aspiration. There were other material benefits too. During a period when most European architects were covering windows with oil paper and canvas to achieve murky translucency, Palladio, working near Venice, the greatest single source of glassmaking in the West, had plate glass affordable and plentiful enough that he could invest his domestic spaces with breathtaking lightness. And at a time when most European architects acquired their knowledge of antique and modern architecture by word of mouth or through the medium of circulated drawings, the Venetian publishing industry made the world both available and affordable to the young Palladio—just as it would ultimately make Palladio available and affordable to the world.

Amazingly, even the system of architectural patronage, which should have hindered Palladio, worked to his advantage. At the time, Jacopo Sansovino was official architect of the Republic of Venice and therefore had his pick of civic projects. Michele Sanmicheli was the republic's chief military architect and thus controlled those commissions. So young Andrea Palladio was thrown by necessity into the less prestigious practice of domestic architecture and had the field more or less to himself.

Along with these concrete advantages, Palladio inherited a short but rich tradition of classical appropriation, called the *all'antiqua*. Founded in the late fifteenth century to reconfigure culture of the Italian peninsula along Roman lines and to purge contemporary building of Byzantine Gothic excess, the tradition began with the harmonious restraint of Bramante and Raphael. This thoughtful classicism was subsequently dramatized in the Mannerist architecture of Michelangelo and Giulio Romano. Palladio's innovation was to civilize and domesticate the exaggerated lines of Mannerism without falling back into classical mimicry. In successfully managing this synthesis—blending the classical idioms of his predecessors,

the fashionable tastes of his Venetian clients, and the unforgiving prerequisites of rural domestic housing—he created the first truly modern, indigenous Italian architecture.

Palladio's progress toward this achievement began in 1537 when the Pedemuro workshop received a commission to remodel a house in Cricoli, just outside Vincenza's northern city gate. The house was owned by the fifty-nine-year-old scion of Vincenza's oldest family, Count Giangiorgio Trissino, who for many years had been a resident of Rome. Count Trissino was the very model of a Renaissance intellectual, a restlessly cosmopolitan scholar, poet, and amateur architect who moved in the highest circles and counted Isabella D'Este and Lucretia Borgia among his confidantes. Trissino was no snob, however. He was an articulate meritocrat who, since leaving Rome after the Sack, had become a passionate booster of his hometown. In keeping with this project, the house in Cricoli was redesigned in the *all'antiqua* style and stripped of its outré Gothic accouterment. It was to house an academy of his devising that would bring progressive Roman culture to the provincial Veneto.

Legend has it that Count Trissino met Andrea di Pietro on the building site at Cricoli. There is no documented evidence for this, but it is a reasonable supposition—as Rybczynski asks: "Where else would a count encounter a stonemason?" The two developed a close relationship. Trissino found Andrea di Pietro to be "a young man of very spirited character and with a great aptitude for science and mathematics." Andrea di Pietro found in Trissino an egalitarian patron who encouraged his natural abilities, trained him in the precepts of Vitruvius, and introduced him to the world outside Vincenza. In 1541 and again in 1545, Trissino would take Palladio to Rome, where the fledgling architect would make the measurements and drawings that were eventually to establish his scholarly fame.

The first trip that patron and protégé took together, however, in 1538, was to Padua, the city of Andrea's birth and of his first apprenticeship to a local stonemason. While he had been away, Padua had become newly cosmopolitan and the intellectual seat of the region.

Here, at the home of Alvise Cornaro, Andrea met two of his esteemed future colleagues, Michele Sanmicheli and Sebastiano Serlio. He also met four university students from Venice, Vettor Pisani, Daniele Barbaro, Giorgio Cornaro, and Pietro Godi, all of whose families would later commission villas from him.

It became increasingly clear that Count Giangiorgio Trissino had all but appointed Andrea di Pietro as the first, great architect of Vincenza. Two years later, Andrea would begin signing himself | 169 | "Palladio," a name with deep personal significance for Trissino. Early in his career, the count had written a Homeric epic, *L'Italia liberata dai Goti*, recounting the campaigns that the Roman general Belisarius waged against the Ostrogoths in sixth-century Italy. At one point in Trissino's narrative, an architecturally trained angel named Palladius guides the heroes through a splendid palace emblematic of Italy's Goth-free past and Goth free future. Trissino had named the angel Palladius after Pallas Athene, the goddess of wisdom. By taking his own name from Palladius and Athena, Andrea Palladio claimed their dual inheritance. He would, after all, spend the rest of his life liberating Italy from the Gothic.

Palladio's influence persists today because works of architecture are not works of art. Works of art are wild cards in the hand that culture deals us. Their function is not determined until the hand is dealt, and as a consequence, art remakes and reforms itself through a frictionless process of addition or subtraction. For better or worse, works of architecture are not so protean. They may be subject to the whims of fashion and driven by the exigencies of climate and technology, but they are face cards in that mythical, cultural hand—their function does not change. There is a world of difference between suppressing the painterly mark as Roy Lichtenstein does in his paintings and suppressing the windowsills and stair banisters in a public building. Thus, Palladio's parameters of "convenience, durability, and beauty" still apply, and the practice of architecture changes within their narrow window of forgiveness. Because of this, any successful work of architecture is mightily predisposed to remain so,

as Palladio's have. Palladio's buildings remain repositories of artistic options in a way that Michelangelo's sculpture or Raphael's painting do not. A painter may admire Raphael and a sculptor revere Michelangelo without confronting the challenge of their mastery on a daily basis. No architect can stand in a Palladian space without feeling the live challenge of its effortless grace.

The Palladian challenge to subsequent architects is all the more pressing because Palladio was, after all, the first great scholarly authority on his own buildings and their first great popularizer. His reputation has always derived as much from the conceptual elegance of his *Quattro libri*—from the portable, practical applicability of that book—as from the mysterious eloquence of the buildings themselves. There is Palladio the meticulous scholar of antique architectural practice and pedagogue who taught the West how to build, and then there is Palladio the conscientious artisan, quiet poet of Renaissance classicism and scourge of Gothic excess.

Palladio's book and Palladio's buildings, his theory and his practice, have such distinct constituencies that there may well be no single, living Palladian who, in his or her heart of hearts, loves both. The schism is a defect of contemporary culture and not of Palladio, but it is no less real for being so. Scholars and theorists love the *Quattro libri*, which are all history, design, concept, rigor, and process. Belle-lettrists and closeted architects love the buildings, which never quite conform to their own conceptual schemata and invariably present themselves as symphonies of nuance and detail, of angled light, shifting texture, and palpable atmosphere.

Some scholars, perhaps wanting Palladio's buildings to be conceptual artifacts like his theories, argue that the villas never were intended to be "real" farmhouses with functional attic granaries and usable stables but rather were meant to be genteel "ceremonial" farmhouses—faux temples with symbolic stables and vestigial granaries. The traditional distancing of aristocratic life from commerce, they argue, would have precluded actual grain in the attic or live horses right next door, and even if it didn't, horses smell bad, and

grain makes dust and attracts mice. Theorists like this kind of argument, because if Palladio's villas were, in fact, "symbolic" farmhouses, they may be said to house the "idea" of farming, as contemporary museums house the "idea" of art and court buildings house the "idea" of justice. By disdaining to store grain and to shelter animals, the villas might qualify as serious, canonical "critical architecture" by contemporary standards.

There are three problems with this argument. First, it ignores the historical etiology that justifies building farmhouses as Roman temples. In Roman religion, augurs traditionally stood within a rectangular site called a *templum*, where, facing south, they would read the signs of weather and wildlife to predict the future. Farmers do the same, and the practice of augury always declared its roots in the ancient agrarian life of the Italian peninsula. Nothing could be more correctly or self-consciously *all'antiqua*, then, than closing this circle and building a Roman temple as a farmhouse. Second, the argument presumes that sixteenth-century *nobili* were as prissy about mice, dust, horses, and commerce as contemporary architects. This leads to the doubtful conjecture that a commercial farmer, because of his lineage and the dust, would expose a cash crop to theft and the elements in a temporary structure while a secure, elevated, aerated granary waited readily at hand. Finally, and most egregiously, the argument implies that horses smell bad. As the child of a family no less enamored of the horse than your average, galloping Venetian aristo, I must insist that, for horse people, *nothing* about a horse smells bad.

Strangely, though, neither Palladio the theorist nor Palladio the practitioner, considered separately, is entirely persuasive. Palladio is a great designer and a master builder, but the poetry of his buildings is far from uniformly inspired, and the abstract underpinning of his practice is usually more conventional than conceptual. Basically, Palladio had one general idea. From left to right, inside and out, and bottom to top, Palladio's villas aspire to present themselves as extensions of the human body. Seen from the front or back, they mimic the body's left-right symmetry. Inside and out, they express the courtly

metaphor of outward decorum and inner grace. Bottom to top, the buildings ascend in decreasing increments that allude to the legs, torso, and head. Seen from the side, the buildings are, in fact, boring (with the exception of the famous Villa Rotunda, which has fronts on all four sides). Seen from above, the footprint of a typical Palladian villa is just a stretched façade. The front is projected onto the back, so the prospect of the building from behind is a nuanced mirror image of its front. All these strategies are effective, of course, and in some sense original, since there was no strong tradition of freestanding domestic buildings in the Renaissance. But it is hard to imagine them impressing us today were it not for Palladio's gift for intimate grandeur. Put simply, the man knew scale. He knew how big was too big, how high was too high, and how wide was too wide. He understood that human beings feel the space they inhabit as an extension of themselves and that, as the space expands, so does their sense of proprietorship. The larger the space grows, the larger we feel, until, suddenly, with that last anxious inch, we feel small, as our presence is dwarfed by the enclosure. Palladio invariably expands his spaces to the warm inner edge of this point, and feeling this, we are charmed by his making us larger and flattered by his not making us smaller.

Perhaps this is why so many first-person accounts of Palladio's buildings describe them as magical artifacts. The villas are found to be "enchanting" and "uncanny." They "cast a spell" and "hypnotize." Goethe was awestruck by the authority of their physical presence. "You have to see these building with your own eyes to realize how good they are," he writes. "No reproductions of Palladio's designs give an adequate idea of the harmonies of their dimensions; they must be seen in their actual perspective." Palladio worked in an age that saw aesthetics as the science of happiness, and if a perfect house may be described as a domestic structure in which one feels more charmed, amazed, and blessedly at ease than human beings have any right to be, two or three of Palladio's villas must qualify. Even those predisposed to sneer at the very idea of "perfection" or "mastery" must ultimately acquiesce to the body's assurance that what

Fred Astaire is to savoir faire, what Lou Reed is to resentful pettiness, Palladio is to graceful equanimity.

This is no small gift, but it is the gift of theory in practice and not of one or the other. By dividing Palladio, reducing him to a scholar, we deny ourselves access to the transitional territory, in which Palladio emerges as someone who knew exactly who he was and exactly what he was doing. This is a Palladio who makes sense, a Palladio possessed of the subtle ability to convey that, as lovely and powerful as his buildings might be, he is just another tradesman lively at his work. This trick, which is not really a trick at all but the attribute of a generous personality, explains why Palladio's buildings are never quite as intimidating as their clients might have wished them to be— why their aspirations to grandeur always bear with them the exquisite glimmer of a smile.

This aura of sweet self-consciousness is the key to Palladio's charm. Viewed in its light, the distance we instinctively feel between the exquisite form of his buildings and their quotidian functions seems less critical or ironic than joyfully self-aware. Palladio, showing us his hand, lays it out for us and rescues these buildings from the vice of pretension by the simple stratagem of not pretending. Unlike most of his predecessors and contemporaries, Palladio is never impersonating classical architecture; he is *performing* it—and, being Palladio, he arrived on the scene at exactly the moment when the performance could best be appreciated. It is reassuring that it still can be, since the real benison of Palladio's performances is the good-natured permission they grant us to take the stage he has provided and perform with commensurate self-conscious elegance.

Morris Lapidus

Fontainebleau on Collins Avenue in Miami Beach is a nifty hotel and a multifaceted cultural monument. Fontainebleau's opening in 1954 marked the rebirth of Miami Beach as a luxury resort. Today, the hotel's example informs the insouciant look of Miami Beach itself—Lapidus Land, it might be called. Its elegant curved façade stands along with Cadillac tail fins, starburst clocks, and boomerang coffee tables as a monument to the gregarious vernacular of postwar America, which is only now receiving the respect it deserves. More seriously, Fontainebleau marks the global debut of conceptually driven commercial architecture. It stands as a tribute to its architect, Morris Lapidus, who had the courage, the education, and the enthusiasm to create the first freestanding building designed not just to house commerce but to facilitate it.

When Lapidus embarked on his Fontainebleau project, he was already a famous designer. He had revolutionized commercial design in Jazz Age Manhattan with his trademark boutiques. In the '30s, the chain store did for Lapidus's designs what the phonograph record did for popular music. It became the magic vehicle of dissemination. During this period, the design innovations Lapidus created for toffs and flappers in Manhattan—the Theresa Pharmacy, the Parisian Bootery, the Regal Shoe Store, the Doubleday Book Store, and the Palais Royale nightclub (designed as a speakeasy for Benjamin "Bugsy" Siegel)—spread across the country, sometimes under Lapidus's supervision and sometimes the "Lapidus look" was just stolen. So pervasive was Lapidus's influence on the look of postwar America that it's hard to imagine now that in 1931, in Jacksonville, Florida, Lapidus had to argue strenuously with Mr. Mangel, of Man-

gel's Ladies Apparel, to let him paint the interior of a new shop in a variety of colors, *for the first time ever*. Lapidus painted the store in pale greens, roses, and blues. It worked.

Hollywood was quicker on the uptake than Mr. Mangel. Lapidus's '20s-look designs were integrated into the deco chic of movie musical sets throughout the '30s for Busby Berkeley extravaganzas and movies starring Fred Astaire and Ginger Rogers. Lapidus would ultimately steal their versions of his own ideas back for his resort hotels. In this way, Morris Lapidus redesigned the parts of America where most Americans spent their time. Everything from the boutiques on Fifth Avenue today to the mega mall and themed casino resorts derives from his essential imaginings. Like Norman Rockwell, Lapidus saw the *theater* of American stores. He understood American commerce as Scott Fitzgerald did, as a landscape of Gatsbyesque dreaming. "It's all theater," Lapidus said to me, "that's where I started. As a young man, I wanted to be an actor, probably because, for immigrants of my generation, who didn't know anything about America at all, it was all theater anyway."

It never occurred to Lapidus that one shouldn't refine this mythical landscape of consumable dreams and invest it with style. Instead, this would become Lapidus's métier, and during his itinerant years, he evolved a solid, conceptual understanding of just what commercial architecture could and should do. Out of this understanding, he would design Fontainebleau, an iconic luxury hotel that had nothing to do with luxury hotels of the past and everything to do with luxury hotels of the future. As Lapidus put it to me, "My negative example when I started Fontainebleau was the Biltmore in Coral Gables with its dark spaces and off-putting aura of old-time gentility." Lapidus's Fontainebleau spoke a new language, one that Lapidus himself had invented: the language of the boutique, the theater, the nightclub, the movie, and the arcade—the new American world.

So Fontainebleau made history. It declared commercial architecture's independence from the tastes and traditions of public, residential, and industrial design and, like most declarations of

independence, Fontainebleau started a war. This war was fought on battlefields far removed from the James Bond glamour and George Raft swank of the actual hotel, far from the beach, the babes, and the blue cocktails in the lounge, but it was a serious war indeed. The morning after Fontainebleau opened, Lapidus woke up to find that all the dramatic innovations for which he had been so highly praised in the shops of New York were deemed outrageous and vulgar in a freestanding hotel in Miami Beach. Lapidus was shocked and nearly destroyed by the hostile reception. He never fully realized that he had crossed an invisible class boundary by actually designing a building, and he bore the scars of having done so for most of his life, but he lived long enough to see the war won.

The combatants may be variously defined. Lapidus saw it as a conflict between his own "architecture of joy" and a cadre of academic killjoys. There is much to be said for this position. Lapidus took the human comedy very seriously. (His largest surviving painting is not a picture of a building at all, but a painting of people listening to a musical performance, Rubenstein at the piano, painted in a style somewhere between Hogarth and Rockwell.) As Lapidus would tell you, he watched people, not walls. He took the bright theater of human sociability as his personal arena. Irony, surprise, wit, serendipity, coincidence, bathos, and outrageous extravagance were tools in his toolbox, and there was no law against them until Lapidus used them to such great effect in Miami. One might describe Lapidus's vision of public space by extending the title of his second autobiography, *Too Much Is Never Enough*, so it reads *Too Much Is Never Enough, but Just Enough Is Nothing Much at All*.

In my own view, this part of the quarrel was, in essence, pedagogical. It arose less from what Lapidus did than from the fact that he knew what he was doing—from the fact that Lapidus provided a conceptually coherent model for commercial architecture from which other architects could and did learn. It was as if, after years of playwrights learning to write plays from Aristotle's writing on tragedy, Aristotle's lost book on comedy was suddenly available. So,

academics hated Lapidus, not for his buildings, but for the exquisite rationality of his ideas, for the fact that his buildings taught lessons that were no less intellectually driven than the academics' own and that were, in fact, the perfect inverse of Aristotle's tragic vision. Critics and historians were slow in recognizing this, of course, but when they did, to their credit, they began changing sides on Lapidus and Fontainebleau.

The academic and popular press began by sneering at Fontainebleau as a kitsch monstrosity, an affront to modern purity and the International Style's glamorized haut-factory aesthetic. As Teutonic purity became more tedious and tainted by authoritarian habits, critics jumped ship. The war between the Fontainebleau and the gleaming, high-dollar factories of International Style architecture gradually revealed itself as a war between the theater of American commerce and the drama of European industrialism, between the comedy of American democracy and the tragedy of European history.

In a tragedy, form follows function. We catch perhaps a glimpse of a possible happy ending, but the ineluctable logic of probability brings about the tragic denouement. Herein resides the primal idea of modern architecture: the idea that each element follows from the next to make an internally coherent enclosure, so the ideal work of modern architecture would have neither entrances nor exits. In a comedy, we grow anxious at the probability of a tragic conclusion, and then against all odds, surprisingly, improbably, a happy ending occurs. This would be Fontainebleau in a nutshell, a designed strategy for delivering more joy than you have any right to expect, with a soupçon of surprise.

In the revised academic narrative of the 1970s, l'affaire Fontainebleau was reinvented as a war between repressive modernists and the permissive Morris Lapidus—a postmodernist avant la lettre. This would have been fine, had modern architecture, like modern music, art, dance, literature, theater, and film, ever created anything with the crazy, jagged, permissive tang of twentieth-century modernity, but it did not. In fact, Lapidus's Fontainebleau has a great deal more

in common with Igor Stravinsky, Pierre Matisse, Vaslav Nijinsky, Pablo Picasso, James Joyce, Max Reinhardt, and Fritz Lang than does any selection of works by modern architects. Viewed collectively, modern architecture proposes, at its best, a high-dollar, paint-by-numbers, industrial religio-tribalism congenial to robber barons, corporations, and commissars. Morris Lapidus, unhindered by class prejudices and European high-culture sympathies, had the common sense to realize that modernism was not a religion but a new style to be applied as one wishes.

Even so, American ideas about class were part of the war over Fontainebleau. The great urban theorist Jane Jacobs would have described the argument as a conflict between the preferred pleasures of two social classes. In her book *Systems of Survival*, Jacobs notes that the professional and financial classes in America, in their time away from work, almost invariably seek out nature's sanctuary and free-flowing, unstructured, contemplative leisure time. America's commercial classes, on the other hand, from bottom to top, seek luxury, comfort, and convenience—easy fun in a hurry, one might say, and these fun seekers were Morris Lapidus's audience. He created commercial Edens for the commercial classes.

Two historical events made this possible. First, in the years following World War II, the United States came to terms with itself as the international commercial powerhouse that Alexander Hamilton had envisioned. In the years after the American Revolution, America saw itself as Thomas Jefferson did, as an agrarian nation of gentlemen farmers. In the years after the Civil War, America saw itself as Andrew Carnegie did, as a financial and industrial juggernaut. In the years after World War II, America was finally capable of producing more goods than its citizens could consume. More Americans lived in cities than not. They had to shop for what they needed, and as a result, Americans' lives became more interdependent. In this milieu, the commercial classes came to the fore. They were the glue that held urban America together.

Second, as an additional bonus, America in the postwar years was

safe, well policed, and quickly becoming suburbanized. This meant that, for the first time in human history, freestanding, undefended, unclustered commercial architecture became possible. Commercial architecture could finally be purely itself, and of all the thinkers and builders who pondered the culture of post–World War II America, Morris Lapidus saw this most clearly. The liberation of commercial architecture was his own liberation; its promise conformed perfectly to his view of architectural history, which began, as Morris explained to me, with two concepts of architecture: the ramada and the souk.

The ramada is a stockade, a corral that keeps things in and keeps things out. Its vertical enclosure implies an invisible pillar of air that connects the earth to the heavens, the earthly nation to its god above. The walls of the ramada provide the model for all official and public architecture; they define our territory and keep us safe from invasion, from time itself, and from all those events that flow laterally across the surface of the world. The souk, however, is just a floor and a ceiling: A piece of cloth for a roof, supported by four sticks, a rug on the ground for a floor, with objects arranged upon the rug for sale. There are no walls because commerce admits no boundaries. The souk defines commercial space: a human-height stratum of atmosphere extending around the world.

Historically, these two forms are intermixed. Commerce funds government. Government protects commerce, so the souk is located in a marketplace protected by walls or in a street protected by public buildings. Traditionally, all the great icons of commercial architecture were inextricable from the civic architecture of which they formed a part: Trajan's Market in Rome (whose curves foreshadow Fontainebleau); the Grand Bazaars in Isfahan, Tehran, and Istanbul; Palladio's Palazzo della Ragione in Vicenza; the Gostiny Dvor in Saint Petersburg (probably the first purpose-built commercial center); the Burlington Arcade in London; the Galleria in Milan; and the great arcades of Paris.

I mention these marketplaces here because Lapidus mentioned them to me in his ninety-seventh year to explain the provenance of

his work. I mention them also because no other architect or architectural historian has ever mentioned any of these places to me except to demonstrate the receding planes of Palladio's façade or to decry the dreamlike flow and flurry of the bazaar as the opiate of commercial culture.

The bright theater of public commerce that terrified and entranced Walter Benjamin in his notes on the Paris arcades and that angered and dismayed John Ruskin in *The Stones of Venice* beguiled Morris Lapidus from his first visit to Coney Island. Not surprisingly, then, when I asked Lapidus what he was proudest of in his career, he cited his transgressions: all the elements of twentieth-century building that "modern architecture" failed to exploit or to account for. "Well. I made curves work," Lapidus said. "I even made S curves work, which is not easy. I made colors work. I made artificial light, plate-glass façades, and ornament work as well. I proved that architecture is still an expressive medium, like music, that it can make people happy."

The curve, he said, was the key, and the curve of Fontainebleau was his favorite. "Here's why," he said. "Back in the '20s and '30s, when I was designing stores, I lived on the road. I would come into town on a train, dead tired, and go to a local hotel. I would go up in the elevator, step out, and look down this dark, *endless* hall, under this endless yellow line of twenty-watt bulbs. My knees would almost buckle, so when I finally got to design a hotel, I thought of curving the whole thing. The hall would still be long, of course, but it wouldn't seem so long because of the curve, because you couldn't see the ends of it. This also expresses another principle of mine. I let the inside determine the outside, because I'm designing buildings for the people in them, not as objects to be appreciated from traffic helicopters."

Lapidus went on to unpack the virtues of the curve at some length. Curves, he said, signify leisure, because a curve is the longest, most beautiful distance between two points and we're not in a hurry. Curves are sexy, because human beings are curved, and the curvier, the sexier. Curves stand for change, because curves are how we mea-

sure change and express it. Curves signify flexibility and adaptability to nature, because nature isn't rectangular. Curves also stand for self-sufficiency and independence, because curved walls can stand free and straight walls cannot.

"A lot of good things about a curve," Lapidus said, "and about ovals and circles and those biomorphic shapes I call 'woggles,' too, because they don't have any normative 'size' relative to the rectangular enclosure. They can be as big or as small as you wish and they don't have any particular vantage point. They look okay from every direction and they invite you to check them out."

When I asked Lapidus about my favorite effect of his— the column disappearing into the lighted "cheese hole"—he explained that when you're designing stores in New York, there is always a building over the store, tons of steel and masonry. The columns have to be there, holding up the building and reminding you of all that weight. The same holds true in large hotels, but if you run the column into a lighted hole, the weight disappears. The whole place seems lighter. Lighted cheese holes without the column do the same thing, like the oculus in the Pantheon, only the cheese holes are nondirectional. The opposite of the column running into the lighted cheese hole, he explained, was the "beanpole" he invented to punctuate spaces, a five- to seven-inch-round pole running from the floor to the ceiling that is obviously incapable of supporting anything. Even so, it makes the space look lighter. In any other culture," Lapidus remarked, "these would be cited as examples of architectural wit that do their job. They would be regarded as amusing design anecdotes, like Palladio painting brick-shapes on plaster. In our culture, they are cited as heresy."

Taking the model of the souk, the underlying project of all Lapidus architecture is to make the walls disappear, to screen them, or to make them very interesting, like the French faux-mural in the lobby of the old Fontainebleau, before which Lapidus's famous stairway to nowhere ascended. In his shops, Lapidus used indirectly lit display niches in "woggle" shapes to display merchandise and desubstantiate the walls. His first act designing a shop was to expand

the plate-glass display windows to control the whole space of the first-floor façade, so the store looked like Ali Baba's cave cut into a building; then, by recessing store entrances as much as twenty feet off the sidewalk, he folded or curved the glass into mini-arcades that created two large display stages on either side, breaking down the implied barrier between the storefront and the store itself. "Once you're in the arcade niche," Lapidus said, "it's hard not to go into the shop. You're kind of trapped."

From the street, his stores became little proscenium theaters, softly lit in the front and brightly lit in the back to draw you toward the flame. Lapidus also broke down the distinction between the signage and the building by integrating architectural graphics into the façade above the display window, so the off-putting wall seemed as insubstantial as a page of text. Ideally, everything floated; everything aspired to weightlessness; everything was touched with illusions created by glass, Lucite, artificial light, neon signage, indirect fluorescents, theatrical color, mirrors, and illuminated frosted ceilings. Before Lapidus, mercantile culture had resisted such innovations lest the store compete with its own merchandise. Lapidus understood that if you sold the store, the merchandise would sell itself, especially if the store itself was a replicable trademark, as it finally became with the rise of franchised chains.

All these innovations are integrated into Fontainebleau to great effect. They would become so pervasive in their time, however, that it is worth remembering that someone actually *invented* them. That would be Morris Lapidus, who (on an embarrassingly modest budget) would combine all the things he had done so far into Fontainebleau. He multiplied the spectacle of their interaction, as if he had been given, not just a storefront on Fifth Avenue, but *all* of Fifth Avenue with a beach into the bargain. As a result, the footprint and elevation drawings of Fontainebleau don't tell us much—about as much as the footprint and elevation of a movie set or of an informal garden would. The architecture resides in the cinematography, in arranging and directing the dance of vision, in the invitation of what disappears

behind what from which angle, what brightness promises delight just beyond our view. So Lapidus is not in the walls but in the vistas, in the sight lines that look across, over, and around, that look up from under and down from above, that look through the hotel, down into the bar across the pool, and out to the ocean in an ever-unfolding theater that plays before our eyes as we move through the fair.

Finally, I would like to return to the war over Fontainebleau and suggest here that it was a war with no bad guys at all, just a family quarrel between indigenous Americans and their immigrant brethren at the beginning of the twentieth century. Second- and third-generation Americans of Lapidus's generation could hardly help but feel the weight of the nation's dark inheritance: the cruelty of the Civil War, the shame of Reconstruction, the infamy of the Indian wars, the toll of World War I, the catastrophe of a depression, and then a bloody World War II. These citizens, in their exhaustion, with their dark memories and chastened hearts, wanted America to be better, somehow, to be purer and less embarrassing, however that might be done. On the other side of the quarrel were the new Americans, the immigrants and first-generation dreamers, who wanted America to be *everything!*

Fontainebleau is a monument to that everything—to the imported optimism of a generation of dreamers, born with the twentieth century, who shaped the very tone and texture of our lives today. What George Gershwin was to American commercial music, what Billy Wilder was to American commercial film. Each of them was educated in the inheritance of European high culture. Each of them had a choice between the ivory tower and the street, between old Europe and new America. All three chose new America. All three invented a high popular style and saw it prevail, and each, in varying degrees, paid a price for his success. If Lapidus suffered more than Gershwin and Wilder, it is only because modern music and modern film were genuinely modernist idioms. *Rhapsody in Blue, Double Indemnity,* and Fontainebleau remain, however, as monuments to their wanting everything.

Art Fairies

London, October 2007. The Frieze Art Fair building is plopped down amid the manicured verdure of Regent's Park. I step out of the cab and take one look. Here's what I think: If, rather than recruiting Tony Blair to attack Saddam Hussein, George Bush had simply attacked Tony Blair, and if, in the ensuing Armageddon of reciprocal fecklessness, George had actually won, the American Officers Mess in London would look a lot like the art fair building that Frieze commissioned from Jamie Forbert Architects. The interior, I know, will be *temporaneo con amenità*, the same MDF and Euro-chic fixtures, the same tall, transparent drapes in the lounge, the decorative chrome in the restrooms, the tasteful scatter of knockoff designer chairs. From the street, the sprawling array of interlocking white rectangular units is all but occluded by aggressive fencing and other accouterments of surveillance. There is also a security staff that would suffice at Guantanamo.

Even so, I love art fairs, love nothing better, but the building is still scary—so I yank down the bill of my All Blacks rugby cap, hunch my shoulders, and approach through the rain, imagining my own diagonal traverse across the screen of a video monitor, thinking this totally twenty-first-century thought: "Do these pants make my butt look Islamofascist?" Then I'm inside, and, whew, it's just snooty art stuff. I shoulder up to the credentials window, present my credentials, and receive a colored card that proclaims my degree of access to the temporary amenities within. Since I am on assignment, I get a really "good-colored" card that will get me through all the portals through which I wish to pass. Even so, I know that there are *better* cards. I know that there are people all around me who

have the *best* card, the Willy Wonka card that will pass them though enclosures of escalating exclusivity and ultimately issue them into the intimate presence of . . . oh, I don't know . . . maybe Sir Nicholas Serota, the very icon of Labor gentry, in a tan, glen plaid suit, comfortably disposed in a Gehry Club Chair with a matching ottoman to support his wonderful shoes. Sir Nicholas will turn, smile, and lift a snifter of brandy to welcome the chosen . . . and someone's life will be complete.

The knowledge that I am banished from these intimate occasions—some imaginary and many all too real—weighs on me as they are supposed to. They make me feel diminished. Ideally, everyone at an art fair ends up feeling diminished in some degree, because that's the gig. Out on the floor, talent, status, ambition, and greed will duke it out with no holds barred. Nobody knows who wins, or quite what winning means because the ground is always shifting. To cite an instance, here's a short, stylized history of the event that is about to take place: the Collectors' Preview. For the first fifteen years of my life as an art fairy, the vernissage that is held the day before the opening was sotto voce. People who had flown in that afternoon dropped by for a drink, a little gossip, and maybe a drawing. As fairs began to overtake biennials as places to be seen, invitations to the Collectors' Preview became more and more urgently coveted. Captains of finance stopped being rude to gallery assistants in the hope of obtaining one. Eventually, art fair administrators found themselves opening their doors to swirling prides of tycoons, yachtsmen, power widows, and black-clad curators dressed like "SNL Sprockets." The press found these profitable melees inelegant. They made comparisons to Super Market Sweep and the Oklahoma Land Rush. There was murmuring among the terminally refined.

So, prestigious dealers responded by refining access. In the run-up to a fair, some whales were offered the opportunity to buy work sight-unseen; others were invited by the artist's studio to pick something out at the studio before it went to the gallery, where another

group was invited by to pick out something from the gallery before the unsold works were shipped to the fair, where the Collectors' Preview was reduced to a clearance sale for locals, restaurateurs, cruise ship auctioneers, and provincial art advisers. The body language of the staff proclaimed that the pickings were thin—and, thanks to proliferating art fairs, getting thinner—and thinner still because sold works (and works that weren't selling) were immediately switched out on the walls (as they still are).

Fairs stayed profitable, but winnowing took its toll. Art fair "buzz" in Chelsea bars plummeted toward the lows set by Scandinavian biennales. High-end hookers of many sexes stopped circling the dates and booking their flights. Even the reason for staging an art fair was virtually obliterated. They had stopped *attracting new money*, because the boys and girls at the top of the art world had forgotten that all of our great expectations for new money and new talent are bound up with Magwitch, making his fortune out in Australia, and young Pip, dancing away in the mosh pit with a hungry heart. Then, in a blink, everyone remembered. Shameless Hogarthian frenzy was born again. Once again, rakes in their progress are treated with respect. Beautiful women dress up, get drunk, and sleep with strangers; Damien Hirst's manager, Frank Dunphy, whose résumé includes Led Zep, Coco the Clown, and a stripper named Peaches Page, is no longer cause for alarm. Galleries withhold their fair offerings until the last minute, and captains of finance must now wheedle plaintively with lowly gallery assistants for the magic card that will admit them to the lounge for the only good coffee in twenty square miles.

There have also been adjustments to retain the frisson of exclusivity. Before the official vernissage there is now an avant vernissage—and often several—for the ridiculously special. To exhibit works that are too expensive, too cheap, or too confidentially held for wall space at the fair, many large galleries now maintain off-site "closets." Even so, the playing field has leveled as prices have risen, so if you are new money, we won't call you that. We will call you a "new collector," and

as you wander past hundreds of booths filled with incomprehensible objects, you can be proud of yourself because, believe me, this fair's for you! Think of it as high-dollar speed dating. Choices glimmer by like twilight traffic on the 405, and if you have to think about it, don't think. Thinking about art while shopping is like thinking about your fingers while playing the piano. Better to buy the damn thing, put it on the lawn, and think about it then, but *never* think about art at an art fair. Art is more serious than that, more "spiritual" if you wish, and one is better served by decoding the dazzle that has you reaching for your purse: the fashion, décor, chatter, presentation, sumptuary habits, white asparagus, and naked peer pressure.

Remember that an art fair is a con but it's not a trick. It cheats you fair, so such occasions are very important training for new collectors, because, however rich you are, you can't learn *how* to be rich playing pitch-and-putt in Boise or throwing down vodka shooters in Misto Kyyiv. You need a structured, anonymous public site where you may absorb the evolving global etiquette. You need to know exotic things, like how to distinguish Ukrainian accents from Russian accents, lest you insult the stranger with whom you're chatting in broken English. You need to make major decisions, like where do you actually stand on Zegna and Zac Posen? Or maybe, like me, you are still of two minds about haut prêt-à-porter.

Simply, you need to be rich while appearing to be serious, cosmopolitan, knowledgeable, and rich, and thus deserving of invitations and gorgeous discounts. In pursuit of this goal, a "new collector" is well advised to attend the Frieze fair in London. One might easily fly to a fair in Miami or Venice or São Paulo just for the fun of it—and just have fun, like the nouveau trash you are. Commercial fairs in Northern Europe, however, are still closely associated with pig carcasses, jam, woolen socks, and leather jerkins, so attendance at an art fair in London signifies a certain level of moral seriousness and social ambition, especially if you are staying at The Claridge, drinking in Macanudo, forgiving of the frayed edges and disapproving of the Dale Chihuly.

My wife, Libby, and I, however, are old school. We are staying at the Cadogan in Sloan Square, where Lily Langtry stayed, where, right down the hall, Oscar Wilde was arrested for misplacing his penis, in room 188, on April 12, 1895. If "The Oscar" were still around, he would be peeved at my arriving too late for however many "advance, advance previews" have taken place. There must have been a bunch since London society has more tiers than a Himalayan rice plantation, but I am happy with the plain old Collectors' Preview. The forgathered art lovers are urgent but under control. I scan the crowd for the little European man who sat across from me on my flight from Minneapolis to London, but no luck. My wife is late, but no surprise. The doors open and there is shoulder bumping at the bottleneck, but once inside the seekers disperse into the souk quickly and quietly, like power walkers pretending to be swans. I scan the walls for goodies that most fairgoers are too young to recognize. The wife arrives and we scout the "conversation pieces." There is always an "ironic" piece about "class," a faux-radical offering on the relationship between high art and popular art, and, if you're lucky, a "statement" of butt-clenching vulgarity about the vulgarity of money.

Frieze hits the trifecta. In the tradition of Marie Antoinette's peasant cottage constructed within the walls of Versailles, Rob Pruitt has transformed Gavin Brown's booth in this posh London flea market into a flea market booth worthy of the Jersey flats—and Rob has pretty cool rubbish. There are old magazines, Brownie cameras, signed photographs, orphaned TV remotes, googly eyes, and other desirables. I scrounge around for stuff about Esther Williams and Sonja Henie, who were our neighbors when I was in junior high. Finding none, we push through the crowd gathered in front of the next booth and bump into Clarissa Dalrymple, who wants to borrow a twenty-pound note. The Chapman brothers, it seems, are somewhere up there, signing and defacing British currency, and Clarissa doesn't want to have the Chapmans sign her cab fare back to the hotel. Since it's the Chapman brothers, I ask her if she wants a fifty. She shakes her head firmly. "Oh nooo," she says. "A fifty would be

vulgar!" Clarissa is the head mistress of fine distinctions, so I lay the twenty on her and wish her good luck.

Libby and I wander over to Richard Prince's Dodge redo. According to the press, Richard has taken the shell of a 1970 Dodge Challenger and tricked it out with all the most neo-sick technology: a high-tech transmission, chassis, and suspension, new bucket seats, a new dashboard, and a 440-horsepower 5.7-liter engine. A snappy NASCAR/Lichtenstein paint job completes the ensemble. For the exhibition, a zaftig brunette in a bathing costume reclines on the right front fender, pushing the car down and raising questions about the new suspension.

Nodding at the model, I observe that Richard might have gone more Venice Beach and less Venice.

"Or more Venice and less Mestre," the wife observes.

We stroll away, comfy in our cattiness. We pass a kid who is explaining to his friend that the really *radical* thing about Richard's Dodge is that you can drive it. It's, like, a *real* car, and not just a sculpture, like a Charlie Ray or something. So it's a custom car. Wow. What a concept, I say, and it occurs to me, as we head outside to smoke, that after thirty-five years of looking at art, and putting aside all questions of quality, I have just seen the three most easily explained works of art on the planet Earth.

The Cartier party that night is at Soho House in Shoreditch—a little touch of Vegas in the Smoke. We elevator to the roof, where there is a large dining room with a parade of sliding glass windows down the long side. The windows open on to a turquoise swimming pool surrounded on the other three sides by deep, redwood benches, upon which celebutantes, surrounded by their retinues, pose for team pictures. The self-consciousness is thick and we are all so yummy that I am loving it. Out on the deck I meet Peter Saville, who designed all those great album covers for Joy Division and New Order. I am about to say something complimentary when a plunging bimbino with an orange buzz cut nearly topples me into the pool in

her rush to kiss the whip. I retreat and, luckily, at dinner, I'm seated at a table with Barbara Gladstone—the Larry Bird of art-world trash talkers. We talk about Barbara's new gallery in Brussels and then we talk trash.

We are still talking trash, standing by the table waiting for dessert, when a handsome young man comes up and gives Barbara a hug. Barbara says, "Oh, Dave, this is [*room noise*] Chapman," so I know it's one of the famous Chapman brothers, but I don't know if it's Jake or Dinos. Also, I am in my lighthearted talking-trash-with-Barbara mode so I stick out my hand and say, "Great to meet you! You played with Oasis, right?" I regard this as a gentle, laddish sort of tease and expect the same in return. Instead, Jake (or maybe Dinos) turns on his heel and stalks away. Barbara pats me on the arm. I try to be brave, but now I'll never get my twenty signed.

Someone touches my arm. It's Matthew Slotover, the éminence grise of Frieze. With his longtime colleague Amanda Sharp, Matthew is copublisher of *Frieze* magazine and codirector of the art fair. According to *ArtReview* (which doth dearly love a list), he is the eighth most powerful person in the art world. We are pals anyway. I wrote for Matthew when he edited *Frieze*, and most importantly, we met cute. A decade ago, Matthew and Amanda road-tripped through the American West. On their way into Vegas, they called us and we had them over for coffee. We stood on the balcony, looked at the Strip, and had a great chat. Matthew gave us some magazines. We gave them some books and walked them out to the car.

The pocket patting began when we reached the car. Matthew, it turned out, while taking magazines out of the trunk had locked his car keys into it. Phone calls ensued, and here they were: Matthew and Amanda in America, standing around in the 120-degree desert heat in a dirt parking lot in Las Vegas, Nevada, with two virtual strangers upon whom they presumed they were imposing. We leaned against the wall in a sliver of shade. I was happy for the company. Matthew was mortified. The key guy finally came and everything was fine. We waved them off to the Grand Canyon, and for reasons that I can only

attribute to utter cultural insensitivity, I tell this story to the gathered partygoers. Halfway through, I glance at Matthew. He has that weird smile you get when you have just walked into a plate-glass wall. I could just die.

In the short space of an evening, I have given the appearance of cutting the illustrious Peter Saville, I have insulted a Chapman brother, another treasure of the empire, and remortified my old friend Matthew, who is the eighth most important person in the art world and one of the nicest. I think about blaming all this on Barbara Gladstone, but I can only sigh, dust off my hands, and think, "Well, my work here is done." I drag Libby away from her conversation and head for the elevator. When we step out into the night air, my head clears immediately. I have, I realize, come down with an art world virus. All it took was one big sniff of ambient self-congratulation to induce an ego erection that deluded me into imagining that my behavior mattered in the least. It didn't. The Cartier debacle wasn't a debacle. I am an idiot.

At eleven the next morning, for my sins, we pile into an official Frieze vehicle with Clarissa and a French lady and set off for Winfield House, the official residence of Robert Holmes Tuttle, American ambassador to the Court of Saint James. Winfield House, which is also in Regent's Park, will be the site of my debut as a certified courtier, so I am reassured by having Clarissa along to identify each servant's task by the accouterments of his or her costume. Clarissa is also good on the layers of remodeling Winfield House has undergone since Leonard Guthrie designed the mansion in 1936 for Barbara Hutton and Count von Reventlow. In the late 1960s, Ambassador Walter Annenberg and his wife, Lee, commissioned a massive and hugely successful renovation. Every ambassadorial couple since has added their little fillip.

Robert and Maria Tuttle, thank you very much, have hung some of their top-flight twentieth-century American art: De Kooning, Rothko, Ellsworth Kelly, Franz Kline, etc. In the receiving line, I ask Tuttle

about his wonderful Agnes Martins. He tells me they look better in LA, and I'm sure they do. As I wander off, I realize that, despite the Bush connection, I kind of like Tuttle. I have seen him around the Los Angeles art world performing with unfailing good humor. He walked into Patricia Faure's gallery one afternoon, and Patty, who in her heart is still the Dior model she was in the fifties, came tripping out of her office on her tiny feet, palms up, and waving like Betty Boop, squealing. "Oh my God, here is that *handsome* car dealer!" A little hug, a little cut, and Tuttle just grinned and gave her a big hug, so points for him because we all love Patty. In her heyday, she banged Sinatra.

Back in Winfield House, our art-spotting tour turns up one mystery—a large white book on a coffee table with the word "Tuttle" printed on the cover. We all stare at it, not sure if we can touch. Is it a baby book? A family album? Pictures of cars? Finally, I tip the cover open and it's a large catalog of work by the American artist Richard Tuttle. This ignites enough speculation (Father? Son? Bastard son? Casual acquaintance?) to get us back to the fair for my talk.

Here, I must note, that had I known when I accepted the invitation to deliver the "keynote address" at Frieze that the harmony of the fair was so complex as to require four keynotes, I might have thought again. Had I known that these keynotes were held every afternoon at high tea for the floor staff in a dank tent with folding chairs and rain drumming on the canvas (*temporaneo senza amenità*), I certainly should have. Had I remembered that the British are an intensely theatrical people, I would have been better prepared to mount the stage and face two spotlights in my eyes and none on my notes. But I wasn't and I immediately embarked upon a cascade of bad decisions. First, I didn't complain about the lights and decided to wing it. Second, since I have known nearly everyone in the tent for decades, I abandon euphemism and simply identify the people I am talking about. Some of them are in the tent, so it seems pretentious to do otherwise. Third, I can't read my opening remarks, so I begin by suggesting that integrity might be coming back into fashion in the arts. This scares everyone sober.

After my talk, I follow the BBC "culture commentator" and his cameraman out into Regent's Park, where I am carefully positioned on a bench and introduced on camera with considerable gravitas. So why am I not surprised when the BBC solicits my thoughts on Damien Hirst's diamond-encrusted skull—the fourth most easily explained work of art on planet Earth? Crown jewels + Yorick's skull = Anglo icon. My position: the skull's production costs are too high to make the price multiplier impressive. I mean, what's the production cost of a major Picasso? Two francs?

The BBC dude asks, "But isn't Damien suggesting that art is priceless?"

"Not if you break it down for parts," I say. This Americanism slides right past.

Back at the hotel, two tantrums on my e-mail, one from Nebraska and one from California. Both take violent exception to things I said three hours ago in Regent's Park. One phone call and I discover that my off-the-cuff remarks to a few friends in a soggy tent in London have been podcast worldwide by *Frieze* magazine. I doubt if I would have spoken otherwise, so I am not surprised the next morning when someone stuffs the *Art Newspaper* into my hands. There it is: a crude, unauthorized, tragically ungrammatical transcription of my remarks with every name luminously boldfaced and correctly spelled—except for one. In my talk, I mention that discriminating collectors in my hometown own a lot of paintings by Morris Louis, and as a result, Louis was given a retrospective at the Fort Worth Museum of Modern Art. Fine, fine, except *Morris Louis* (the postpainterly abstractionist) has become *Maurice Lewis* in the *Art Newspaper*, an artist concocted by Googling up a long history of misspellings in the British press.

Now, it sounds like I'm sneering at the people with whom I grew up. A retrospective for *Maurice Lewis*!? In Fort Worth!? A lesser man might have flung his wrist to his forehead and confessed to feeling, you know, violated. Not I. The art world eats words like a meat grinder and spits them out well chewed. So what?

Miami: December 2007: We wander up to the Shore Club Condominiums on the night before Art Basel opens. The weather is beautiful. The surveillance is nominal. Buff fashionistas (or rent boys) wearing high-waisted white slacks with no shirts—like topless, blond zoot-suiters—stroll by on the sidewalk, because nobody cares in Miami. As the hostess guides us to Arnie Glimcher's table at Nobu, Bill Jordan from Dallas slips by and whispers in a deep southern drawl, "Well, *Maurice Lewis*, as I live and breathe!" I drop my head and raise my hands in abject surrender.

Libby and I find our seats. The Glimchers are there: the folks, Arnie and Millie, the kid, Marc, his wife, Andrea, and the artist Jim Dine. At the next table, there is a party hosted by Dallas collector Howard Rachofsky with many Texans in attendance. Many of them, I fear, are purported collectors of the dread *Maurice Lewis*. Libby, who usually knows what to do, quickly embarks on an ambassadorial visit to the Lone Star state. I pantomime my genuine attention to what Arnie Glimcher is saying. Most art dealers, I should admit, conform to Peter Schjeldahl's description of Larry Gagosian. "He's not complicated," Peter says, speaking of Larry. "He's like a shark or a cat or some other perfectly designed biological mechanism"—which is not an insult. Warhol was similarly well designed and uncomplicated. Arnie, however, is complicated and enthusiastic. He has run Pace Gallery (now Pace Wildenstein) since the sixties while keeping one foot in the movie business, involving himself in films that require more intellectual attention than Hollywood is accustomed to investing in: *Gorillas in the Mist*, *The Mambo Kings*.

Tonight, Arnie is excited about the new gallery that Pace Wildenstein is going to open in Beijing. He's also excited about his new film, *Picasso and Braque Go to the Movies*, produced and narrated by Martin Scorsese. The film deals with Picasso's and Braque's enthusiasm for modern media and technology, like the motion pictures, of course, but also aviation, which so entranced Georges and Pablo that they called one another Orville and Wilbur and regarded themselves as comparable pioneers of Modernity. Then we talk about the auction

houses abandoning all pretense to prior ownership and taking new work on direct consignment from living artists. Arnie thinks these artists are mortgaging their futures. "Someone needs to place the work with an eye on history," he says. "Auction houses, you know, . . . they sell *dishes* and *knife rests* . . . and *furniture!*"

The next morning, outside Joan Washburn's booth on the floor of Art Basel, Dagny Corcoran is telling us a tale. Dagny runs Art Catalogues, a trendy bookstore in Los Angeles. Last month a collector came in wanting exactly eight feet of impressive art catalogs—no Jews, no Iranians—no more than four thousand dollars' worth. Dagny said sure. She made up a list that came to forty-five hundred dollars and called the guy. No, he said, four grand is the budget. Dagny made a new list and brought it in. She called the collector. He wondered if she would bring the books out to Beverly Hills? Dagny said sure—deep breath, slow exhale. The collector greeted her with his decorator, who pointed to a shelf and wondered if Dagny would put the books in. Sure, she said and did. The decorator stood back with his finger to his cheek. Then he walked up to the shelf and started pulling out books whose spines he found "unimpressive."

Now there was a hole, and Dagny, fearful of what might happen next, strode up to the shelf, divided the books to either side, and plonked the big Armani book down flat into the space, so the name on the spine read like a billboard. She plonked a crystal turtle down on top of the Armani book and stepped back. Long silence. Dagny avoiding their eyes. Then the collector said, "Wonderful!" Now, would she take back the books with the unimpressive spines? Dagny said sure, but she'd have to bill them for her design time. The collector sighed and directed the houseboy to move the unimpressive spines out to the pool house. At the door, the decorator told her thank you *so* much. The room is just magic.

"Makes it all worthwhile," Dagny says to us back in Miami. "For the arts, you know."

We are still dishing outside Joan's booth when a lady bumps

through our little crowd. She is leaving, in a hurry, looking over her shoulder, and saying, "Well, if I were *poor*. I might buy it."

I take a look. She's leaving a large, absolutely pristine, sixties painting by the late Raymond Parker of Prince Street. "Price?" I ask Joan. "75K," she says—the only top-quality bargain I've seen on the floor. The lady is too rich to buy it and I'm too poor. Go figure, Joan says, rising up on to her toes to wave at someone behind me. It's the irrepressible Peter Saul, best known to the broader public for his seventies paintings of Richard Nixon copulating with Chairman Mao. Peter is happy as a child. He has just sold a painting, right down there. We should go look at it. We will, we say. Peter, of course, sells all his paintings. He's always happy as a child, and I always go look at them. This time I see only the back of Peter's painting as two gallery assistants carry it away.

But what the hell. Tragedy tomorrow—comedy tonight: a party honoring the career of Emilio Pucci, marchese di Barsento (1914–92). My wife proclaims herself sick (of a husband who can't provide her with competitive frocks) and takes to her bed feigning the vapors. I leave her watching *Pride and Prejudice* and set out for a baroque mansion three blocks west of Collins Avenue and eight generations back in time. There are Moroccan tiles in the courtyard. Light pours out of a door on my right, opening into a white, Georgian ballroom where helium-filled balloons, each covered with Pucci fabric, bounce hither and yon, each with a Pucci frock floating beneath it—like a dance party for thin girls with colorful thoughts ballooning over their heads. I pass through the ballroom and out into the yard. On my left: a giant marquee with an ocean of tables. On my right: a raised Gatsby pool with a baroque proscenium. In front of me: a baroque fountain splashing away. All around me: those art sissies and fashion trash who make art parties infinitely preferable to dinner with the dean.

Marc and Andrea are there, Becca Cason Thrash, in Pucci, need I say. Michael Govan, Todd (the God) Eberle, Jay McInerney, and

everyone else previously mentioned in this essay. Dinner is fun, not quite a food fight, but a lot of wine is sloshed. I go to say hi to Becca Thrash, who, seemingly just for the fun of it, has risen from the dusty streets of Harlingen, Texas, to the board of Friends of the Louvre. Becca is in the midst of a slightly garbled account of the gala she is planning for the Louvre—the first on the site of the museum. She looks up, drops her persona, and gives me a shy, Texas-girl wave. I am transported back to a Dairy Queen on a hot Texas afternoon. I wave back and drift off to chat with the twin fonts of superficial wisdom on all things Pucci: Marina and Benedetta Pignatelli, *madre e figlia*, princesses both and possessors of an attribute that all Italians covet, a pope in the family, Innocenzo XII (1691–1700), described by Robert Browning in *The Ring and the Book* as "innocent in name and nature, too." Marina and Benedetta are less innocent than that, being high-hearted fashionistas who know everyone who doesn't do anything.

Marina lives in Rome. She is dressed in vintage Pucci. She tells us about old times in the villas of Capri, of her childhood friend Cristina Nannini, who married Emilio Pucci, and of her own experience, at age seventeen, modeling Pucci's Cruise Collection at Canzone del Mare (once Gracie Fields's mansion). Marina's daughter, Benedetta, is my tapas and gossip buddy from Las Vegas. She is one of those sleepy-eyed beauties you don't see much anymore, but she has her passions. Most recently, Detta has been driving around southern Utah checking out the polygamist communities and the women in their prairie dresses with the long skirts and puff-shouldered sleeves. Her present project, she says, is to sell the whole Mormon couture thing to her pal Miuccia Prada.

Then Marina remembers, when I ask, that Emilio's first couture was the skintight uniforms he designed for his ski team at Reed College in Oregon. This reminds me that, in his life away from fashion, Pucci was a Fascist twit and, in his younger days, a fan of Mussolini (which brings to mind Hugo Boss, who designed the SS uniforms). This explains the penchant for uniforms, and I immediately see the

sources of Pucci's sleek sportswear in the dramatic language of Marinetti and Italian Futurism. Thank you, Jesus, for one freaking idea at a fashion bash.

I awaken to eternal sunshine and gaze down the beach, amazed again at how easily Miami drains the structure and content out of everything. It cooks things down to a bright, warm residue of objects, flesh, and noise, so I head down to the fair. I am finished looking, so I check out the tradecraft, because it's tricky. The decision to buy needs to feel voluntary, and most collectors smell a rat if you flatter their vanity. They are that insecure, but even so, the vanity of wealth is such a glaring vulnerability that you have to do *something* with it. Many dealers challenge it immediately with blatant social and intellectual condescension. This works, in a Don Rickles sort of way, but there are subtler techniques.

Leslie Waddington, with whom I have just had a chat, has been known to displace his natural enthusiasm for something on to something else. He drags you away from what you want and waxes eloquent on some little Matisse bronze he has just bought for himself, then cleverly translates his enthusiasm to whatever you want to buy. If you rise to the bait, you've bought it. The late Leo Castelli was not above preying on your patriotism. If you liked something, Leo would always remember that Princess Totally-Imaginary had "sort of a hold" on it. Your job was to convince Leo to sell this masterpiece to a red-blooded American. Leo and Leslie may be categorized as perfumed parlor snakes.

Barbara Gladstone is more General Patton than Walter Pater. She is stern and businesslike, and business guys love that kind of talk from a girl. I pass her booth. She is jabbing her finger at a potential buyer saying, "Now you have to hang this. If you're just going to put it into storage, I don't know. I owe the artist more than that." A little further on, I glimpse Margo Leavin disappearing. She backs a step away from a potential buyer and begins to speak more and more softly. The collector approaches, leans forward, and leans even further

forward as Margo ever so gently evanesces. The instinct to reach out and grab her back from the brink of oblivion is so strong that, ultimately, I know, he will fall into the snare.

Now you know some tricks against which there are no defenses. My only advice: *Just talk price, condition, and provenance!* This is not a bull session in the dorm. The first negotiator who mentions aesthetic quality usually loses. If you ask for a price, and the dealer says, "Oh yes, that's a wonderful piece," the price is probably soft. If you say, "Oh, this is lovely! What's the price?" you have probably just raised it, since art is valued by the interest invested in it. Having done this, you must now keep the color in your face when the dealer calmly quotes some outrageous, unattainable number. Should your face pale, you have left yourself open to the sweet smile, the shrug, and the most killer closing line in the business: "Well, if you can't afford it, you can't afford it." Palms upward. Billions of dollars' worth of art has been sold this way.

End of day 2. The real business is over. The socially challenged pack to fly home. The parties roll on to the music of money, driven, this year, by four dominant themes: the auction house inroads into the retail market (Oh my!); the vogue for contemporary Chinese art (Don't do it!); new dealerships, for Pace in Beijing, Gladstone in Brussels, Gagosian in Rome and Moscow (Yadda yadda); and, finally, the perceived synergy between luxury products and contemporary art (Stop me before I kill again!). I am looking at Glenn Schaeffer's blue John McLaughlin at his condo in the Shore Club when John Stromberg from Williams College joins me. It turns out that we both use McLaughlin's paintings as price integers— so a quarter-million-dollar painting by Eric Fischl would be a "five McLaughlin" painting and obviously much too dear at that price.

We head down to Bob Collacello's party at the Delano, but it's overflowing with love for Bob. We continue south to the garden of the Setai, where Lorenzo Fertitta is hosting a party that feels mucho old Habana for his Ultimate Fighting Championship. There are blaz-

ing torches, screens upon which bloody canvas is projected, and a few hundred buff, compact fighters in tuxedos squiring tall Valkyries with wonderful breasts. Libby and I walk in with a kid from Munich and James Kelly, an art dealer from Santa Fe. We feel safe amid all these fighting hearts.

To reach the Sotheby's party at the Mandarin, one must trudge past a great wall of half-baked Chinese postmodernism, because there ain't nothing free. Libby and I are seated at a low table between the editor of *Diplomat* magazine and her boyfriend, the editor of *Spears*, the London financial magazine. Each table has a tall, square crystal vase filled with water. Albino goldfish swim in the lower depths. A curve of calla lilies is cantilevered out of the top. Orchids and votive candles surround each crystal skyscraper. Nice, but about halfway through Chef Pierre Gagnaire's piss-elegant dinner, the ensemble creates a mini-eco-apocalypse. The votive candles heat up the water so the albino goldfish are literally cooking before our eyes. (There is something Roman, we decide, about just sitting there watching them cook.) Then an orchid bursts into flame. Someone reaches to put it out. The vase tilts, splashes water and Callas lilies all over our white asparagus and green mashed potatoes. The fish are rescued. Several gentlemen abandon the site of wretched karma. I go over and talk to Dennis Hopper, who is trying to get his kid into the Crossroads School.

Larry Gagosian's party takes place in a South Beach club. It boasts the loudest music, the coldest air-conditioning, the youngest girls, the richest guys, and the most fragile and ephemeral couture—a lot of those sky-high, YSL pumps with the straps around the ankle. Larry is cordial. Libby chats with the designer Eli Tahari. I chat with Stephanie from *Vogue*, who would probably be carded at Toys "R" Us. Planet Earth is far away. When we step outside, however, my prayers are answered. There he is: the little European man who has followed me from London to Miami. He stands under a streetlamp, flipping through a pad of notes, and reading entries to a portly giant with a bushy mustache. Latin American banker is my guess.

Now all is well. My theory is confirmed, so here's the setup: On the way to Frieze I had nearly missed my flight to Gatwick, so I was last in line to board. Ahead of me, all the clean young adults in their dark suits and rimless glasses were turning right into coach, clutching their PDAs. When I turn left into first class, here is what I find: two spunky kids wiggling their butts to get comfortable in the back row on my left; in the back row on my right, two young Neapolitan priests in their long frocks chat quietly, clearly brothers too, with Rudolph Valentino haircuts; a third Italian priest, with a shaved head, sits in the window seat in front of them; beside him sits the little European man—who is about five feet tall, perfectly proportioned, and exquisitely dressed. His feet barely touch the floor. When he rises, he lifts himself up using the armrests. When the stewardess serves our pig-swill, he dines meticulously with an inverted plastic fork.

I take a seat across the aisle from the little European man, beside a tall, young Londoner with a shaggy seventies do. He is wearing an expensive leather jacket stitched into yellow and black diamonds. By the time I sit down he is already watching porn reels on his laptop, not avidly but thoughtfully, with a professional eye. He watches all the way to Gatwick, switching out discs and batteries. At one point I gesture toward the screen and say, "Are you in this business?" He answers in a polite west London accent that betrays his highly cultivated Ronnie Wood aura: "You might say that, I guess," he says. "I been working for this Croatian bloke." I am from Las Vegas. This is enough for me.

So there we are in first class. Where are the rich dudes? Where are the senators and CEO's, the board members and remittance men? Well, they are all flying private, of course. This is the new age. Class is no longer a curtain between cabins. We are client-citizens now, new Romans. Everywhere is Mexico. The honchos fly private. The clerks fly coach, and who flies in first? Dependents and swamis—the kids, wives, courtesans, priests, pimps, chefs, and decorators. So I want the little European man to be an art swami like me or an honest pimp like my seatmate, to make it perfect. We are the courtiers of the new

world, who, as Thomas Jefferson observed, would "rather give up their power than their pleasure."

So think of the art world as a beach and money as the surf. Waves roll in but they always suck back out, leaving a few masterpieces and taking a little part of the beach with them. So, when a really gnarly monster rolls in, the best we can hope for is that it will leave some beach behind as it sucks away, and some treasures in the sand along with the wreckage and the bodies—because it will suck away. Nobody talks about this, but we all know it will be soon.

Full of this knowledge, on the last night of the fair I go to the movies—to a screening of *Lou Reed's "Berlin,"* performed by Lou and his band in a Brooklyn warehouse and filmed by Julian Schnabel. For tonight, the sound system in the theater has been beefed up for serious rock and roll, so it's close to the best of both worlds—a nicely executed performance film with clear, overwhelming noise.

Berlin is Reed's bleakest imagining from the seventies—an artistic triumph, a financial disaster, and pretty much the master narrative for downtown Manhattan in the echoing dusk of sixties glamour. The songs are harsh and addled, the story is a whimper of demented jealousy, and the music really kicks. The subject is trivial, but the urgency and intensity of the performance clear my palate and improve my mood about the possibilities of art and the importance of death. At one point, on the screen, Lou is riding up on a wave of noise. He actually smiles. I glance toward Lou and Laurie Anderson, sitting in the row in front of me. Lou is smiling back at himself on the screen. I hope he's feeling the same thing I am: that artists in the worst of times can create great art. Artists in the best of times? Maybe not so much.

Little Victories

It's two o'clock on a Monday morning. Outside my window, the lights of Las Vegas stretch out into the cool desert night. The "city that dozes but never closes" is dozing now, and there is not much traffic on the street. As usual, I'm sitting here in my little office writing a little essay on my little laptop, and for the moment, I'm all right. To my left, sitting on my desk amid the stacks of papers and magazines, there is a small sculpture by Ken Price, the color and form of which we could discuss at some length. A Patrick Caulfield silkscreen print called *The Sweet Bowl* hangs on the wall above the desk. It has been hanging there, over various desks in various cities, for thirty years. The only thing missing is my dog, Ralph the Beagle, who, were he still among the living, would be sleeping on my feet. If Ralph were here, things would not only be all right, they would be perfect, but perfect is not really the issue here. Small is the issue and the virtues of a small life among serious books and difficult objects, writing small essays out of personal conviction for a small audience.

There was a time, you see, when things would remain all right well into the day, when I could make some fresh coffee, walk out on to the balcony, and watch the dawn reflected on the western mountains. No more. When the sun comes up, the phone will ring, the fax will ping, and the e-mail will start blinking. All smallness and intimacy will evanesce. The flutter of the breeze around my face and shoulders, the subtle glimmer of Kenny's sculpture, and the cool asymmetry of Patrick's print will recede from consciousness, and I will be thrust once again into the far-flung enormity and litigious impersonality of what now passes for contemporary culture. E-mails will solicit my opinion on the apocalypse of the moment, on the relevance and edu

cational efficacy of contemporary art and its institutions. I will fill out three-page information sheets for bureaucratic support workers at institutions where I have been engaged to lecture. Only a few years ago, pundits did punditry and lecture engagements were handled with a phone call and a little chat. Now I am solicited for sound bites and booked like a caterer with instructions to be standing at a certain place at a certain time, from whence I will be escorted to the podium, from which I may find my own way back to the airport.

The amazing thing about all of this is that I haven't changed at all, nor has my practice. I write as much as I always have and for the same venues. I make almost as much money as I did in 1972 and exercise no more worldly leverage than I did then. The art world has changed around me, however, and not, in my view, for the better. For twenty-five years, I was a journeyman artisan in a marginal industry whose size was commensurate with its public importance. Today, I am a plug-in subcontractor in a bloated corporate culture that has embraced all the wickedness of mass culture and mass education in its quest of dollars at the door. More distressing still, I find myself inadvertently complicit in this lemming-like rush toward the mainstream. In recent years, I have published two little books—a polemical broadside about beauty and a collection of narratives about popular culture. These books were intended to be what they are in fact: footnotes appended to the hundreds of thousands of words I have written about difficult art for appropriately specialized publications. These footnotes are now considered to constitute my entire oeuvre, to define my thinking about art. The knowledge I derive from this ludicrous anomaly is that denizens of the new, mainstream, corporate art world are more interested in a raconteur chatting about Liberace than in a serious critic writing as clearly as he can about an artist as beguiling and difficult as Robert Gober.

Hitherto, the difficulty of serious art like Gober's has mandated the smallness of the art world, on the presumption that an art community is composed of people who wish to engage and come to terms with difficult art. Waiving this prerequisite has made the large art

world possible. Unfortunately, without the mandate to engage diffi-
culty and opacity in works of art, difficulty and opacity themselves
have become shtick—visual attributes that distinguish the spectacle
at the *Kunsthalle* from the spectacle at the Cineplex. We know it's art
because we don't understand it and don't plan to try. Comfortable
disinterest in the presence of things that elude one's understanding,
however, constitutes the very definition of philistinism, and today, of
course, philistinism passes under the guise of tolerance. We refuse to
engage difficult objects lest we find them wanting, trivial, or inconse-
quential. This, of course, would signify our intolerance. And this, of
course, would limit our target audiences, cost us dollars at the door,
and necessitate a smaller art world—which raises these questions:
Could this culture ever produce enough interesting art to fill the
spaces presently available to exhibit it? Would it matter if it did?

After my experience of the last two years, I think not. During this
time, I curated a modest international exhibition for an institution in
New Mexico, and I hasten to assure you that selecting and designing
the exhibition were genuine pleasures. I was allowed to indulge my
passion for tiny increments, eloquent gestures, and fine distinctions;
I was allowed to work with artists who care about such things; and
we were allowed to get it as right as we could. The experience of being
allowed, however, soon became chastening and strangely demeaning.
At the outset, I assumed that I was being recruited because of what I
believed. It turned out that I was hired because I believed something—
and that, whatever I might believe, the institution was there to make
it so, and it did. The fact that I wanted to make a large exhibition look
smaller, to make large spaces seem more intimate, to change door
heights, door widths, and wall lengths by inches rather than feet,
mystified those assigned to assist me, but assist they did, because
they were there to help.

The entire project left me deeply unrequited, however, and this
dis-ease may be taken as a signifier of my own obsolescence. I have
always conceived of cultural institutions as representing constituen-
cies of artistic conviction that have their life-spans and then, as styles

and fashions change, fade from prominence. More to the point, I have always taken the overthrowing and reforming of cultural institutions to be the artist's and the critic's first secular task. Contemporary artistic institutions, however, by assiduously abjuring any artistic conviction, have rendered themselves virtually invulnerable to overthrow or reform. Artists and critics, it would seem, are supposed to have convictions; institutions, cast in the role of parental overseers, are presumed to be above all that. Thus, the exhibition that I conceived as a tiny but heartfelt mandate for change was conceived by its sponsoring institution as an exercise in privileging sufficient diversity to ensure its perpetuation.

This new structural order in the art world has three important consequences. First, the efforts one expends on behalf of one's artistic convictions can have no possible consequence at the administrative level of international culture. Art may change the world, incite the revolution, but it will almost certainly leave its administrative institutions intact. Second, the whole idea of having artistic convictions is effectively infantilized by the parental oversight of disinterested enablers who, having no artistic convictions themselves, cannot help but regard those who do as willful children. Finally, the present situation guarantees that there will be no social commonality or continuity of interest between those who administrate official culture in its stratospheric, abstract sweep and their clients—the artists and critics who live in the world of light and air, thought and feeling, love and language, color and objects. These earthly creatures who make small distinctions that they have every right to hope will have large consequences are trivialized even as they are lionized.

Strangely enough, it is the simple disjunction of interest and enthusiasm between those who administrate artistic culture and those who execute it that I find the most distressing on a day-to-day basis. I was wondering the other day: what if the pleasant young woman from the institution who calls to secure my address and social security number were to ask me what I thought about Robert Gober's piece in Venice? What if the pleasant young man in the

expensive suit who escorts me from the door of the museum to the podium were to express some interest in the topic of my lecture? I honestly don't know what I would do. I would probably break down in tears and tell them everything. I would tell them about my nifty Ken Price and the breeze off the desert, about the essay I just wrote about Roy Lichtenstein's brushstroke paintings and the ebullience of my late dog Ralph, about the book I just read and the painting I just saw. Fortunately for my public dignity, this will never happen—but it should.